Praise for Susan Fales-Hill's
Always Wear Joy

"In capturing the earthiness and the pain behind her mother's electric public persona, Fales-Hill shares with us a woman who is an inspiration to the many mothers and daughters, not to mention sons, who read this touching memoir."

—*San Antonio Express-News*

"A breezy, well-written account of Premice's life and times, the survival skills that women of her generation used and the lessons they imparted." —*Newsday*

"A proud daughter memoir of the author's life with her mother, Josephine Premice, one of the pioneering Black Broadway performers. Sometimes touching, sometimes funny, this family memoir will resonate with most readers." —*Ebony*

"A distinguished memoir as well as an important contribution to black cultural history." —*Kirkus Reviews* (starred)

"Someone wrote *I Never Sang for My Father*, but Susan Fales-Hill's book, *Always Wear Joy*, could be subtitled 'My Mother Always Sang for Me.' If this memoir of an amazing woman, an amazing marriage, and a wondrous daughter-mother relationship were a novel it would be dismissed as unlikely to happen to real people in real life. An American aristocrat, romance, ships, show business, love, laughter are some of the ingredients. Let me confess to a joyous conflict of interest. I knew the author's parents and met the author when she was a youngster. And so I say this love-filled, uplifting book will gladden your heart, moisten your eyes, and leave you smiling at the end: The book, the life, read on."

—Malachy McCourt, author of *A Monk Swimming: A Memoir*

"An extraordinary woman in real life and on the page, Susan Fales-Hill's mother, Josephine Premice, always walked with her head up and her eyes forward. And she left in the dust those who could not understand how she did it with one hundred years of history around her neck. Premice simply made adversity an accessory, anger a purse, and joy a lifestyle."

—Whoopi Goldberg

"A wild roller-coaster ride through the worlds of the WASP elite, the black upper class, Harlem, Hollywood, and the Broadway stage. The breathtaking experiences of both mother and daughter will leave you gasping for air. Magnificent!"

—Lawrence Otis Graham, author of *Our Kind of People: Inside America's Black Upper Class*

"At last, at last a memoir by a daughter who appreciates and loves her mother, at last."

—Bill Cosby

"A frank and touching account of an unconventional upbringing and of a talented, glamorous mother who refused to be defeated by the many disappointments that life handed her. Singer-dancer-actress Josephine Premice never became a household name, but Fales-Hill's tribute to this valiant pioneer and bewitching diva is a fitting memorial. Premice's indomitable joie de vivre emerges vividly and may inspire the reader as it inspired her daughter."

—Ken Mandelbaum, Broadway historian

SUSAN FALES-HILL is an award-winning television writer and producer. She has worked on shows ranging from *The Cosby Show* to *A Different World*, *Linc's*, and *Suddenly Susan*. Her writing has also appeared in *Vogue*, *Town & Country*, and *Travel & Leisure*. She lives in New York City.

Always Wear Joy

My Mother
Bold
and
Beautiful

SUSAN FALES-HILL

Amistad

An Imprint of HarperCollinsPublishers

Grateful acknowledgment is made for permission to reprint photographs on the following chapter openers: prologue, photo reprinted by permission of the Estate of Bert Andrews; chapter 7, Foto NIKAL; chapter 8, photo copyright © Herman Leonard Photography, L.L.C.; chapter 12, photograph by Derek Photographers; chapter 13, photograph by Miki Duisterhof, courtesy of *Town & Country*; chapter 15, photograph by Timothy Fales. Author photograph © 2002 by Julie Skarratt. All other photographs courtesy of the author.

FIRST AMISTAD PAPERBACK EDITION 2004

Designed by Elliott Beard

Printed on acid-free paper

The Library of Congress has catalogued the hardcover edition as follows:

Fales-Hill, Susan.
 Always wear joy : my mother bold and beautiful / Susan Fales-Hill—1st ed.
 p. cm.
 ISBN 0-06-052356-5
 1. Fales-Hill, Susan. 2. Racially mixed people—New York (State)—New York—Biography. 3 Haitian Americans—New York (State)—New York—Biography. 4. Mothers and daughters—United States—Biography. 5. Premice, Josephine. 6. Actresses—New York (State)—New York—Biography. 7. New York (N.Y.)—Biography. 8. Haiti—Biography. 9. Fales-Hill, Susan—Family. I. Title.
F128.9.A1 F35 2002
974.7'10049697294'0092—dc21
[B] 2002032886
ISBN 0-06-056672-8 (pbk)

04 05 06 07 08 ❖/RRD 10 9 8 7 6 5 4 3 2 1

To Vinnie, a very great lady

To Aunt Adèle for her intelligence, sensitivity, and humor

To Enrico, my Marcus Aurelius

*To Aaron for the gift of his love, and for seeing me through
the "long day's journey"*

*To my father and mother, who showed me
infinity instead of life's limitations*

*To my daughter, whose reach already exceeds
her grasp, may you "travel with head held high,
just as far as your heart can go."*

CONTENTS

Through a Glass, Darkly

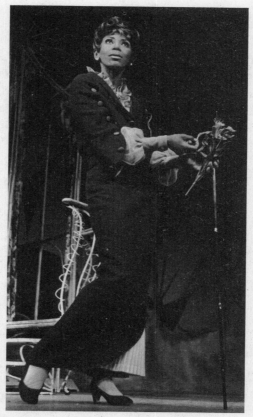

Josephine in House of Flowers, *1968.*

"I did work with [Katherine] Dunham in Ethel Waters' show, 'Blue Holiday.' That was after I got over thinking I was ugly. I really did. A friend told me to stand in front of the bathroom mirror and repeat over and over, I am beautiful. It worked. I began to feel beautiful, which is very important."

—JOSEPHINE PREMICE,
in an interview for the *Daily News*, February 11, 1968

Our house had many mirrors. Since my mother, an actress, believed firmly in the virtue of contemplating one's own reflection, she made sure to have one installed in every room except the kitchen and my father's study. Each night before tucking me into bed, she would sweep me up in her dancer's arms—double-jointed Balinese dancer's arms, she always pointed out—and waltz me around before every mirror in the house. In my frilly night-gown, I imagined myself the heroine of the swashbuckler film we'd just watched, and during which my mother had pointed to the five-hundred-room Chenonceau-style movie set and exclaimed, "That'll be our house someday." How she planned to make the leap from an eight-room apartment on New York's then seedy Upper West Side to a palace in Europe, she never specified. My mother never let reality dampen her dreams. And I believed she could make anything happen. In her arms, I became deaf to the wail of police sirens outside and the drumbeats and chicken squawks of voodoo ceremonies taking place in dark side streets fourteen floors below us. Every night my mother transported me from West End Avenue and Ninety-seventh Street, from 1960s New York, to a magic kingdom.

Pausing before each looking glass, she and I would recite in unison and at waltz tempo, "Good night, Mistress Susan, good night, good night." She'd laugh the rich, guttural laugh that ensured that even in a room crowded with towering adults, I could always find her and run to the safety of her amber-scented cocktail

skirt. At our first stop, one of three full-length "door mirrors" in the deep burgundy–colored bedroom my parents shared, I'd beam adoringly at the reflection of my mother's face, a sharp-angled mahogany heart dominated by enormous dark eyes. Her chiseled features were heightened by her elaborate makeup, or "face painting," as she called it. For her, applying makeup, or "putting on her face," became an elaborate ritual performed every morning at her bathroom mirror. With her Max Factor Dark Egyptian pancake makeup, eyeliner, and false eyelashes—which, arrayed on the milk-glass shelf in her bathroom, looked to me like bushy black centipedes—she became her own creation, a portrait, a rendering of herself, my mother, a queen.

She'd smile back at my café au lait–complexioned face in the mirror with such joy and pride, as though every night she experienced the happiest moment of her life. Her cheek was as fresh and soft against mine as her silk charmeuse blouse. Soon we glided across the living room's dark, shining parquet floor to the double doors separating the living room from the dining room. Four mirrors sent back our reflections, and so eight laughing, dancing, smiling figures stared back. Beyond our own images and various pieces of furniture, the red damask slipper chair, the tumbled marble garden planter, which sat on the floor as a gargantuan ashtray, and through the doorway, I could see the reflection of my parents' deep, dark burgundy bedroom. Its somber hue contrasted with the pink-and-green rosettes on my nightgown. It loomed as a place of mystery, a repository of grown-ups' secrets. But there was no time to dwell on this darkness; my mother kept us moving on the "tour of beauty." Off we went, through the double doors to the huge mirror that covered the upper half of one wall of the dining room, above the marble-topped sideboard. The myriad lights from the Italian chandelier, a bouquet of copper wildflowers that hovered above the heavy Victorian walnut table, danced and glistened, creating tiny

rainbows in the mirrors that refracted the light from the rhinestone earrings and bracelets my mother often wore. It was our own version of a Versailles sound-and-light spectacle, and to my six-year-old eyes, just as spectacular. One refrain and we departed for the entrance hall. There we stood in the mirrored door of the coat closet, the white-and-gilt baby grand piano huge behind us, like a relic from a rococo past life or perhaps a televised Liberace recital.

And thus we progressed until we reached my room, where at long last my mother would lay me down and sing me a lullaby in Creole, the dialect of her family's native homeland, Haiti. "*Ti oiseau, ti oiseau.*" Her gravelly voice tickled my spine like an electric charge. I giggled uncontrollably, wanting her to stop yet begging her to continue. Finally, I would pass from my mother's strong, loving arms into the embrace of night and sleep.

Many years have passed since we first built our dream castles. She is seventy-four, and dying. Now, it is my turn to hold us up to the looking glass once more before we say good night.

New York
January 2001

Life Is Beautiful

CHAPTER ONE

Here's Josephine

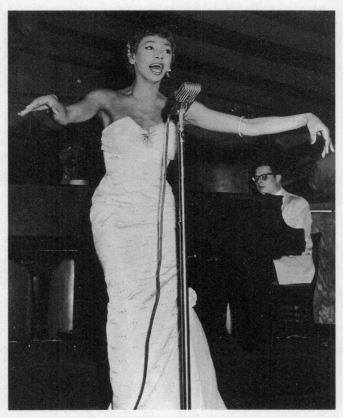

Josephine dazzles a nightclub audience in the fifties.

"Mom, what do I put down on the school form
where it says 'Mother's Occupation' when you're
not acting in a show?"

—ENRICO FALES, age 8

"Tell your teacher, 'My mother's an unemployed legend.'"

—JOSEPHINE, age 41

reathe in!" my mother commanded in her low, smokier-than-Bacall timbre, as she took a puff on her cigarette and cinched my lean, as yet unblooming fourteen-year-old physique into the pearl-gray *peau de soie* ball gown. "I bought this dress years ago, in Paris, from my friend Jacques Fath, one of the great designers." Each of my mother's gowns told a story of her life, her performances, and her travels. As she drew the zipper up, the dress's whalebones rose and folded over my pitifully underdeveloped bust, encasing me in femininity. Though just a few years earlier, white women had declared their emancipation in a bonfire of brassieres, in our home such garments represented neither bondage nor second-class citizenship, but rather glamour and its almost infinite transformative power. To my mother and her bevy of beautiful black diva friends and fellow performers Lena Horne, Eartha Kitt, Diahann Carroll, Carmen De Lavallade, and Cicely Tyson, women who had survived segregation, the Great Depression, World War II, the civil rights movement, and many a bad romance, it was creativity, illusion, and high style, not gunnysacks, earth shoes, and the dreary truth, that set you free.

"Your waist was tiny!" I exclaimed in admiration. My mother flashed her cat-that-swallowed-the-Hope-diamond grin.

"When I married your father, I could wrap my arms around it and shake hands with myself." She laughed her caressing, husky laugh. "You're going to be much taller than I am. That's why it fits you already. I'll have to take it in here!" she said nipping the strap-

less top of the bodice tight around my mosquito bite–sized breasts. I ran my hands over the forlorn, unfilled cups. "I was always flat-chested," she reassured me. "It's far more elegant! Big breasts are vulgar," she declared, casually demolishing in two sentences a hallowed canon of American beauty. She pulled a pink rayon overdress with three-quarter sleeves and dusty rose velvet piping off the Singer sewing machine perched on the dining room table and helped me into it. "There, go look at yourself." She prodded me toward the mirrors on the folding double doors. "Beauty *lele*," she cheered.

I straightened my back as though a string had tugged my head, standing taller and prouder. I could see my mother's reflection beaming at her creation. She had done it again—transformed an old frock and pennies' worth of fabric into an exquisite costume and an indelible memory. I smoothed the skirt.

"You musn't lift the skirt when you walk," she warned. "Women didn't do that in those days." My mother seemed to know the dress protocol of every age, as though she had lived a thousand years rather than a mere fifty. She made the suggestion less for my performance in the school play than as a stage direction for life.

"It's beautiful," I gushed, kissing her on the cheek.

She hugged me. "It will be when I'm done, my angel. You'll be the most incredible creature on that stage." She didn't want me to follow in her footsteps and become an actress, but she was determined to prepare me for a "lead role" in the world.

"The lace!" she screamed, suddenly remembering. "We don't want it too dark." She grabbed her cigarette and dashed into the kitchen. On the stove, next to the simmering pot of aromatic curried chicken, steam rose from a saucepan filled with tea. Using a pair of pasta tongs, she removed a half-yard of lace soaking in the amber-colored liquid. "See, you leave it in the tea, and it turns a brand new piece of lace from the five-and-ten into an antique.

When it dries, I'll sew it on the sleeves of the pink overdress. Then you'll really look like an eighteenth-century lady."

"Enrico," she then bellowed toward the firmly shut door to his bedroom, through which we heard the strains of Jimi Hendrix singing, "Manic de-pression's captured my soul." My then seventeen-year-old brother failed to answer. "Enrico!" my mother yelled louder, the veins on her neck bulging.

"What?" he answered with teen exasperation.

"Dinner in fifteen minutes. Call your father at the pub!" My mother rolled her eyes. "He looks just like your father and has the same brooding personality."

I nodded in sympathy. Even at age fourteen I wondered what we were to do with them. When would these Fales men start participating in life's banquet? Usually, my mother and I left them to skulk in their private chambers, reading their innumerable books— Enrico of science fiction and occultism, Papa of naval architecture, mathematics, or history—while we performed the "rites of glamour and joy" in the prewar apartment's front rooms. But this was a Monday, one of only two "dark" nights for the Broadway musical *Bubbling Brown Sugar* in which my mother was starring. She insisted we dine together as a family.

Enrico, six feet two inches tall, slender as an asparagus stalk, his medium-sized Afro flattened at the back from lying down, entered scowling and crossed toward the wall phone to dial Mikell's, the Columbus Avenue watering hole of New York's black intelligentsia in the sixties and seventies.

I knew it would take at least forty-five minutes for my father to tear himself away from the bar and the group of lawyers, musicians, doctors, and worldly women with ripe bodies who affectionately called this lone WASP in their midst "Big Tim." While waiting for my father to wend his way home, I ran off to the quiet of my own bedroom. Once there, I memorized my lines from the

play by repeating them over and over as I walked back and forth from the window overlooking the dilapidated welfare hotel across the street to the tall Chippendale cabinet filled with my collection of antique porcelain dolls on the other side of the room.

Two days later, my parents sat at the back of the large Louis XV–style ballroom, which served as the Lycée Français de New York's auditorium and exam room, watching the unmitigated disaster we called our annual school play. Since we were students of a French school, our repertoire consisted of the classics of the Comédie Française. That year, we butchered *La Colonie*, Marivaux's comedy of manners about pre-Revolutionary French aristocrats marooned on a desert island. The piece opens in the aftermath of a shipwreck, but no doubt we succeeded in making our audience feel they themselves were passengers on a doomed vessel. I posed onstage, in my perfectly fitted Jacques Fath ball gown and pink overdress with its "antiqued" lace ruffles, tensely waiting for my costar, a pale, pimply slip of a boy, to spit out his line. He stood, the proverbial deer in the headlights, eyes wide and unblinking, mouth agape, not uttering a word. The cardboard box at the foot of the stage rose visibly as the *souffleur* leaned toward us and loudly read my fellow thespian his next line. The boy repeated it in a robotic doggerel. The cardboard box settled back into its original spot. Cued at long last, I delivered my lines in a voice nearly as strong as my mother's, thinking to myself, *Maybe the rest of you can afford to flail around the stage making fools of yourselves, but I'm up here representing my family, and black and mixed people everywhere. If I screw up, I drag hundreds of thousands of people down with me.*

At the end of the painfully long performance, my parents cheered loudly, no doubt ecstatic at their deliverance from truly horrendous theater. I joined them at the back of the room as the parents collected their children.

"*Bravo, chérie,*" said Papa, tugging on his prominent nose, as he often did when thinking.

"*Merci,*" I answered.

"Your daughter was wonderful," commented Mrs. Bardey, a voluptuous young French mother who always wore miniskirts. "Is Susan going to be an actress like her *maman*?"

"No, if she becomes an actress or a nun, I'll kiiiiiillll myself," my mother objected with all the pathos and melodrama of an ante-bellum actress in an overwrought production of *Uncle Tom's Cabin.*

I knew my mother was the last person on earth who would ever commit suicide. She loved life too much to willingly leave the party before "last call." But even at fourteen, I understood what she meant. She never wanted me to suffer the rejections she had at the hands of directors, producers, and an entertainment industry that in 1976 still offered very limited opportunities to black actresses. Though that year our nation jubilantly celebrated its bicentennial, performers of color had yet to gain their independence from age-old stereotypes. On the small and big screens, for the most part, black women had a choice among playing down-and-out hookers, sassy assistants, or someone's hefty, hand-on-hip Mama. For my mother, the exhilaration of performing was always undercut by long weeks and months spent waiting for someone to offer her a job, and the pain of knowing that in spite of her training and talent, there were parts she'd never have the chance to play simply because she'd been born into the "wrong" ethnic group.

"When I started my career in show business, everyone told me I was too dark. Now they tell me I'm not black enough. Story of my life, I can't win," she'd joke.

She'd even endured slights from her own people. On her first day of rehearsals for *Blue Holiday*, her first Broadway musical, the light-skinned star, Ethel Waters (who went on to play the grand-mother of the tragic mulatto passing for white in the movie

Pinkie), walked in, took one look at the dusky nineteen-year-old, and bellowed, "Get that black bitch off the stage"; in later years Ms. Waters would claim that she had nursed my mother through her first show. She accepted such a fate for herself, but refused to accept the hard-knocks life for me. She raised me to believe that acting was not a profession but a novitiate. One didn't choose it on a lark or at a job fair. One "entered" the profession "thoughtfully, reverently, and in the fear of God," because there was nothing else one could possibly do and be happy. That was the gospel according to Josephine Premice Fales.

Though she had named me after her good friend Susan Strasberg, daughter of the formidable acting coach, Lee, my mother decreed early on that I had not been called—by the gods of method acting, I suppose. Besides, she had other plans for me. I would begin my education at the finest schools, not just in this country but in the world. I could attend a Swiss boarding school, Le Rosey, like my father, or perhaps a finishing school where young ladies learned about fine wines and gourmet food. When asked by a less-than-charitable female acquaintance what I would do with this education if I married a truck driver, my mother retorted, "The truck driver will eat well."

Once "finished" and college-educated, I would go on to a glorious career. All paths were open to me—except of course the stage or the Church. I would become powerful, I would "run things," not sing for my supper as my mother had until she married my father.

Though she didn't want me to follow in her footsteps, my mother had few regrets about her own career. "It was the only thing I could do and breathe," she always explained to me. Though she had many other gifts, for painting, designing clothes, decorating, choreography, and writing, Josephine Mary Premice knew she'd be a performer from the time she could speak.

Once when she was about two and half, my grandfather, the tall and dignified Lucas Premice, clad in his ubiquitous charcoal

gray pin-striped suit with high-waisted pants and suspenders, took her, his tiny brown bundle of bones and energy, to Coney Island. When he let her out of his sight for just a moment, she vanished. He panicked. Suddenly, he heard a roar of laughter and applause from a crowd of bystanders. He looked up to see his child up on a small platform, dancing and making faces for the multitudes in a pint-sized interpretation of the antics that were then winning Josephine Baker raves on the Paris stage. Livid, he snatched her off the makeshift stage over the vociferous protestations of the Depression-era crowd desperate for a moment of joy.

"Let her go on, she's so cute!" they pleaded. Lucas would not have it. His daughter was not a clown, an organ-grinder's monkey, required to perform at the bidding of strangers.

He and his wife, Theloumène, a Haitian horse trainer's daughter, were raising Josephine and her older, quieter sister, Adèle, to be ladies, "noblewomen" worthy of the name Premice. Though his passion for equality and social justice eventually led him to join the American Communist Party—which at the time fought not only for workers' rights, but also, though perhaps out of pure self-interest, for equal rights for people of color—Lucas had been born into the Haitian landed gentry, the son of a graduate of Saumur, the West Point of France. According to family lore, Lucas's mother gave birth to him in the middle of a sugar cane field, while surveying her lands. Lacking proper swaddling, she allegedly wrapped her newborn in the Haitian flag, imbuing him from the cradle with intense patriotism. Lucas was fiercely proud of both his heritage and the family lineage. The Premices, like other landowning island families of color deemed amenable to the French colonial cause, had been ennobled by Napoleon's sister when she visited Haiti with her husband, General Le Clerc, in 1802. Lucas allegedly had claim to the title Comte de Bodekin.

Never mind that he and his young family now lived in a

brownstone in Brooklyn and that Lucas now made his living as a furrier. Never mind that it was 1929, they were black, and in America at the time that technically made them second-class citizens. Lucas had not come all the way to the United States from Haiti to see his daughter grow up to be a minstrel. His daughter would marry a diplomat, or become one herself. She would "perform," as well-bred ladies did, in drawing rooms, for polite company, not on a public stage for "vulgarians." Though Lucas squelched his daughter's debut, he could not squelch her desire to perform.

A sickly child with rickets, my mother nonetheless developed an early passion for dance. Her parents still did not approve. Running around a stage in tights, or even less, was not the future they envisioned for their Haitian *jeune fille bien rangée*. But the bow-legged child would not let them stop her. She agreed to violin lessons in order to gain permission to study ballet, tap, and jazz. When she was fourteen, Owen Dodson, a black poet, Yale School of Drama graduate, and family friend, asked her to choreograph his production of *Jason and the Golden Fleece* at a theater in Harlem. By then Lucas and Theloumène had realized that attempting to prevent their youngest daughter from entering show business was as pointless and potentially hazardous an exercise as standing in the path of a charging rhinoceros.

At the time, the early forties, modern dance and black concert dance were beginning to be taken seriously as art forms. Many leftists and bohemians perceived the new dance aesthetics as an expression of freedom; they enthusiastically supported the efforts of experimental and ethnic dancer-choreographers, promoting dance festivals and integrated dance schools. As a young girl, my mother studied with some of the era's most influential innovators, including Charles Weidman, a pioneering modern dancer, Martha Graham, and African-American anthropologist-cum-choreographer Katherine Dunham, who took her inspiration from the ritual

dances of Haiti and other islands in the Caribbean. At sixteen, my mother auditioned for and won a part in the latter's company only to have Lucas rip her off the stage a second time. He had accepted his daughter's becoming a performer but insisted she take her "rightful place" as a "star," not as a "lowly" member of some corps, waving a palm frond in unison with twenty other women. Much to his teenage daughter's dismay, Mr. Premice politely explained to Miss Dunham that Josephine danced solo or not at all.

My mother soon justified her father's presumptuous prediction, becoming a headliner in dance concerts in the forties (one of a handful of performers hailed by *New York Times* dance critic John Martin as having changed the face of American dance), an internationally acclaimed nightclub singer and Broadway musical star in the fifties, a legitimate theater actress in the sixties and seventies, and a television and stage actress in the eighties. In a career that spanned nearly fifty years, from Jim Crow to political correctness, and which included record-breaking moments—two of the shortest running shows on Broadway, *Blue Holiday* and *Mr. Johnson*—and several firsts—for example, three of the first professional black productions of classic plays *Electra*, *The Cherry Orchard*, and *The Glass Menagerie*—she performed in every medium. Once she got married and Enrico and I were born, she chose to focus on us and forgo work opportunities, so she never became a household name like the friends with whom she'd begun her career, Eartha Kitt and Diahann Carroll.

Still, all my life, people have approached me to tell me what an incredible performer my mother was. She wasn't just "Mommy," she was an artist whom friends and complete strangers admired. "Your mother, what an extraordinary dancer," I heard from a woman who had seen her in 1943 and 1945 at the annual African Dance Festival at Carnegie Hall produced by choreographer Asadata Dafora, the first impresario to present African dance to American audiences as an art

form rather than an ethnographic freak show at a World's Fair. First Lady Eleanor Roosevelt had attended both performances with Mary McCleod Bethune, the pioneering black journalist who at the time served as president of the National Council of Negro Women. Only seventeen years old at the time of the first concert, my mother danced the principal role of "the bride," and in the second concert, she shared the stage with Bill "Bojangles" Robinson (the great vaudevillian and veteran of Shirley Temple movies), who tap-danced to the accompaniment of seven African drummers.

"Your mother is the most unbelievable singer and comedienne," film director Mike Nichols told me when I met him as a teenager. He'd known my mother from her days at the Village Vanguard, the funky West Village nightclub where Harry Belafonte, actress Judy Holiday, and composers Betty Comden and Adolph Green, among many others, launched their careers, and the great jazz trumpeter Miles Davis could be found of a night jamming with Charlie Parker and Max Roach. With its mixed bill of comedy, poetry, and music, the club attracted everyone from Fred Astaire and Tallulah Bankhead to sailors, hookers, black Harlem socialites, and New York University students to watch the nightly shows in its smoke-filled basement room. From there, my mother had gone to Max Gordon's dressier East Side nightclub, the Blue Angel, with its gray velvet walls, one of the few New York supper clubs of the era that dared to welcome "Negro" patrons and feature "Negro" talent for its largely white, well-heeled clientele. Singing calypso and dancing in Haitian peasant garb, she turned her two-week booking into a seven-month stint, a record for the elegant *boîte*.

"Are you ever going back to Europe? And when will you do another one-woman show? We're dying to hear you sing 'Two Ladies in the Shade of a Banana Tree,'" an elegant gay man asked at a cocktail party in the Hamptons. He had seen my mother in *House of Flowers*, the 1954 musical by the American

novelist and society gadfly Truman Capote, set in a bordello on a tropical isle. The original production had been choreographed by George Balanchine, founder of the New York City Ballet, and featured Arthur Mitchell, his first black principal dancer and the future founder of Dance Theatre of Harlem, and painter-chore-ographer Geoffrey Holder in the chorus. The cast included Pearl Bailey, already a famous nightclub singer and comic, and ingenue Diahann Carroll.

"Your mother is a legend," Mrs. Wolfe, an attractive house-wife from upstate New York, told me when I was nine as we sat by the pool of a hotel in Haiti. She'd read about my mother in the diaries of the Cuban writer Anaïs Nin. My grandfather had brought both my mother and her sister to Ms. Nin's New York apartment as teenagers, and they often participated in her multi-cultural salons. Of one such soirée, Ms. Nin wrote:

> I gave a party for the Premices, Albert Mangones, Olga, Moira . . . Lionel Durant, Charles Duits, Gerald Sykes, Ellen and Richard Wright. . . . Albert Mangones is almost white (his mother was Spanish), an ivory white, with softly waved hair. He has just won the gold medal for architecture at Cornell. He plays the drums and sings. He is well educated and refined. He sang while he drummed and Josephine danced. . . . Josephine is an inspired dancer, abandoned, savage and violent in her gestures.

"Your mother revolutionized the business," the stand-up comic Red Buttons told me when I met him at an awards ceremony in 1991. He'd performed with my mother in the fifties at Catskills resorts. "She was never beaten down by racism," he continued, "and those were tough times." He admired her dignity, and the image that she presented at that time, glamorous, international, sophisti-cated. It was not what white audiences expected from a black

singer in those days, but she made them accept her as she was. She did not let the reactions of the public daunt her.

Once, at a performance in a Los Angeles nightspot, Joan Crawford commented most audibly from her front-row table, "I don't think she's so pretty."

My mother stopped midsong, turned to the screen legend, and said, "Oh, Miss Crawford, you're looking in your mirror." As the patrons erupted in laughter, the reed-thin, "not so pretty" black woman resumed her song.

Ironically, it was the self-assurance imparted to her by the proud parents who never wanted her to enter show business in the first place that gave my mother the courage and chutzpah to enter such an impossible profession for a black girl, particularly a skinny, dark-skinned one. But in the end, my mother never concerned herself with fitting in or with what people thought. Though she did have her occasional moments of self-doubt. She always wore long skirts because she didn't like her scrawny legs. "I have calves like a chicken bone," she'd joke, striking a Barbizon School of Modeling pose in front of a mirror. She'd laugh at her own reflection, then shrug her shoulders as if to say, "I am what I am." In her performances, as in her life, she was an original.

As very young children, my brother and I did not always value our mother's profession. During a performance of the 1968 off-Broadway revival of *House of Flowers*, our mother looked out across the footlights to see some four hundred smiling fans and her two scowling children with our fingers firmly stuck in our ears for the entire evening. At the end of the show Enrico at least had the grace to applaud. He and our Italian governess, Bruna, encouraged me to do the same.

"No," I pouted, "clapping hurts my hands." My critique did not end there. "I don't like seeing you act," I informed my mother.

"You become another person." It did not occur to me as a five-year-old that that was indeed the point of the exercise.

What I did love, from the youngest age, was watching her rehearse at home with her accompanist, Sammy Benskin, a kind, soft-spoken gentleman with eyes that drooped sadly like a basset hound's, lending him an air of empathetic melancholy. I would sit in our living room on West End Avenue and listen intently as Sammy played the white baby grand and my mother belted out tunes like *"Vinganca!"* (Vengeance!), one of my favorites, the sad ballad "Quiet Room," and *"La Mamma,"* which tells of a vigil for a dying and adored mother. At four, five, and six, I memorized and sang lyrics I couldn't possibly understand: *"sta per morire laaa mamma."*

I didn't know how deeply *"La Mamma"* resonated with my mother, who had lost her own mother at eighteen. She never spoke of the pain of it. I knew only the facts, that my grandmother had predicted her own death a few months before it occurred by reading the grinds at the bottom of a coffee cup while sitting in the kitchen with her two daughters. "When you come back I will no longer be here," she announced to her eldest daughter, Adèle, who was leaving to study in Germany. My grandmother's passing seemed, in my mother's telling, more a testament to my grandmother's powers of clairvoyance than to my mother's sense of loss. And so I sang *"La Mamma"* to myself as a soothing lullaby, not an agonized cry, for death was a distant notion. When I looked at my mother, I saw a mystical, powerful being who could and would live forever.

When she walked into a place, whether a ballroom or a butcher shop, people brightened instantly and stood up taller, basking in the glow of her megawatt smile. Even the drag queen prostitutes in the neighborhood excitedly called out, "Hello, Miss Premice, looking sharp too-day," whenever she emerged from our building in full makeup and the fluffy mongolian lamb coat she wore to go to the supermarket.

"Thank you, darling," she'd reply with the enthusiasm of a well-bred hostess welcoming a guest to her garden party. "Darling," of course, was code for "I have no idea what your name is, but I'm going to make you feel as if I do."

She could turn a trip to the grocery store into an adventure, and ordinary objects into treasures. She had once transformed the cheap hardware store chain link they used for pulling the flushers on old-fashioned toilets into a necklace attached to earrings. For my first costume party, she pulled items from her own closet and turned me, aged nine, into Cleopatra, Queen of the Nile, complete with catlike eye makeup, headdress, striped lamé dress, and a cardboard scepter sprayed gold. My mother saw beauty in everything from the simplest flower to the color contrasts of a well-marbleized steak. And she made sure I noticed all the hidden treasures of our then unfashionable neighborhood, from the tall, mocha-skinned cashier at Sloan's supermarket who'd once danced in the chorus of the Cotton Club, the famous Harlem nightspot where Lena Horne and Duke Ellington started their careers, to the copper cornices oxidized sherbet-green that crowned the tops of once grand turn-of-the-century buildings. Every morning, she threw open my bedroom curtains on a new day of adventure as she sang out, "Rise and shi-ine!"

I wanted to be just like her: beautiful, elegant, funny, and "all made up." Though I looked nothing like her, I took pride in the fact that I had inherited her long double-jointed arms. I couldn't get enough of her company and followed her everywhere, even to the bathroom. She rarely lost her patience with me, though she often did with my brother, who reminded her of her husband. Every so often she would yell in frustration, at no one in particular, "Everyone in this house has their own room but me!" And indeed, it was true. After our governess returned to Italy when I was seven, I had my bedroom, Enrico his, and Papa had a study in which he

cloistered himself for hours on end, but there wasn't a single room just for my mother. Only her bathroom remained as her refuge from the incessant demands of a brilliant, charming, but self-absorbed husband, a sometimes moody son, and a high-strung daughter. "My baby's name is Drama. Everyone else is out looking for the silver lining. You're out looking for the clouds," she'd chide when I worried about school or expressed my deeply felt fear that the sky would indeed fall, and soon, on my young head.

Perhaps her greatest and most sustained performance was the one she gave in her very own home, a juggling act on an epic scale. In the eight rooms high above Ninety-seventh Street, she created the illusion that she was invincible and that our Eugene O'Neill-esque family, fully loving one moment and loathing the next, was united, sane, happy, and strong. It was a pretense she was able to maintain until I reached adulthood. The illusion probably saved my life and destroyed her health. I've never needed to study the lives of Catholic saints to understand the words "She died that you might live." My mother sacrificed herself for me, but she didn't do it wearing "rags of righteousness," the faded housecoat of "dream-deferred mamas," the pallid blue caftans of postcard saints. She did it in rhinestones, full makeup, and high, high heels.

Someday He'll Come Along

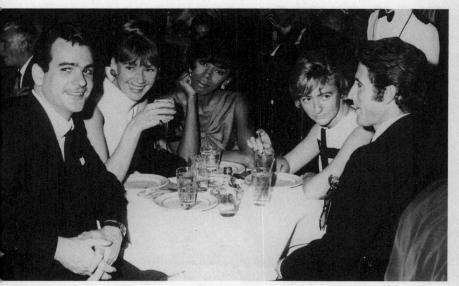

My parents at El Morocco with friends, among them the
author Françoise Sagan (second from right). My father is first on the left.

"It is the justified boast of the Anglo-Saxon that, unlike some Latin races, he has, on the whole, refused to marry Negresses."

—CLARENCE BLAIR MITCHELL,
my great-grandfather, from his essay,
Plain Talk on the Negro Problem, 1947

"That's the mother of my children."

—TIMOTHY FALES,
my father, Clarence Mitchell's grandson, upon meeting
my mother for the first time in 1958

A 1958 playbill for *Jamaica*, the musical in which my mother was appearing when she met my father, features an ad for Benson and Hedges cigarettes in which a beautiful brunette, clad in a strapless evening gown and jewels, reclines on the winding marble staircase of a stately home. A few steps below her, a dark-haired swain with his back to us extends an incandescent lighter toward the woman's waiting cigarette. Her full lips curl in an expression of knowing expectation. Above the photograph, verses from Byron promise, "No sleep till morn when youth and pleasure meet / To chase the glowing hours with flying feet." It was in the world of beautiful people smoking and drinking in romantically lit supper clubs, in an era of American hegemony and white privilege, an era before twelve-step programs and surgeon general warnings, that my mother followed her heart and married my father.

She wanted to be the elegant belle in the ball gown greeting the Prince Charming who lights up her life. She had the evening dresses, she just needed to meet the man. In the mid-fifties, she had even recorded an up-tempo Calypso rendition of "The Man I Love." "Maybe I will meet him Sunday, maybe Monday, maybe not / But I'm sure I'll meet him someday," she sings out with the boundless exuberance of a confirmed romantic, an unmistakable smile in her voice.

Timothy Fales, my father, was a product of the rarefied Anglo-Saxon world of Henry James's novels. He grew up in a townhouse on the Upper East Side of New York and on a country estate where tall

grandfather clocks handed down through generations funereally sounded the passage of the hours. Chintz slipcovers camouflaged the furniture in the summer. In the winter, the household staff removed them to reveal mahogany frames, red damasks, and somber blue velvets. The same old Irish woman who had raised my grandmother became my father's first governess. "My dear nurse, Bessy," Grandma would warmly reminisce. "Bessy was a bitch," my father declared, giving the lie to all of Grandma's fond recollections.

His father, DeCoursey Fales Senior, a descendant of William Bradford, the first governor of Massachusetts Bay Colony, served as the president of the New York Bank for Savings and as commodore of the New York Yacht Club. My father's mother, a Colonial Dame of America, rode sidesaddle in the Essex Fox Hounds hunt. He had two older brothers, DeCoursey Junior and Haliburton II, whom he followed in the traditional Anglo-Saxon Protestant boy's scholarly pilgrimage from Buckley to St. Paul's and eventually to Harvard. Young Timothy found his journey interrupted, however, when St. Paul's kicked him out for allegedly seducing one of the young housemaids. His parents eventually packed him off to Le Rosey, in Switzerland, then a playground for naughty boys from the "best families."

The great Fales family scandal was that Timothy's paternal grandmother was believed to be Jewish, or *Juive*, as it was whispered in their coterie, as if saying it softly and in French lessened the "blow" to the family dignity. The other gossip among the hunt club set of Gladstone, New Jersey, was that my grandmother had not been fathered by Clarence Blair Mitchell, her mother's husband, but by the king of Morocco during one of Mrs. Clarence Mitchell's extended trips abroad. Because my father never wanted to fit into that "caste into which it had pleased God to call him," he adored that version of his heritage: illegitimate grandson of the King of Morocco. Not for him the staid world of Pimm's cups and

prep schools, gentlemen's clubs and convenient marriages to the *comme il faut* Caucasian girl next door. He had chosen such a girl in his twenties, a somewhat aloof blond fashion model, and the union was both unhappy and brief.

He relished being different and forged an iconoclastic path in both his career and his social life. He left Harvard to go to sea, then became an executive in a shipping company. Months after he married my mother, a good friend from boarding school invited him to come to Rome and start a business, a center for international trade dealing primarily in luxury goods. As my mother told it, her new husband arrived home one afternoon and announced, "We're moving to Europe." Josephine did not argue, she packed. When that business faltered after six years, my father moved our family back to New York and took a job as an analyst at the Wall Street firm Bear Stearns. He left Wall Street in 1969, when I was six, and devoted the next eight years of his life to writing a history of the Caribbean.

He'd arise at six o'clock each morning and hole himself up in his study, where he arranged his many books alphabetically and segregated them by language—English, French, Italian—and subject matter. Each afternoon when I returned from school, my mother would prod me to go and greet him. I'd stand hesitantly at the study door calling out, "*Bonjour, Papa.*"

Without turning to look around, still consumed by the book or manuscript before him, he'd respond, "*Bonjour*, Cougie," using the nickname that arose when my brother first tried to pronounce my name. I'd gingerly enter and peck him on the cheek. He'd offer a quick smile in response, uncomfortable with physical affection as well as with interruptions of his solitary pursuits. He displayed the greatest patience toward my brother and me when teaching us to sail or snorkel or when sharing the seemingly inexhaustible stores of his knowledge. He never tired of answering the "why" and "what

is" questions that are a child's constant and often exasperating refrain. I developed a good attention span listening to his lengthy and highly detailed answers to what I may have considered simple queries. I learned not to ask unless I had at least half an hour to listen to a minilecture, followed by a "field trip" to Papa's library shelves to consult and cross-reference at least three relevant tomes. On most occasions, the answer led to a short disquisition on a related topic, which led inevitably to another tangent. Attention deficit disorder was not an option. Papa excitedly digressed and footnoted and spewed until, overwhelmed with information, I would say at long last, "Thank you. I have to go and do my homework." My father would relent, looking somewhat deflated, as if he'd offered me his greatest treasure and I'd refused it.

When I was fourteen years old, after a long sabbatical from paid work, my father returned to his first love, the sea, as a captain in the merchant marine, in part to prepare for the merciless onslaught of college tuition payments. Like a latter-day Sir Richard Burton (the nineteenth-century explorer, as distinct from Elizabeth Taylor's husband), his work and his passion for cultures not his own took him around the world. He would return with tales of what he had seen: the venal customs officers in Pakistan, the Indian beggar children maimed by their own parents to render them more pathetic and thereby lucrative, the destitute Haitian man who'd fallen on his knees before him begging for work, and Papa's brokenheartedness at having none to offer. An ethnic chameleon, he was mistaken for an Italian when we lived in Rome. In the French Caribbean, his Creole was so good, the local authorities suspected him of spying for the CIA. "I belong everywhere and nowhere," he would sometimes declare as if offering a summation of his life.

In choosing Josephine Premice, the actress, the Haitian girl raised in Brooklyn, my father did not truly "marry out of his class and race." Rather, he married a girl whose mother had kept her two

daughters in on Saturday afternoons to school them in such rarefied social graces as setting a table for a five-course meal and curtseying to the various ranks of nobility leading up to and including a queen. This training might seem bizarre if not utterly useless for two little black girls growing up in Brooklyn and attending public school, but my grandmother envisioned a brighter, loftier future for her daughters. Though she herself was a splendid cook, Theloumène Thomas Premice, who worked in a toy factory making stuffed animals to add to the family coffers, refused to pass her culinary skills on to Josephine and Adèle, insisting, "You will enter a kitchen only to give orders." Josephine found her mother's teachings most helpful when she began traveling and performing in nightclubs around the world. By the age of twenty-seven, she had headlined in all the major capitals of Europe and South America. She'd been embraced by President Vargas of Brazil, hailed as "Madonna Negra" in Italy and "La Bombe" in France. In the tradition of black American performers like Josephine Baker; Florence Mills, a noted Broadway star of the twenties; and Cole Porter's muse, the red-headed Virginian known as Bricktop, Josephine Premice conquered Paris and international society.

And so in my mother, my father found a fellow citizen of the world, an equally multicultural soul mate who could match him witticism for witticism, language for language, affectation for affectation. She could travel with him anywhere, except perhaps to the seedier sections of Bombay or Timbuktu.

"Your parents are united in their sophistication and their snobbism," Diahann Carroll, my mother's best friend and one of my several honorary aunts, joked during one of our many forensic forays into my family's past.

My parents' first meeting was the stuff of celluloid fables, or so my mother always made it seem. I don't remember when she first told me the story of their courtship, but she repeated it to me

often. And I reveled in it each time the way other girls might revel in *Cinderella* and *Sleeping Beauty*. My parents' mutual friend, Johnny Galliher, a dapper WASP socialite and man-about-town, brought the then thirty-year-old and soon-to-be-divorced Timothy to see *Jamaica*, a popular Broadway musical. The story centered on an island woman, Lena Horne (in her Broadway debut), who longs to leave the tropics and her fisherman beau, played by Mexican actor and former MGM contract player Ricardo Montalban (cast after Harry Belafonte became unavailable), for the bright lights of Manhattan. While most of the fabled black Broadway musicals of the twenties, such as Eubie Blake's *Shuffle Along*, had been written by black composers, *Jamaica*, like other black musicals of the fifties, had been created by white tunesmiths. Yip Harburg and Harold Arlen began their careers composing classic songs such as "Stormy Weather" for the Cotton Club, moved to Hollywood, and together won the Academy Award for the music of *The Wizard of Oz*. *Jamaica* was the first Broadway musical to hire black stagehands and a black stage manager. Josephine played Lena's best friend and Ossie Davis's fiancée. Although the producer, David Merrick (who had recently brought Laurence Olivier to Broadway in *The Entertainer*), practiced equal opportunity behind the scenes, he didn't want to cast my mother because of her dark complexion. The director, Robert Lewis, a cofounder of the Actor's Studio, did. He'd hired my mother a few years before for her first nonmusical play, *Mr. Johnson*. After her audition, Mr. Merrick pronounced my mother "not pretty enough to play Lena Horne's best friend." He apparently suffered under the misperception that black women selected their friends the way the South African government ranked its population, by "degree of whiteness."

My mother remained unfazed by his critique. She looked him in the eye and said, "Mr. Merrick, I'm going back to Paris to sing. And after you've seen every other actress in New York, I'll be the

most beautiful girl you've ever seen." With that, she exited the Imperial Theatre, and three weeks later received a call from Lewis begging her to return and take the role.

My father knew the moment he saw her hoisted aloft by a bevy of muscle-bound chorus boys, which included Alvin Ailey, that he would make this brown-skinned pixie with the big voice his bride. She sang a song satirizing American Cold War foreign policy, "Leave the Atom Alone," and he fell in love. Johnny brought him backstage to meet Lena Horne and Josephine. As they stood in Lena's dressing room, my father told Johnny, "That Josephine Premice is the mother of my children."

Now, my mother looked anything but maternal in her island-girl sarong and bare midriff. And she didn't give my father the time of day. She was thirty-one years old and committed to her career, not to the pursuit of matrimony. Far from innocent, she'd had her heart broken more than once and, for the time being, wasn't looking for any more trouble from the opposite sex. Despite my mother's intrinsically romantic nature, she'd just given an interview to the *Morning Telegraph* in which she stated emphatically: "I'm a bachelor girl. . . . That's the whole truth and I'll tell you why—no man ever came along and tried to change it. Not one I'd change it for, in any case. I think men are crazy. They don't know anything about actresses. They either see them as living, breathing flames—which they aren't—or they are scared to death of them and feel inadequate, which isn't very male of men, is it?" But a few sentences later she admitted, "I'd love to meet a man who'd make me want to be just a feminine fluff, all soft and goo-eyes." Dreams of love notwithstanding, she refused to let my father's charms impress her. This tall, lean, not-yet-divorced lothario who looked like he'd just seduced Anita Ekberg over Camparis on the piazza could save his widow's peak and dimpled grin for some blowsy blonde. Josephine Premice, self-supporting actress, wasn't buying.

Upon leaving the theater, Papa insisted to Johnny, "I must see her again."

He began sending flowers, to no avail. Josephine, the ice princess, refused to melt. A few weeks after their first encounter, Hubert de Givenchy, the great couturier, arrived in town. Papa got wind through the society grapevine of a cocktail party that my mother was throwing for Givenchy at her brand-new flat on West Fourth Street. Josephine had just moved out of her father's house—where she bivouacked between club engagements—much to Lucas's dismay; he considered it disgraceful that a single woman lived alone. When people called his house looking for her, he pretended she had just stepped out to run an errand.

Timothy called Johnny in desperation, begging him to bring him to the fête. Johnny called Josephine to ask her permission. She had no objection. She liked throwing parties in her three-room triplex. She invited all sorts of people—Bobby Mackintosh, the tall, handsome wunderkind costumer of such Broadway hits as *The Boyfriend* starring Julie Andrews; Jane White, a young singer-actress and daughter of noted black journalist and NAACP cofounder Walter White; Geoffrey Holder, the painter and dancer from Trinidad who'd performed with Josephine in the 1954 Capote musical *House of Flowers*, and his new bride, the dancer Carmen De Lavallade; stage and screen actor and bon vivant Bob Weber; and Gene Hovis, then a young dancer. Josephine would whip up a batch of paella—a dish she'd learned to make during her trips to Spain—throw on a full ankle-length skirt, and warmly welcome her guests. Occasionally she'd grab a pot from the kitchen and, clad in her Paris best, sing a Haitian song while accompanying herself on her makeshift conga drum. She had met Givenchy in Paris, and like most designers he adored her lean gamine physique, her exuberance, and her devastating sense of style. She was a walking, talking illustration of the word *chic*. My father, seducer of women,

found himself spellbound. Again, my mother paid him scant attention, not out of coquettish manipulation, but out of genuine disinterest.

Two months passed, and many bouquets of flowers withered and died in Josephine's dressing room. Her dresser warned her if that man didn't stop sending her flowers the room would start to look like a funeral parlor. Then one day the phone rang. Timothy said simply, "I've had a great day today, and I know this time you're not going to turn me down for a date."

"No, I won't," she acquiesced.

My parents' first date took place on April 15, tax day as well as the anniversary of the sinking of the *Titanic*. Perhaps this unfortunate coincidence explains our family's flair for the epic and the disastrous. They dined at the Plaza Hotel's Oyster Bar. My mother wore a gray, black, and white tweed Nina Ricci coatdress with mother-of-pearl buttons and a nipped-in waist, a black cloche hat framing her sharp-featured little face. They must have seemed an odd pair to the 1958 crowd, the mahogany-skinned, wasp-waisted woman and her lanky Black Irish–looking swain. Whether or not they attracted stares they did not recall. They consistently refused to worry about what others thought, and that particular evening they had eyes only for each other.

"After that first date, I knew I would never leave your father," my mother often said. And indeed, she never did. One of New York's more notorious seducers seemed to her a forlorn little boy badly in need of love and affection, and so she proceeded to provide it.

In short order, they moved in together, dividing their time between his apartment and hers. They hyperbolically christened their modest dwellings the Summer and the Winter Palace. He brought her espresso in bed every morning and called her Phi-Phi; she introduced him to the wonders of her exquisite cooking. He brought her to Harlem to eat "chitterlings," as she called them, in

her queen's English, steadfastly refusing to drop the g. She took him to her favorite French bistro. He adored her, but maintained his wandering ways. On one occasion during their courtship, he stood waiting for the subway. Across the platform he spotted a dark, lean, utterly sexy girl and set his irresistible brown-eyed gaze upon her. Suddenly the girl broke into a huge smile, wildly waving her double-jointed arms. Timothy realized the fetching woman across the platform was none other than Josephine. He had tried to pick up his very own beloved.

One morning, seven months into the affair, two months after his divorce had been finalized, my father awoke and announced, "We're getting married." There had been no discussion of the future. It was the first time either of them had ever raised the subject. And Josephine was far too proud and independent to ever enter the "ring by spring" footrace that consumed most of the waking hours of the young, single, and female of her generation. The House of Patou had even created a perfume celebrating this extreme sport, called Lasso, "Your secret weapon"; the ad featured a woman in an evening gown tossing a lariat to catch an unseen man. Josephine had other ambitions. Still, she loved Timothy and she'd always wanted a family. Marriage seemed natural.

"You'll have to ask my father's permission," she warned. Off they went to the brownstone on 127 Saint James Place, Brooklyn, then a solidly middle-class black neighborhood.

After his daughter introduced him to Timothy, Lucas banished her from the upstairs parlor, and there the two men sat all night talking about history, the world, and the sea while Josephine and her shy, intellectual sister, Adèle, waited downstairs in the kitchen. Like Timothy, Lucas had gone to sea as a young man; he understood the lure of its vastness and desolation. Papa listened with fascination to the story of Lucas's banishment from Haiti as a result of his participation in one of the many revolutions that con-

vulsed the country in the years prior to the American occupation in 1915. He'd fled to Colombia, living in Cartagena for several years. Eventually, he had made his way to the United States. He'd learned the trade of furrier and become a union leader. Over the years, he'd also helped to smuggle many young people out of Haiti and Cuba, offering his house as a haven. In Lucas, Timothy found a second father, a man whose iconoclastic worldview and rebellious streak matched his own. In Timothy, Lucas found the son he'd never had. At the end of a night-long colloquy, Lucas declared his adoration for his future son-in-law with the line, "It takes more than a million dollars to make a Timothy Fales!" To him, my father was more than the sum of his lineage and his family's wealth. And so, the paternal benediction granted, the nuptials could proceed.

On November 14, 1958—no epic disasters on record for that day—Josephine and Timothy were joined in matrimony by Adam Clayton Powell Jr., the irreverent, rakish Baptist minister who, at the time, served as Harlem's congressional representative, right in their living room, with Lucas, Adèle, and eight other guests, including Bob Weber and Robert Lewis. The party then went off to the theater district restaurant Sardi's to celebrate. There my mother left the somewhat drunken party to their revels to do her evening performance of *Jamaica*.

David Merrick, who would stop at nothing for publicity, saw in this interracial couple a golden opportunity for press. According to my mother, he would call reporters to tell them where the "scandalous" pair might be found. Matrimony greatly enhanced their value as yellow-press fodder. The "misalliance" hit the gossip columns. "Dancer in *Jamaica* Weds Banker's Son," trumpeted one article. "Negro Singer Married to Socialite Ship Exec," read a *Daily News* headline. The *News* article neglected to mention my mother's international success or her recent Tony award nomination for *Jamaica*, but did point out that she had earned the moniker

Spaghetti Legs "for her contortionist ability," a highly relevant piece of information in a wedding announcement. With this line of sexual innuendo, they reduced my mother to a sort of Hottentot Venus, a stereotypical black wanton. A photograph of my parents' first public appearance after their marriage, at a cast party celebrating *Jamaica*'s first anniversary, ran in both the *Post* and the *News*.

Across the country, black newspapers greeted the story with an excitement verging on glee, featuring it as front-page news. They described my mother not as a mere "singer" or "dancer," but as a "sepia star." "Did She Romance Blonde Baron?" asked a headline in the *Amsterdam News* a week before they learned of the marriage. With tongue firmly in cheek, the *Chicago Defender* ran the photograph of my parents holding hands at the *Jamaica* party next to stories of school desegregation in Arkansas and under a headline that announced, "US Maps New Plan for Integration." They reported my father's expulsion from the *Social Register*, the official guide to America's "Best and Oldest Families," as a result of his unforgivable act of *lèse majesté*. "This, of course was to be expected," the *Defender* averred in a tone of resignation verging on the blasé. They compared the scandal to that surrounding the marriage of Kip Rhinelander to a mulatto in 1925. A generation had passed and little had changed.

The WASP Brahmin caste had not yet created a quaint French euphemism for "My son married a black girl." In such rare instances, raised eyebrows and whispers gave way to silent apoplexy, heart attacks, and strokes. Upon hearing the news, close friends of my grandparents' sent a "heartfelt" note of condolence on engraved stationery from their home in Newport, Rhode Island. It read: "To two of my dearest friends, a word of sincere understanding that comes from my heart—Timmy's mistake causes you sorrow, and for you both, and with Jim, in this I share—devotedly, always,

darling Dodo and Jekey—Gaby." DeCoursey Fales Senior was indeed livid that his favorite son, his prize, should choose such a bride. Mrs. DeCoursey Fales, on the other hand, took the news in stride. During the courtship, a reporter had phoned to ask her if she worried that her son would marry this colored show-business person.

"I've never worried about anything in my life," she replied, "and I don't intend to start now." Pragmatic and dignified to the core, she invited her new daughter-in-law to lunch at the exclusive Colony Club for ladies, on Park Avenue. The doddering Irish waitresses must have dropped their platters of cucumber sandwiches as my mother, a "negress," entered the vaulted-ceilinged Terrace Room. "I like her," my grandmother concluded at the end of the luncheon. The daughter of a man who had written pamphlets such as *Plain Talk on the Negro Problem*, which defended slavery— "Probably no one circumstance ever did as much for Negroes as their introduction as slaves into America"—and warned that desegregation would lead to "race pollution," accepted the "colored woman" as a member of her family, no doubt sending her father spinning in his grave. She offered the new bride one piece of advice: "You must tell Timothy you love him every day."

DeCoursey Fales Senior, on the other hand, refused to meet the "upstart." Though my grandmother visited my parents frequently in Rome, where they lived during the early years of their marriage, my grandfather kept his distance. Timothy would not speak to his father again for five years. Occasionally, he would receive a letter from his father, and a check. He would return it uncashed. Like characters in a Jamesian tragedy, father and son swallowed their rage, hid their emotions behind the mask of *noblesse oblige*, and dug in their heels for a long, silent game of chicken.

No doubt my grandfather was horrified not only at having a "colored" daughter-in-law, but also because he received incessant

phone calls from the press, both black and white, as well as hate mail from white strangers ranging from an accountant in Los Angeles to near illiterates. "Mr. DeCoursey Fales, my sympathy goes out to you, in this your, great, sorrow. Your son, should be adjudged insane—He is a disgrace to the white race—He has sunk to the lowest depths—May God give you strength to bear the shame, he has imposed on you and your love ones," wrote a man from Norfolk, Virginia. Another anonymously sent a postcard of quotations: "Darwin said, 'Man sprang from monkeys.' Will Rogers said, 'Some of them did not spring far enough.'" These choice words were followed by a long passage, allegedly excerpted from the "Deep Sea Scrolls." It stated in part: "a fire was built and the man held in the flames by the Devil with his bare hands and the smoke settled on the skin of the Devil's man. That is the reason the African is black to this day." On the back of the card, the sender had scrawled in a childish hand: "Mix white and black paint you git gray. Mix white people and black you git yaller." Both the Los Angeles accountant and an anonymous correspondent sent propaganda postcards from an anti-integration group called the American Nationalist. The cards featured photographs of the ultimate "menace to society": black men consorting with white women. One snapshot showed a grinning Louis Armstrong cutting his birthday cake flanked by two busty brunettes. "Total integration means total mongrelization," the postcards warned while accusing the National Conference of Christians and Jews, the Ford Motor Company, the National Council of Churches, the NAACP, and the Ford Foundation of propagating the "degenerate philosophy of racial integration." Other harassers simply sent clippings from papers around the country featuring the story of the marriage with handwritten comments above the headlines like "How Low Can One Get." My grandmother, who believed in documenting important passages in her family's life kept all these missives neatly bound in a box.

The ultimate coup de grace for my proud grandfather must have been seeing his family name dragged through the papers with unseemly headlines like "Caught With Dancer: He Struck Me Says Lady Private Eye." A week before Josephine and Timothy wed, a private detective hired six months earlier by my father's first wife filed a suit against my father for allegedly striking her. In May, weeks after my parents' relationship began, the detective and the first Mrs. Timothy Fales—who had a paramour of her own—knocked on Josephine's door at 2:30 in the morning. My mother opened the door to let them in. Shortly thereafter, my father allegedly hit the detective. Affidavits flew back and forth between the attorneys, and approximately six months later the suit was settled at no cost to either party.

My mother never shared the private detective incident with me. She left it out of the epic of their courtship. She always painted a very romantic picture of the beginnings of her marriage. The only anecdote that hinted at a less-than-storybook ending was her account of the morning after she and my father wed. My mother sat in bed waiting for her new husband to bring her the habitual cup of espresso. Papa turned to her and declared, "We're married, the honeymoon is over."

"So you see, things change when you say 'I do,'" she'd conclude with a laugh, as she took a puff on one of her long, slim Pall Mall Golds. Not until I reached my thirties did I realize she intended the story not only as an amusing anecdote but also as a cautionary tale.

It was only years later that I learned I had to read between the lines of what my mother said about marriage and men. Camouflaging and redecorating painful, less-than-perfect realities, whether aesthetic or emotional, was one of her principal survival techniques. Days after her wedding, when asked by the papers how her husband's socialite family had reacted to the news of the marriage, she answered, "I'd rather not say." She went on to describe her

own family's reaction (though no one had asked, assuming no doubt that a black family could be nothing other than drunk with joy at the prospect of marrying into a white one). "My parents are healthy people. They take you for what you are here," she said, pointing to her heart. She spoke of her parents in the plural despite the fact that her mother had passed away fifteen years before. Apparently, Theloumène of the at-home-finishing-school lived on in her daughter's heart and mind.

This ability to rise above the unbearable through faith and imagination had carried my mother far. But the same divine madness that enabled her to defy the limitations of a racist society, to triumph in a difficult field, and to comfortingly pretend her deceased mother remained at her side also led her to believe in the false promises of romantic movies and exquisitely crafted cigarette ads.

This Sweet Citadel

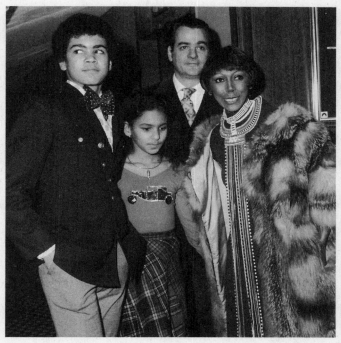

*My parents, Enrico, and me backstage at a special performance by
Lena Horne and Tony Bennett, circa 1973.*

"We know who we are."

—JOSEPHINE PREMICE

Propagandists for racial integration are fond of pointing
out that young children, when mixed with Negroes, show
absolutely no racial prejudice or awareness of skin color.
This, they contend, proves that race consciousness is
unnatural and that children are taught racial "bias" by
their elders. . . . The truth is that young children are
equally unprejudiced against dirt, poisonous insects and a
multitude of other harmful or undesirable things.

—from an American Nationalist postcard
sent to DeCoursey Fales on the occasion
of Timothy's marriage to Josephine

"There is only one race, the human race."

—TIMOTHY FALES

Until I was five years old, I didn't know my parents were "different colors." I had learned how blue mixed with yellow made green when we performed "The Story of Little Blue and Little Yellow," with me in the latter role, at the end of the nursery school year. Little Blue, a four-year-old boy, and I melded and rained little green tissue-paper tear drops on the auditorium stage. But to me, people weren't colors; crayons and clothing and other objects were. Black and white were the colors of *I Love Lucy*, *Ed Sullivan*, and *Jack Lalanne* on the television set, the world of make-believe, not the shades of the real world. My mother wasn't a color, she was Mommy, a beautiful lady in a wig and false eyelashes and lots of perfume who laughed and sang and cooked for me and took me all around the city with Enrico and our nanny, Bruna, whom we called Tata. Tata wasn't a color, she was soft and wore glasses and had a more cushiony body than Mommy. She had nice plump jiggly arms to hug us with, wore Calèche perfume, and spoke to us in Italian. Papa wasn't a color, he was very tall, he came home late at night and didn't say much, but spoke to us in French, called me "Cougie," and drove the car.

Then one day, long before I learned to tell time or to spell, my mother taught me the primary colors of race. It was 1968, I was in kindergarten. Papa had come to pick me up from the lycée, a rare occurrence. He belonged to the old-fashioned school of fatherhood, which left the care of children to their mothers and governesses. I preferred being picked up by my mother because she didn't share

Papa's fondness for walking across the park on the chilliest winter day, the wind whipping through my tights and lifting my gray pleated skirt. Mommy believed in wearing high heels and taking taxis. On this particular day Papa took me to the Museum of the City of New York to see the toy collection and the antique furniture, one of our family's favorite pastimes. Afterward, to my great delight and relief, he decided we should flag a taxi home. I couldn't help but notice his prodigious talent for hailing cabs. By merely raising a hand, he would bring the large yellow vehicles to heel. By contrast, Mommy would spend long interludes standing in her fur, muttering angry words I didn't then understand, like *damn* and *bastard*, as checker cab after checker cab sped past us. I felt certain Papa held magical powers over these vehicles that had somehow eluded my mother. This surprised and confused me because I believed Mommy could do anything. Papa and I arrived home and I went straight to the breakfast room for my traditional afternoon snack, a sandwich of salami on fresh Italian bread.

"How was the museum?" Mommy asked.

"I liked the dolls," I answered, then added, "Mommy, Papa's really good at getting cabs and you're terrible." Her failure in this area disappointed me.

Mommy swallowed hard, then gently said, "There's a reason for that." I looked at her. "Papa's white, they think he's going someplace nice. Mommy's black, they think she's going to Harlem, where many black people live."

"What's wrong with Harlem?" I asked.

"Nothing," Mommy responded, "but the drivers think it's dangerous and they don't want to go."

"But that's not fair," I objected.

"Of course not. These people are stupid, they have prejudices."

"What's a prejudice?" I asked.

"It's when you decide you don't like someone without even knowing them. Based on what you think they are. Based on ignorance. It's very wrong to have prejudices."

"Oh," I responded, and finished my sandwich as my five-year-old mind slowly absorbed the fact that to the outside world Papa deserved better treatment than Mommy.

My mother grew up in an America of lynchings—there were thirty-four the year she was born—and Jim Crow in the South, and de facto discrimination in the North. Even in New York blacks couldn't freely enter every restaurant and museum. People of color appeared in mainstream movies only in secondary roles, carrying a serving tray or a spear. Advertisements in majority newspapers and magazines never featured a nonwhite face. And yet my grandparents managed to instill in my mother a deep sense of pride. They sent her to Haiti in the summer so she would know her culture and experience life in a country where blacks were not second-class citizens, but rulers. They told her of her eighteenth-century Haitian ancestors, four boys born to a white landowning Frenchman and his black common-law wife. Like many other French fathers of mulatto children, the planter sent his sons off to school in France. Upon their return several years later, the boys found their mother had been banished from the main house to a small cabin on the property. Puzzled, they went to see her and asked why she had left the main dwelling. Wordlessly, she drew aside her blouse to reveal the spot on her breast where their father, the man with whom she shared her life and bed, had branded her. One of the boys instantly took off for the main house. Once there, he confronted his father and killed him with one fell swoop of his machete. He then had to flee for his life, but his legacy remained: Premices did not take guff.

* * *

I was born in 1962, eight years after Dr. King's Montgomery bus boycott, three years before they passed the Voting Rights Act, and five years before the *Loving v. The Commonwealth of Virginia* Supreme Court decision struck down the antimiscegenation laws that rendered my parents' interracial marriage a crime in many states. While the blond, blue-eyed *Brady Bunch* girls paraded across our television screen epitomizing the American ideal of beauty, my mother repeated almost daily in her one-woman propaganda campaign, "You look different, and that's wonderful. You *never* want to look like everyone else. How boring!" I knew black was beautiful because of my mother, her strong and independent female relatives, all the glamorous, creative women who visited our home, and the prints of black historical figures such as Dessalines and Toussaint L'Ouverture that adorned the wall of my father's study.

My parents shielded Enrico and me from the ugliness and ignorance of the outside world by enveloping us in a cocoon of high culture, intellectual privilege, and enlightenment from which I would emerge partially in college, and ultimately in adulthood. Only then would I fully understand how the rest of America views race. My parents enrolled me at age four in an international French school, the Lycée Français de New York. There, surrounded by white, brown, yellow, and black students from Italy, Belgium, the Ivory Coast, Madagascar, Vietnam, Egypt, Tunisia, Yugoslavia, Greece, and Senegal, my brother and I did not stand out as oddities. No one looked like anyone else, and so the Aryan standard of beauty common to more homogeneous American environments did not reign supreme. Since we all looked different, worshipped differently, and boasted wildly different last names, we concentrated on what we had in common rather than what set us apart. The teachers generally held the French view that sets greater store by class than race. They considered my mother a very elegant, cosmopolitan lady. Therefore, it never occurred to them to treat my brother and me, or

any other black student for that matter, as intellectually or socially inferior to the white students.

In our home, our parents presented us with yet another multi-cultural oasis. At dinner, conversation flew in four languages, as Enrico and I answered our father in French, our mother in English, and Tata, who'd followed us to New York from Rome, in Italian, and my parents alternately cooed to each other and railed at each other in Creole, the secret language of their marriage, which Enrico and I only faintly understood. Once we returned from Rome in 1963, we spent endless hours with both sides of our family: Grandpère, my formidable maternal grandfather; Aunt Adèle, my mother's classical piano–playing sister; and the Charliers, her French-speaking Haitian cousins, on the one hand; and Papa's two brothers, Hal, an attorney, and DeCoursey, an archaeologist and professor of ancient history, their lively wives and children, and my regal grandmother, on the other.

We often had sleepovers at Grandpère's house on Saint James Place, a few blocks away from Pratt Institute in the socioeconomically mixed section of Brooklyn known as Clinton Hill. Aunt Adèle still lived there with my grandfather and, not having any children of her own, adored spoiling Enrico and me. The neighborhood was quite different from ours on the Upper West Side, where middle-class families inhabited the avenues, and lower-income Puerto Ricans, blacks, and immigrants from Haiti occupied the shabby SROs on the side streets. In Grandpère's neighborhood, nineteenth-century brownstones, rather than fifteen-story prewar apartment buildings, lined the tree-shaded blocks. Most of the neighbors were black, with the exception of a pioneering white couple or two there to "gentrify" the area (in other words, to nab great real estate at bargain-basement prices).

The brownstone next door had been subdivided into apartments rented by low-income families. The little girls who lived

there engaged in "exotic" street games unknown to me, like stickball and the bane of my youthful existence, double dutch. They'd invite me to join them, then fall out laughing at my *über* klutziness. "Jump in!" they'd yell as I stood frozen in terror watching the two ropes whip furiously around, waiting for a moment, an opening that never seemed to come. I didn't have an ounce of their courage or their coordination and marveled as they leapt between the two ropes at lightning speed, keeping perfect time, triads of thick braids bouncing off their heads, then just as seamlessly hopped out to give the next gazelle her turn. The Lycée Français schoolyard offered no training in such regular neighborhood skills. Instead the Lycée prepared us for real life . . . at court in nineteenth-century Europe, offering instruction in such handy arts as polka dancing and fencing. I could have fought a duel with the Count of Monte Cristo or danced at a ball with Chopin, but I couldn't double dutch to save my little mulatto life.

Once I'd thoroughly humiliated myself outside, I'd happily retreat to the safety of my grandfather's dark parlor with the mysterious Geoffrey Holder wedding portrait of my parents. In it they stood, two slim shadows in a narrow doorway, as if hesitating to enter a new world. I couldn't make out their features; they looked very young. The painting both frightened and fascinated me, as did the room with its high ceilings and grand piano. I knew that in my mother's youth the room had reverberated with the sounds of her reluctant violin playing, her sister's lyrical soprano singing voice, and the mingled laughter and applause of the Sunday guests. Now, no one ever sat in this parlor; my grandfather preferred to hold court in his downstairs sitting room or in the large kitchen overlooking the garden and the row of houses beyond.

Two topics instantly raised Grandpère's dander: hip huggers and Duvalier, the ruthless dictator who'd ruled Haiti since 1957 and declared himself "President for Life" in 1964. No dinner in Grand-

père's home was complete without an impassioned jeremiad on both topics. "Pants are not supposed to be worn here," he'd rail in French, indicating the kneecap. "They're supposed to be here, here, here," he'd insist, indicating a spot millimeters below his pectorals. Generally he'd aim these attacks at Enrico, who kept very much in step with the current trends, from Afros to tie-dyed shirts. "Where are your suspenders?" Grandpère would demand. Enrico would look at him in horror. Surely he was not expected to wear the same corny suits that our grandfather did. Enrico's fashion role models were Superfly and the Mack, gorgeous pimps from the blaxploitation movies then in vogue. Ron O'Neal, who played the title role in *Superfly* and frequently visited our home, wouldn't have been caught dead in suspenders. In spite of his irritation, Enrico would listen respectfully, since we knew better than to talk back to our elders. I'd purse my lips and stifle my giggles, exchanging sidelong glances with my brother. We were always greatly relieved when Grandpère finally trained his vitriol on Duvalier.

Over dinner of roast pork and rice with peas, or *doumbue*, Haitian dumplings in black bean sauce, he would weave a spine-chilling tale of Duvalier's atrocities. In my childish imagination, Duvalier loomed as a bogeyman more menacing than any evil witch in Grimm's fairy tales. "He puts on a great black cloak," Grandpère would say in French, wielding his cigarette and gesturing for emphasis. "He goes out into the town square and sits huddled by the fountain, like an old woman, secretly listening to the townsmen's talk. If anyone breathes a word against him, he orders his secret police, his *tonton macoutes*, to kill them the next day." I'd shudder in terror as he continued. "Thousands have vanished that way."

Then Aunt Adèle would lighten the mood, saying in her high-pitched voice, "Cousin Jacques was in school with Duvalier's son, and the poor boy was so stupid, they called him *Tête Panier*,

Baskethead." I couldn't join my grandfather in his ire against hip huggers, but my blood did boil at the thought of this evil man with a dim-witted son torturing and killing people. My mother always reminded me, he'd even kill Grandpère if he had the chance. Over and over again, she told me of going down to Haiti at eighteen with Lucas to bury my grandmother. The customs officials had forced them to open the casket to prove it actually contained a corpse and not guns.

One Saturday in 1970, a year after the Haitian government confiscated my grandfather's passport for fear he would return to the country as an antigovernment agitator, he took me to a rally against Duvalier at the United Nations. As we stood on the plaza outside the grand white tower, I yelled at the top of my eight-year-old lungs with the crowd, "*A bas Duvalier! A bas Duvalier!*" Down with Duvalier! I felt exhilarated, believing our protest might actually help topple this tyrant, this cruel man who'd left my mother with the awful memory of having to open her mother's casket.

The next day, I joined my parents and brother for Sunday lunch at my grandmother's Upper East Side townhouse. There, under the impassive smiles of eight Fales ancestors staring down at us from gilded frames, I recounted my adventure with Grandpère as we feasted on roast beef and Yorkshire pudding served by the unwed Irish sisters, Blanche and Easter, who formed my grandmother's staff.

"Very interesting," my grandmother commented of my escapade, her hands neatly folded in her lap. The notion of her eight-year-old granddaughter yelling slogans in the street with hundreds of "rabble rousers" must have rattled her, given that the only protests in which she'd ever participated were right-wing antisuffragette rallies in 1916. "Now, what are you studying in school?" she said, moving on to more comforting and familiar terrain.

* * *

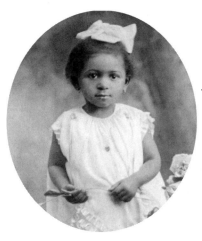

Josephine, age three.

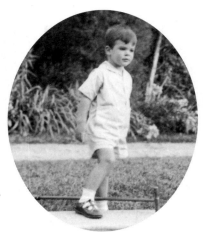

*Timothy, age three,
in the garden at Faleton.*

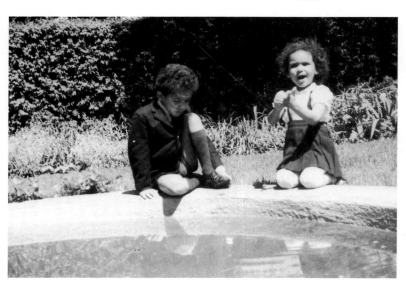

*Enrico and I, ages six and three respectively, playing in the same garden at
Faleton.*

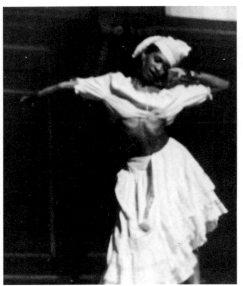

Josephine performs a Haitian dance.
(PHOTOGRAPH BY WILL RAPPORT)

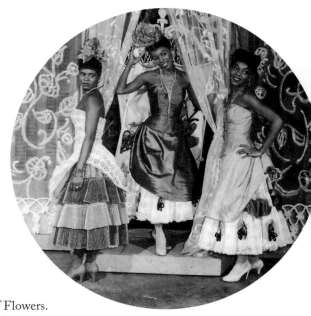

Josephine in House of Flowers.
(PHOTOGRAPH BY ZINN ARTHUR; COURTESY OF THE NEW YORK PUBLIC LIBRARY FOR THE PERFORMING ARTS)

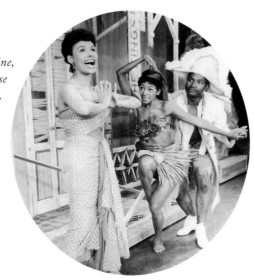

Lena Horne, Josephine, and Ossie Davis rehearse a number from Jamaica. (Photograph by Friedman/Abeles; courtesy of the New York Public Library for the Performing Arts)

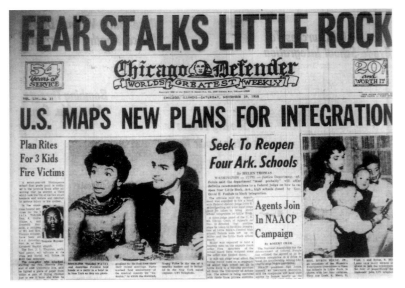

The front page of the Chicago Defender, *announcing my parents' marriage and school desegregation.* (Courtesy of Bettman/Corbis, the *Chicago Defender*, and the Schomburg Center for Research in Black Culture, the New York Public Library Astor, Lenox and Tilden Foundations)

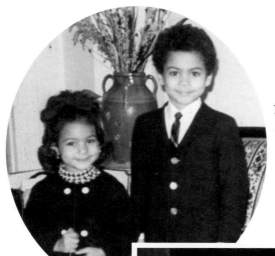

*You must always look crisp:
Enrico and I, ages 7
and 4 respectively, ready
to face the world.*

*My parents with their
friend, Mayor John
Lindsay, celebrating
his inauguration.*
(PHOTOGRAPH BY
BERT SMITH)

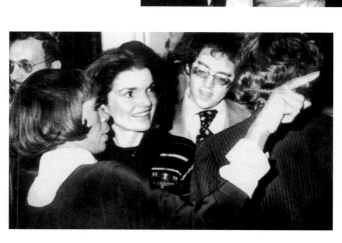

From a Daily Ne
*spread of a party
our house; my mo
with Mrs. Onassi*
(PHOTOGRAPH BY
BILL STAHL JR.;
© NEW YORK
DAILY NEWS, L.P.;
REPRINTED WITH
PERMISSION)

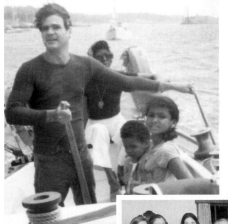

Sailing in Sag Harbor, New York. Enrico and I are in the foreground; my mother is in the background.

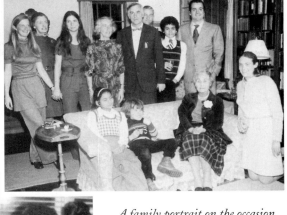

A family portrait on the occasion of my grandmother's eightieth birthday at the Hal Faleses'. From left to right (front row): Me, Christian Martin, Dorothy Fales, Priscilla Fales. Back Row: Lucy Fales, Kak Fales, Nancy Fales, Iten and Decoursey Fales Jr., Haliburton Fales, Enrico, and Timothy Fales.

Enrico and I with Grandpère (our Premice grandfather).

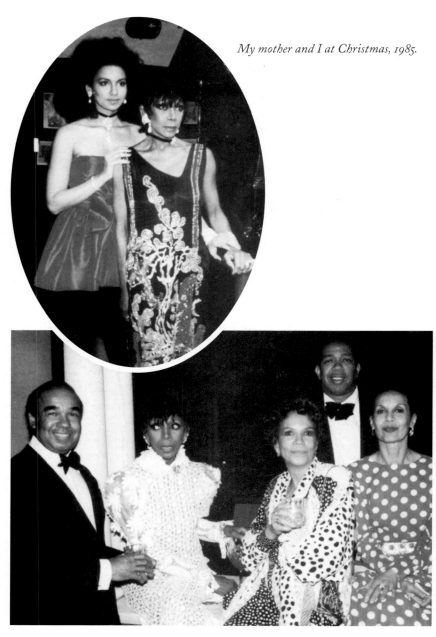

My mother and I at Christmas, 1985.

The semper *fabulous: Bobby Short, Josephine, Corby Britton, Geoffrey Holder, and Carmen De Lavallade out on the town.*

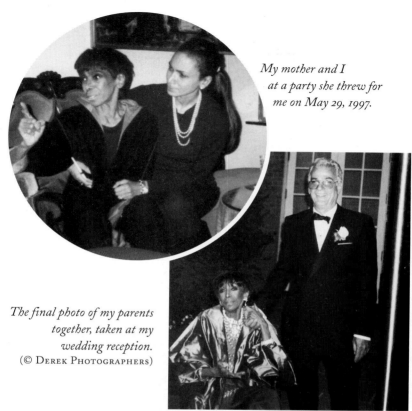

*My mother and I
at a party she threw for
me on May 29, 1997.*

*The final photo of my parents
together, taken at my
wedding reception.*
(© DEREK PHOTOGRAPHERS)

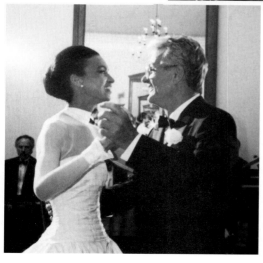

*My father and I at
my wedding.*
(© ALISON TAYLOR)

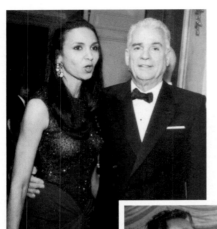

My father and I greet guests at the memorial celebration, held on Mother's Day, May 13, 2001.
(© HAROLD HECHLER PHOTOGRAPHERS)

Nick Ashford, Valerie Simpson, Diahann Carroll, and the Peter Duchin Orchestra vocalist serenade the guests with "That's What Friends Are For" at the memorial supper dance.
(© HAROLD HECHLER PHOTOGRAPHERS)

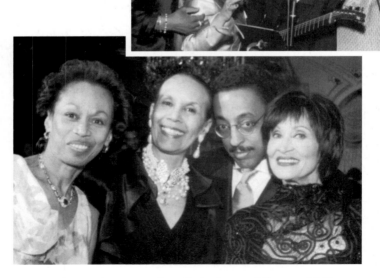

Altovise Davis, Carmen De Lavallade, Gregory Hines, and Chita Rivera smile for the camera and in memory of Josephine.
(© HAROLD HECHLER PHOTOGRAPHERS)

My parents convinced my brother and me that we were the lucki-est children on earth to have claim to not just one but two "noble" heritages.

"You have ancestors on both sides of your family who fought in the American Revolution," my mother often reminded us. "Susan, you're a Daughter of the American Revolution twice over. Remember that if you ever apply for membership."

Even as a child I somehow knew that, my "lineage" notwith-standing, the august ladies of the DAR were unlikely to welcome me with anything resembling open arms. Rather than argue with my mother, I'd just smile and nod in assent. But even such deluded and grandiose statements held a powerful message that stuck: "You embody two wonderfully rich histories, don't let anyone tell you otherwise." My mother reiterated the message every day, in various ways, whether in explaining the provenance of the African chief-tain's chair that sat on the living room coffee table and had been purchased in the nineteenth century by my great-great-great-grandfather Samuel Fales when he traveled the world, or in sharing her excitement over her friend Congresswoman Shirley Chisolm's decision to run for president in the 1972 elections, the first black woman to do so.

Papa made the point frequently that for the genuinely intelli-gent and educated, narrowmindedness became impossible. To him, racism was the hallmark of a truly inferior intellect. His own knowledge of world history verged on the encyclopedic. It was he, as much as my mother, who taught me that black did not stand for a single color, social class, or way of thinking, but rather implied an infinite universe of possibilities. Black could mean a baroque painter Juan de Pareja, an assistant to Velazquez; or the Shake-speare of Russian letters, Aleksandr Pushkin; or one of the greatest generals in Napoleon's army, Alexander Dumas (father of the author of *The Three Musketeers*). A black person could be a world-

class scientist, like Charles Drew, or an extraordinary musician like my parents' African friend Hugh Masekela. My father insisted that African culture and African-American culture were every bit as sophisticated as European culture, that members of his own race had distorted history by design to maintain a status quo. He cited his own grandfather, Clarence Blair Mitchell, as a classic white propagandist and told me about his antidesegregation pamphlets, though he never showed them to me.

While protecting us from racism, my parents did not pretend we lived in a Kumbaya world of equality. They steeled us for the occasional moments in which "America" would intrude upon our cocoon. We would have to learn to balance society's reductive "What box will you check in the census" view of us with our inner knowledge of our true, complex identities. People who deemed us inferior didn't really see us. Thus, when at age six I found myself taunted at summer camp by a white girl in my cabin who would jut out her lips whenever she saw me, as if to suggest mine were too big and "negroid," I could take it in stride. *Clearly, she hasn't looked in the mirror,* I thought to myself. Her own lips were much thicker than mine. She was attributing to me a physical characteristic that she *thought* I should have, given my heritage. I didn't get upset, but met her comments with bemused silence and dismissed her in my mind as a silly, rude girl who needed glasses. Similarly, when I complained that the public and parochial school Lolitas at Dance Theatre of Harlem, where I studied ballet and ethnic dance, tauntingly called me "Miss Thing," because I wore a school uniform and spoke "like a white girl," my mother brushed off their insult with a chuckle.

"I've been Miss Thing all my life," she assured me. "Wear it as a badge of honor."

Anyone was welcome in my parents' home—black, white, rich, poor, gay, straight, Republican, or Democrat. They excluded only

the uneducated and the bigoted. They created their own salon in the living room on West End Avenue. Leading artists and intellectuals of the day—Maya Angelou, well known for her newly published autobiography, *I Know Why the Caged Bird Sings*; Roscoe Lee Browne, who'd made a name for himself in a groundbreaking production of Genet's *The Blacks* in 1961; Kenneth Haig, the British actor who'd starred in *Look Back in Anger*; Dr. Leo Maitland, a prominent black physician and my father's best friend; Diana Sands, an accomplished stage actress; Diahann Carroll; Verta Mae Grosvenor, a cookbook author with two biracial daughters of her own; Bill Gunn, an avant-garde film director; and others—often sat around the living room till the wee hours discussing their lives and their work over my mother's roast pork with endives as Papa manned the stereo, blaring the latest in Caribbean music. Though the black actors usually expressed frustration at the lack of varied and dignified television or film roles, the emergence of a new politically conscious theater in which many of them participated gave them hope. In 1968, my mother's friend, playwright Douglas Turner Ward, formed the Negro Ensemble Company to present plays by and about black people. And for years, my mother and her friends talked about *A Hand Is on the Gate*, the evening of black poetry and song Roscoe directed at the Longacre Theater in 1966. The piece gave Cicely Tyson, Ellen Holly, James Earl Jones, Leon Bibb, Gloria Foster, and my mother the satisfaction of standing on a Broadway stage speaking the words of Paul Lawrence Dunbar, Gwendolyn Brooks, Langston Hughes, and other notable black poets. They received good reviews and my mother earned her second Tony nomination. Though the production ran for only a month, someone brought it up at nearly every one of my parents' soirees as a shining moment of theatrical history, and one of the great experiences of their professional lives. My mother and her friends were further heartened by the revival of "nontraditional

casting"—letting black actors play nonblack roles in major off-Broadway theaters. Such experimentation had first taken place in the federal theater program in the forties. Now my mother and her friends could rejoice in milestones like Diana Sands playing opposite Alan Alda in *The Owl and the Pussycat*, the first time a mixed couple had been presented on the American stage without any discussion of race.

During my parents' dinners, Dr. Maitland, known to my brother and me as "Uncle Leo," usually sauntered in first. A brilliant and charming physician, he often found himself the object of female attention and agitation." He'd go into the kitchen to greet my mother, who manned the stove wearing a long slim skirt, silk blouse, and no apron. She'd grudgingly allow him to peck her on the cheek, but kept him at arm's length. He was Papa's "hanging buddy." Together they'd go pub crawling, an activity my mother was not invited to join. I knew Papa adored Uncle Leo, but my mother distrusted him, and faintly resented him as well. "You and Leo," she'd say to Papa with an exasperated roll of her eyes, "the men who can't say no." I sometimes wondered as a child what question that "no" was meant to answer, but I never dared ask. The topic clearly irritated my mother, so I avoided it. She'd pull a jar of her freshly made rum punch out of the fridge, and Papa would pour it into the large nineteenth-century crystal goblets we'd inherited from his side of the family.

Guests would continue to arrive, all making rather grand, very loud entrances, not a shrinking violet among them. At the time, Maya, who had lived in Africa, had a fondness for elaborate headdresses. These towers of brightly colored fabric added nearly a foot to her already impressive stature and almost grazed the door frames. She'd enter with a warm and ready smile, greeting my father as "Brother" and offering me a copy of her latest volume of verse. Uncle Roscoe would stride into the foyer bearing a large

bouquet of African violets and reciting naughty poems, "The Elephant Is Slow to Mate," a perennial favorite.

"Lady Eugenia," he'd intone with a bow, addressing me by the fake moniker we'd coined, Lady Eugenia Faloopee. I'd return the greeting with a deep curtsey and a delighted grin. I loved Uncle Roscoe; he always treated me like a grown-up.

Thelma Carpenter, the husky-voiced singer who'd performed with Josephine Baker, would lead Enrico and me into the master bedroom with a throaty "Come on, ya'll. Time to do our show." As we lay on the bed looking up at our reflection in the mirror on the ceiling (a present from my mother to my father on his fortieth birthday to lift his spirits and remind him she still found him beautiful), we proceeded to conduct interviews as though it were the *Dick Cavett Show,* or *Merv Griffin,* on which my mother had been a semiregular. Eventually, my mother would come and lure us back into the living room where she would lead me in an impromptu merengue. As we swirled around the furniture, she taught me to swing my narrow hips like a true island woman.

Once the guests settled in for the meal, heaping plates of food on their laps, the conversation flowed. My mother might reenact a ridiculous experience, like the one she had playing Queen Clytemnestra in an all-black production of the Sophocles tragedy *Electra.* In the summer of 1969, she'd excitedly heeded the call of Joseph Papp, the founder of the Public Theater, a call to work for "two dollars," as she put it, bringing the classics to "the people" in economically challenged neighborhoods with the Shakespeare Festival Mobile Theater. Having watched the Watts and Newark riots on our black-and-white television set, she relished taking part in this Great Society experiment. Her dreams of uplifting the race were soon dashed, however, during one outdoor performance in the Bronx. As she stood arguing with her costar, Olivia Cole, in lyrical Sophoclean verse, an inebriated vagrant in the front row

cried out, "Ladies, y'all are beautiful . . . but I don't know what the fuck you're saying."

Papa would go on about the heroes of Caribbean history such as Toussaint L'Ouverture, leader of the Haitian revolt against the French in 1802. "When I finish my book, you can make a movie of it."

"Timothy, that's not going to happen," Aunt Diahann objected.

"Why not?" Papa would challenge.

"Because white America doesn't want to see these people. Do you know what I went through just doing *Julia*?"

"You don't know what you're talking about, Miss Clairol," Papa would retort, purposefully distorting her name. He usually disagreed with Aunt Diahann, whom he regarded with the same distrust my mother held for his best friend, Uncle Leo.

Unfazed, Diahann would look him dead in the eye. "Timothy, I realize you're brilliant and highly educated, and I'm just ignorant little Carol Diahann Johnson from Harlem, but with all due respect, you don't know shit about Hollywood or show business."

The right corner of Papa's mouth would curl upward as if to say, "*Touché*," and his eyes would twinkle mischievously as he laughed and refreshed Diahann's drink.

Calvin Lockhart, a heart-stoppingly handsome actor, with a face as sculpturally perfect as an African mask, often joined these all-night suppers. On one occasion, he arrived with a gorgeous blond woman in tow. Even at eight, I was seriously displeased at the presence of this female interloper. Didn't she realize I'd been in love with my parents' friend since the age of six and fully intended to marry him? "Calvin can play Dessalines," Papa pointed out. "And Richard Burton will play General Leclerc. . . ."

The conversation ceased to interest me since jealousy consumed my thoughts. Phrases floated about, whispered comments, gossip. So-and-so had found herself unceremoniously dumped by

yet another misbegotten lover . . . again. "She had his nose wide open," commented Papa of some other woman. He took pride in being conversant in street colloquialisms. My mother and I avoided them like the plague. We refused to give people what they expected of us.

I stared sullenly at Calvin. It seemed clear that Calvin would not marry this lady. He didn't marry people; he just wore delicious musk cologne, made women want him desperately, and then broke their hearts. On that night, I felt very angry and hurt because he was breaking mine.

Though I didn't always understand what the adults discussed in these gatherings, I knew they talked a lot about longing, and their dreams, dreams they hoped would one day come true. Their lives weren't easy. There was always heartbreak, a lot of frustration, and an inescapable undercurrent of pain. Beautiful Diana Sands died of cancer at 39, on the eve of her marriage to a young man who adored her. Aunt Diahann's third husband, Robert De Leon, a promising young magazine editor, died suddenly in a violent car crash on Mulholland Drive. Gloria Foster, the veteran of New York Shakespeare Festival productions, and her husband, Clarence Williams III—of *Mod Squad* fame—divorced. But in spite of their troubles, my mother and her friends laughed and got very drunk, or as she always put it in her elegant rasp, "Smashed, darling, smashed."

Beyond our home, our parents sought to expose us to as many different environments as possible. My mother resolved to train Enrico and me to function in any situation, with the possible exception in my case of a round of double dutch. She wanted us to feel comfortable in a wide variety of worlds. She brought us to art museums all around the city, and to her hairdresser's in Harlem. At Harold Melvin's Salon, a cavernous space divided into booths, I watched with fascination as the hairdressers "pressed" and curled

my mother's hair and her wigs with black metal "irons" they heated on little electric stoves. All the stylists would come to greet her, except one, a very grand Haitian everyone called Frenchie. He had a leonine mane of kinky hair, a penchant for wearing polyester maxi coats with matching pants, and serious "attitude." He was one of many colorful characters in a neighborhood that seemed to me a giant, friendly bazaar rather than the treacherous war zone depicted on the evening news. My mother pointed out to me that in Harlem men always treated her like a lady. Even their flirtatious comments were respectful, or witty, but never vulgar. Once while she and I walked down 125th Street, a man called out with a smile, "Hello, beautiful sister, you sure got a pretty little daughter. I know you left us when you made her." My mother laughed out loud. Vendors lined the sidewalks with tables where they hawked their wares: paintings, elaborately carved Afro picks, politically inspired jewelry like brightly colored enamel brooches with renderings of Malcolm X or Angela Davis. Occasionally, my mother would buy me a bauble which I would then treasure, like a ring of silver wire shaped into the map of Africa and adorned with beads the colors of the black unity flag, red, black, and green.

In their quest to educate us, my parents took us everywhere, from theater openings to Urban League dinners. We attended theatrical performances we didn't understand, like Derek Walcott's masterpiece, *Dream on Monkey Mountain*, a metaphoric play about the encounter between a primitive and an assimilated black man. I had absolutely no idea what my Uncle Roscoe and handsome Ron O'Neal were going on about, but I felt faintly embarrassed for Ron when he ended up naked onstage, though even at eight I realized he had a rather lovely physique. In 1976, at thirteen, I sat in a bleacher on the stage, watching my mother's old friend Richard Burton in *Equus* and trying to wrap my mind around the main theme of this homoerotic tragedy. My parents dragged us to cock-

tail parties at friends' homes, often centered around political themes. The Belafontes gathered concerned liberals to hear a Native American speak of the historic massacre at Wounded Knee. During his speech, I had an epiphany as I looked at Julie, Harry's wife, in her long black Pocahontas braids and her beaded head-band.

"Mommy," I whispered, "Aunt Julie's an Indian, isn't she?"

"No, she's not. She's a nice Jewish girl."

When I was thirteen and Jacqueline Onassis attended a fund-raiser at our apartment, my mother asked me to lead the former first lady on the "house tour," fully confident in my ability to enter-tain this slender, brown-haired woman whose role in American history I hadn't yet fully grasped. I showed the former first lady my bedroom. "What pretty wallpaper," she commented of the yellow *chinoiserie* pattern adorning the walls. I beamed with pride at my mother's creativity; little did this lady know, this wasn't wallpaper but far less expensive sheets.

"I picked it out. And Mommy put the fabric up herself," I explained. The widow of the "richest man in the world" smiled warmly and seemed duly impressed.

As much as my mother strove to protect my brother and me, to turn New York into our personal wonderland, she could not always keep reality at bay. Gradually we became aware that though when we looked at white strangers we saw human beings, when they looked at us they saw at best alien people, at worst, lesser, near-animal creatures. One winter night, she, Enrico, and I left the Lambs' Club, a private club and theater where she was performing in *Yoohoo, Aunt Carrie's Coming*, a musical comedy written by Ray-mond League, a black advertising executive, about his middle-class Southern family's dispute over a piece of property. Enrico was eleven, I was eight. We stood on Forty-fourth Street, right in front

of the theater, waiting for a cab. My mother, clad in a wool pant-suit, clutched her silver fox fur shut against the cold with one hand and held mine with the other.

A cab containing a passenger pulled up to us, the door opened, and a white man in a business suit leaned out, looked the three of us over, and asked my mother, "How much?"

My mother exploded with a fury I'd never seen before. "Get out of here, you son of a bitch," she roared and the taxi door slammed shut. The passenger, looking annoyed, settled back into his seat.

I hadn't understood the man's question. What in the world, I wondered, could someone say to my smiling mother to make her so very, very angry? She was shaking and yelling, "God in heaven," even after the cab had sped away. It terrified me to see her so upset.

"Mommy, what did the man want? Why are you so mad at him?" I asked, baffled and eager for reassurance, a return to normalcy.

"He thought I was selling myself . . . and the two of you," she said, her voice still tremulous. She grabbed us close to her. I could feel her muscles tensing beneath the fur. Enrico said not a word. "We need to get home," she insisted.

I didn't want to upset my mother by asking any more questions, but I tried to figure out what "selling us" meant. I had yet to learn of prostitutes or sex, let alone pedophilia. Yet somehow I knew the man's proposal was obscene. We had done nothing to deserve this insult. We were simply a color that made a strange man think my beautiful mother was someone who would climb into his taxi with her children and go off to do something awful and wrong. I knew the worst part for my mother was that it had happened in front of us. And there was nothing she could do to stop it.

Though we couldn't control the world, try as we might, we could arm ourselves against its bigoted assaults with excellence. As we reached adolescence, our parents, my mother in particular,

schooled us in the catechism of every black child of a striver: you must excel just to be considered equal. This was one of our family's several paradoxes: on the one hand we were encouraged to consider ourselves just human beings, on the other hand my parents taught us that we were emblems and that the eyes of the entire world were upon us. We had to speak more beautifully, earn higher grades, display more exquisite manners, read more books, and always, always dress better than our white counterparts. Along with our privileges came a responsibility to elegantly represent both our Haitian and our WASP families, the black race to which America assigned us and the products of mixed unions. Mulattoness *oblige*.

My parents warned us that America fully expected us to fall flat on our biracial faces, to be basket cases, monumental screw-ups, proof positive that the races should not mix. White children could go about in sneakers and rags yet expect equal treatment; we could not. White children could get arrested for drug possession and go on to successful careers; we could not. Any major infraction of society's rules on our part would lead to coverage in the papers, due to our parents' social standing, and needless to say the public disgrace and fall of both the Premice and the Fales families, a descent just as swift and horrific and final as the abrupt collapse of the House of Usher. Or so my overactive adolescent imagination interpreted my parents' words. I accepted my "ambassadorship" with earnestness and solemnity, an inspiring trumpet fanfare playing in my head whenever my mother delivered the "duty" speech. By my words, actions, and dress I would heed the clarion call, I would "represent."

My brother, however, refused to toe the line. He shared my father's ambivalence toward the Fales family "lineage," pride alternating with scoffing countercultural dismissiveness. He seemed to revel in transgression. At fourteen, he refused to wear jackets and ties, to my mother's utter horror.

"You've graduated from Row of London suits to rags," she'd yell in dismay at least once a day. He smoked, he drank, he tried marijuana. At fifteen, the school authorities caught him doing graffiti with a group of other private-school boys. That Enrico would engage in vandalism, graffiti, the expression of street kids, horrified my mother and me. Enrico defined it as art, a revolutionary mode of self-expression. His rebellion and his anger toward my parents made no sense to me. Didn't he realize we lived in paradise? Why, I often wondered with resentment, did he insist on ruining my pretty picture of our family and making our parents so mad? I especially dreaded the monthly report card because his abysmal grades always unleashed an inferno of yelling and screaming and rage.

"You're brilliant but you refuse to work. You're bringing me zeroes as big as this," my mother would cry, as she formed a gargantuan O with her hand to illustrate. Once, she spanked him so hard, her bracelet came unstrung, its parts exploding about the breakfast room in a hailstorm of pearls. "Look what you made me do!" she yelled.

When he was in a good mood Papa would affectionately put his arm around Enrico and called him *fiston*, my little son, in a warm gentle voice. But when he was angry he would turn beet-red with rage and hurl epithets. "Idiot! Cretin!" his voice thundered through the house. I'd escape to the relative quiet of my room until the fracas subsided. Invariably, my mother would come find me and, seeing my worried expression, say, "Everything's going to be just fine."

Somehow all of my parents' screaming, anger, and hitting never inspired Enrico to change. Over the years, he grew more sullen, it seemed, and more defiant. My mother would spend hours racking her brain for the cause of his obstreperous behavior. "We shouldn't have sent him to that Montefiore school in Rome. They

spoiled him there; if he didn't feel like painting they'd go outside for a walk." It never occurred to her that the cause of his problems lay in her own erratic treatment of him, in my father's moodiness, in the impossibly high standards they set, which were at odds with their own sometimes self-destructive behavior. In pensive moments she'd offer rationalizations: "Fales men, stubborn late bloomers. Your grandmother always says so. Uncle DeCoursey didn't even get married till he reached forty."

Yes, that explained it, I believed, hereditary bad behavior. I felt it my duty to compensate for the "shortcomings" of the men in the family. I would do my part to uphold the family honor. I concentrated even harder on my good fortune at being born into such extraordinary clans, and on becoming a source of pride for them both. I would be everything my mother hoped and wanted and strove for me to be. And surely that would solve everything.

CHAPTER FOUR

Our Cherry Orchard

Faleton: land as far as the eye could see.

"Why is everyone around here so proud of buying their clothes at the rummage sale?"

—JOSEPHINE PREMICE

I sat mesmerized in the dark stillness of Joseph Papp's Public Theater. Onstage, clad in a wool turn-of-the-century traveling suit with silk frog closures and Persian lamb trim, my mother captivated the members of the Ranyevskaya family with her card tricks in this all-black production of Chekhov's *The Cherry Orchard*, originally directed by James Earl Jones, who at the time had already garnered a Tony award and an Oscar nomination playing the lead in stage and film versions of *The Great White Hope* (the thinly veiled story of Jack Johnson, the first black heavyweight boxing champion). Her sleek body cocked at an angle, sharp blade-like hips thrust forward, she drew the cards with a long, flowing stroke of her arm. I knew how hard she had struggled to achieve this air of effortlessness. I had watched her stumble, fail, and begin over and over again in our living room. Each unsuccessful attempt was punctuated with a frustrated cry of "Shit!"—a word I knew not to include in my budding vocabulary on pain of a smack across the mouth from my mother's lethally bejeweled hand (one racial difference my mother readily acknowledged: white mothers give time-outs, black mothers give spankings). After tireless hours of at-home rehearsals, there my mother stood, calm, composed, curseless, manipulating the cards as though she had emerged from the womb a magician, making the impossible look easy.

I was too young to grasp all the nuances of Chekhov's "comedy," but when Madame Ranyevskaya bemoaned the inevitable loss of her once-grand estate, my ten-year-old heart bled. I didn't

know why the caged bird sings, but I did know why the dispossessed landed gentry wept. *New York Magazine* theater critic John Simon didn't share my enthusiasm. For him, these "Negro" actors were "black cherries," undeserving beneficiaries of Mr. Papp's penchant for "nontraditional casting," aping the ways of the pre-Revolutionary Russian aristocracy.

To me, ten black people sitting around lamenting the loss of a genteel way of life felt like dinner with my Haitian relatives. They had all known lives of elegance and plenty in Haiti, surrounded by servants, shuttled off to Europe at eighteen to study. My great-aunt Destine, my grandfather's sister, presided over a coffee plantation in the rural town of Aquin, which she ran like a feudal fiefdom, with antediluvian plumbing to match. There was neither electricity nor running water; servants dutifully waited for you outside the water closet. Like serfs of old, they had to ask Destine's permission to wed, and the local priest would not deliver a sermon unless she pre-approved it. Destine, a fiercely independent woman who'd refused to marry the father of her five daughters, had conducted her affairs properly and so ran no risk of losing her acreage. But in the United States, Destine's daughters, my mother's cousins, experienced the genteel poverty of the West Indian exile. In postwar, prefabricated apartments they strove to maintain an *art de vivre* by preparing elaborate meals, holding forth on poetry and art, and reminiscing about their youth. And so there was nothing contrived to me about this collection of black actors, whose skin tones matched the palette of my mother's family from "high yellow" to dark brown, delivering nightly elegies for bygone days of grace.

Chekhov's words also captured for me my deep love of Faleton, my paternal grandparents' estate in Gladstone, New Jersey. This was no fiction being presented onstage, it was my life and a foreshadowing of the inevitable loss of a magical, comforting world I held dear. It was always whispered in the family that when my

grandmother, Dorothy Mitchell Fales, passed away, the 450 lush green acres would be sold, parceled out. Faleton would vanish, and with it the oasis of my childhood fantasies, the kingdom of many of my fondest family memories. We spent most weekends and the months of July and August at the estate. In the summertime, there were no grades, no dreaded report cards, and Enrico couldn't graffiti the trees or go off with mischief-making friends. He and I spent our days playing badminton, swimming, and walking the endless grounds. Papa didn't leave us to go pub crawling with his single friend Leo, but snuggled with our mother every evening. She dressed in long chiffon spaghetti-strap gowns from seasons past, and in her stiletto "love-me pumps" stood singing to the fireflies as she passed Papa pieces of chicken to grill on the hibachi. At Faleton, we seemed to live the dream of the endless old movies my mother and I watched together.

The first time my mother set foot in the local convenience store in Gladstone in 1964, the clerk behind the counter immediately greeted her with a "Welcome, Mrs. Fales." My mother turned to my father puzzled; how did they know who she was? My father just smirked. The number of minorities in this part of New Jersey wouldn't have rated so much as a percentage point. Not even the help or the gardeners were of color. The nearest black woman was somewhere in deepest Newark. Who else could the size-four black woman be but the one who had—pass the smelling salts, please—married into the Fales family.

One night, many summers later, as my parents lay in bed, my mother complained of the wasp that buzzed and circled overhead. "Haven't you figured it out after all these years, Phi-Phi?" Papa replied. "You're in Waspland."

Waspland soon fell in love with my mother. The ladies and gentlemen of the tweedy hunt club set would rush across a room to greet her, this apparition in high heels and full makeup. They loved

her warmth, her booming laugh, and her unwavering sense of self. Josephine walked among Gardeners, Pynes, Dillons, and Chubbs as if she'd spent her entire life in their midst. She didn't try to tone herself down, or deemphasize the differences between herself and these Anglo-Saxon Brahmins, but proudly spoke of both her stage career and her heritage. She presented herself as a unique and independent world unto herself, which they had no choice but to accept. Eventually even my grandfather fell victim to her charms.

It wasn't until we returned to America in 1964 that Grandpa finally decided to meet his son's bride, and his two youngest descendants. At that point, he knew us only from the photographs my grandmother brought back from her annual visits to Rome. We lunched with him at Sardi's. I sat propped up on a stack of phone books, and Enrico sat up straight, deftly managing fork and knife. After a two-hour luncheon, Grandpa rose to say good-bye. He took my mother's long, slender hands in his, looked her in the eye, and said, "I'm very glad to finally meet you." And he meant it.

It had taken Grandpa five years to recover from Boston Brahmin my-son-married-a-black-girl apoplexy, but now he began to revel in the charms of his chic actress daughter-in-law. We became Sunday lunch regulars at his Manhattan townhouse. A big drinker, Grandpa always prevailed upon my mother to fix him one of her world-famous, guaranteed-to-get-you-smashed martinis.

Each Sunday, Grandpa would wait with eager anticipation to see what the family fashion plate had chosen to wear. "Is that the latest style, Josephine?" he'd comment of her beautifully tailored two-piece skirt suits. The women of his *über*-WASP coterie subscribed to the dowdiness-is-next-to-godliness, come-as-you-are school of personal grooming. Old money meant old frocks, sometimes purchased at the Episcopal church rummage sale, then accessorized with a well-worn pair of Talbot's tassel loafers and a discreet circle pin from Raymond C. Yard. Dowdiness showed an

admirable lack of vanity and proper respect for the Family Trust, which an industrious ancestor had had the good grace to accumulate. My grandmother, an undeniably beautiful woman with porcelain-blue eyes and long wavy hair that she wore gathered in a softly undulating chignon, managed to make even the drab uniform of her caste look elegant. Her swan-necked perfect posture and regal bearing transformed print wrap dresses into exquisite raiment. It didn't matter, though, for her husband had long ago ceased to notice her. He had chosen her out of admiration rather than love and remained married to her not out of attachment, but out of an aversion to scandal. For people of their "station" and upbringing, death offered the only respectable escape from a less-than-perfect union. Mr. and Mrs. DeCoursey Fales bore their marital misfortune with stiff-upper-lip stoicism. They belonged to a generation raised to believe that, the first article of the Constitution notwithstanding, happiness was neither a birthright nor a worthy pursuit. Life consisted of the fulfillment of prescribed duties, the preservation of the family trust, and the dignified performance of rituals handed down over generations.

One such ritual was taking up residence in the country. Every summer, Mr. and Mrs. DeCoursey Fales packed up their household and repaired, suitcases and servants in tow, to Faleton. My grandfather had built the stately main house on the property soon after he and Dorothy Mitchell, the belle of Bedminster, wed in 1917. There was another large house on the estate, an eighteenth-century clapboard at the bottom of the hill occupied by my uncle Hal, a highly respected partner at the law firm of White and Case, his cheerful wife, Kak, and their rowdy brood of five children. Elsewhere on the property, there were stables, a garage apartment for the groom, and a quaint two-story for the caretaker and his family. A dilapidated Victorian house occupied the edge of the property. Papa told me Grandpa had lent it to a friend who had

lost all his money in the crash of '29. The family never vacated, and apparently the man's descendants still lived there free of charge. It stood at the beginning of the property line as a warning that all worldly goods vanish.

In this rural hunt country of rolling fields bordered by neat rows of trees, people re-created the great landed estates of Thomas Gainsborough's England. Social life revolved around The Hunt—as in thirty people in pink coats on horseback and dozens of hounds mercilessly chasing a panting fox across endless fields—and The Races, an American version of Ascot. The local gentry hired cooks and butlers from Portugal, Spain, and Eastern Europe. My grandmother preferred the Irish, but when her cook and housekeeper, the unwed sisters Blanche and Easter, retired, she had no choice but to turn to "swarthier" Europeans. Grandma never expressed any prejudices against blacks, but she was almost pathologically mistrustful of people from the Iberian Peninsula and "Italians." Her gardener was an attractive white gay man, Dick Mervin, who was such a charmer that he became a "walker" of sorts for the local grande dames when they had a dance or garden party to attend. Once she was widowed, Grandma never went that far, though she adored Dick. She could overlook race, but never class. She was decidedly of the Victorian mind-set that we should all remain firmly entrenched in the stations into which it had pleased the Almighty to call us.

For nearly every summer of my childhood, we made the pilgrimage from the swelter of New York to the "green and pleasant land" of Gladstone. In the early years, we occupied the guest rooms of the main house. I loved sleeping in the four-poster bed with the canopy that seemed to loom like a crocheted sky miles above my head. My parents endured rock-hard horsehair mattresses and twin beds, much to their dismay. On one of our first visits, Grandma decided to take Enrico and me to Saint Luke's Episcopal Church, where she and Grandpa had worshipped since they first wed. The

entire congregation wondered who the beautifully dressed, well-behaved children were. "My grandchildren," my grandmother stated proudly. My brother mesmerized the local ladies by bowing and kissing their hands. They didn't know grown men who displayed such courtliness, let alone five-year-old boys. They pronounced us charming.

Three years after welcoming his prodigal son back into the fold, my grandfather died of leukemia. Enrico went to the funeral; I was deemed too young. All I knew was that I would never again see Grandpa, the kind old man in the top hat who laughed loudly and took us out for pony rides. Papa never spoke of his father's death, following the well-established family tradition of swallowing one's pain whole. My mother complained to me for years afterward that Grandma had issued the edict that no one cry at the funeral. She found this directive inhuman, which was ironic, since crying didn't seem to be something she ever did. She got mad, and sometimes I knew she was sad, but I rarely if ever saw her shed tears.

Life at Faleton went on as before, except Grandma sold off the horses, and we moved into the groom's apartment, my parents having tired of living as guests in the main house. They wanted their independence from my grandmother's unromantic sleeping arrangements, bland menus, and rigid schedule: breakfast in the dining room promptly at seven-thirty, lunch at one, tea in the living room at four, dinner at seven. My mother was no early bird; applying her false eyelashes—yes, she wore them, even in the country—before 10 A.M. was too tall an order. Besides, she enjoyed preparing her own meals, in a kitchen where Tabasco was not *verboten*, but a staple.

Second in importance after beauty in our family's hierarchy of false idols was good food. We worshipped at the altar of gastronomy and disdained those who did not treat their palates with respect. Never would we darken the drive-through window of a McDon-

ald's or a Burger King. These newfangled fast-food joints were for the uninitiated, for "food philistines." Papa, who like most WASPs had been reared on the American interpretation of British cuisine, had been transformed by his wife into a most discriminating epicure. My mother did not view cooking as drudgery but as yet another art form, one of the small things that made life more beautiful. Her repertoire of recipes, like her repertoire of songs, chronicled her life and travels. She whipped up rice with black Haitian wild mushrooms, "Black Power rice," as my Haitian aunts had dubbed it, steak au poivre and matchstick-thin *frites*, Brazilian *feijoada*, homemade gnocchi with fresh tomato sauce and basil straight from the vegetable garden, pasta primavera. She spoiled us with a nightly feast, delighting in the fact that she had created not one but three food snobs. Even hamburger in her hands became a succulent seared beef confection bursting with sweet onions, parsley, and capers, an explosion of flavor. She would not have our palates insulted by the dull dishes Grandma instructed her cook to prepare. We ate at my grandmother's table as infrequently as possible. My mother would always feed us before or after, and we'd have a good laugh about the meal we'd endured. We liked being just the four us, a world unto ourselves within the family confines.

We did, however, religiously attend Sunday lunch. The menu never changed in the eighteen years I attended: roast beef and Yorkshire pudding, broccoli with hollandaise sauce, followed by a perfectly lovely dessert. The china service and silverware dated from Grandma's wedding in 1917. She had the table set with bowls with jewel-toned candied fruit in the winter, and Steuben glass grape clusters, apples, and pears in the summer. She felt looking at the glass had a cooling effect on a sweltering day, and it did. Dorothy Mitchell Fales gathered her entire family at her rectangular table, adding and removing leaves depending on which sons or grandchildren were in attendance. At our peak, we were fourteen. The

children would sit by order of seniority, the youngest occupying "starvation corner," the last part of the table to be served. That poor soul, often me, would have to watch as the adults piled steaming slices of rare beef on their plates, knowing that by the time the butler reached the far end of the table with the platter, only a shriveled and desiccated brown heel of beef would remain. My mother was appalled. In her culture, children were fed first. However, this was her mother-in-law's house and Josephine respected the sanctity of a hostess's domain. She'd wink at me across the long table as I stared dolefully at my stringy, juiceless portion as if to say, "Mommy will take care of you as soon as we get home."

Cocktails, meaning one glass of sherry per customer and some warm macadamia nuts proffered like precious gold nuggets on a crystal serving dish by the butler, took place before lunch. Papa sat in a chair, his head buried in the *New York Times* crossword puzzle, as the other adults made polite conversation. Their talk hinted at the "real world" beyond Gladstone's split-rail fences and manicured lawns: Weren't all the casualties in the Vietnam War tragic? someone would ask. President Nixon was a fine president, offered another, to which my father would give off a disdainful snort.

"Indeed, he and Kissinger know what they're doing," Uncle DeCoursey, an awkward, gentle giant, haltingly ventured in the stuttering mid-Atlantic that belied his brilliance as a historian and archeologist.

"He's a cretin," Papa rebutted, not bothering to look up from his magazine, his voice dripping contempt and impatience.

"I can't get number six across," Grandma interjected, pulling out her crossword puzzle to defuse the hand grenade Papa had tossed in the direction of her eldest and most awkward son. "What is an Italian word for 'softly,' Timothy?" she asked the most encyclopedically erudite of her three brilliant sons.

"Pianissimo," Papa grumbled, still not looking up.

"How can those fathers not hug their sons when they come off the plane? They've been prisoners of war, their families haven't seen them in years. It's terrible," my mother opined in reference to the nightly news segment on the war in Vietnam. The Fales men resigned themselves to silence. Grandma remained poker-faced, her hands folded in her lap. Her own mother, an austere woman who threatened to dress her all in black if she ever dared admire herself in a mirror, had shown little warmth toward her five children. Family affection was not my grandmother's favorite subject. Aunt Kak smiled at my mother and nodded in agreement.

"Mrs. Onassis is buying a property in Bedminster," Aunt Iten, Uncle DeCoursey's German-Jewish-born wife, declared, entering the conversational fray.

Grandma stiffened. "All those photographers! She'll ruin the hunt!"

Grandma tried valiantly to adjust to change, to grandsons who wouldn't cut their hair, to a granddaughter who lived the bohemian life of a hippie and took her six-year-old son hitchhiking. But some things she just couldn't tolerate, chief among them Mrs. Onassis riding to hounds in her oversized sunglasses, rabid paparazzi in hot pursuit. In a further sign of a world gone mad, a son of one of the finest local families had been rejected by Princeton, and Maria, daughter of Grandma's own Spanish cook and butler, Nicole and Valentin, had been admitted. Imagine! Grandma felt as though she harbored the enemy. The right corner of Papa's mouth curled into his patented wry smile. "She's obviously smarter than the Chester boy," he volleyed.

Grandma raised an eyebrow. She refused to dignify that comment. Papa loved to see his caste beaten at their own game. He delighted in Enrico's and my "achievements," since they debunked the myth of white superiority.

Changing the subject, my mother told Grandma about my progress in school. "She's got *tableau d'honneur*, honor roll again!"

"Well done, Susan," Grandma beamed. "What are you reading these days?" she asked. She always took an interest in what Enrico and I had to say about our scholastic and intellectual discoveries. She'd ask us to return in the afternoon for tea so we could settle in for a good long chat about a volume of classic literature, our teachers, and our courses.

From time to time, after lunch Papa invited Enrico and me along on an afternoon hunt, one of his favorite pastimes. He shot pheasant, quail, and very occasionally, rabbits. We were escorted by our Brittany spaniel, Neptune, whom my brother had managed to convince my parents to get by lobbying all their friends at cocktail parties. We walked across the fields, picking *fraises des bois*, tiny wild strawberries, along the way. My mother claimed one should only wash them in champagne as the French did. Suddenly Neptune would stop in his tracks, flare his liver-colored nostrils, and raise his right paw in "point" position. We headed silently in the direction he'd indicated. We had our prey. Neptune would stop again as we moved closer, prowling toward a bush with the stealth of a small lion. Then, he ran and flushed the bird out. Papa aimed and shot, once, twice. The shots resounded in the open air, the bird plummeted from the sky. Enrico and I cheered. Neptune ran to retrieve bird and lay it at Papa's feet. Papa, Enrico, and I didn't exchange many words during these outings. Talking wasn't the point. It was the walking in silence, side by side, sharing with my father one of his sacred, solitary rituals.

Papa had tried to include my mother in this hobby. He had visions of romantic hunts, just the two of them. He took her down to the old Abercrombie and Fitch to have her fitted for a shotgun. They measured her long arms, and she bought a hacking jacket. The stylistic aspect of the sport appealed to her greatly. She duti-

fully applied for and obtained a gun license, probably the only "hunter" on record photographed in full makeup and false eyelashes. On a crisp Saturday in October, Papa excitedly began her training in the field behind our little house. As Enrico launched clay pigeons in the air with the special spring-operated catapult, Papa stood behind my mother, positioning her legs and arms. "Ready, Phi-Phi?" he asked in his loving baby voice.

"Yes, darling," she answered, shutting her right eye, and scoping ahead with the left as she gripped the trigger with a manicured finger.

"*Tire!*" Papa commanded Enrico in French. The clay pigeon—a sort of terra-cotta hockey puck—flew toward the sky. My mother aimed and shot. The kickback from the gun nearly knocked her off her feet.

"That was strong," she commented, stunned.

"You'll get used to it, Phi-Phi," Papa assured her as she reeled. "Again," he commanded.

"Come on, Mommy, you can do it!" Enrico and I encouraged her.

Josephine shook her head with resolve. Yes, indeed, she could do this. She would be a true partner, a hunting companion for her husband, the most glamorous hunting companion the woods had ever seen. She planned to accessorize the rubber boots, her hacking jacket, and the rucksack with jewelry and a magnificently coiffed wig.

"*Tire!*" Papa ordered again. Enrico launched the pigeon. My mother aimed, shot, and was nearly felled by the impact from the butt of the rifle.

She didn't look happy, her shoulder ached. Still, she hung in and repeated the process over the course of the next two hours. By the time we returned to the little house, large bruises had appeared on her shoulder. After one more afternoon of "training,"

my mother conceded defeat. She didn't make a habit of quitting, but she told Papa that the gods clearly had not intended her bony body for this sport. She volunteered to continue to pluck and cook the game once he brought it home. No doubt, his wife's abdication disappointed my father. He had waxed poetic describing the long afternoons hunting would allow them to spend alone together. Once his wife quit, he packed her gun into the closet and never raised the subject again. My mother found her gun license quite useful as a form of identification . . . at Bloomingdale's or Saks when she wanted to pay by check.

"Do you have a driver's license?" a saleswoman would ask.

"No, but you may have my hunting license," she'd announce grandly as she proffered it with a manicured hand.

After this misadventure, my father and mother resumed the traditional hunter–angel-of-the-hearth roles. When we would return from a hunt, she stood waiting with a fresh pitcher of pink lemonade. She watched as we performed the ceremony of the "revelation of the bird." Neptune sat, his chest puffed out, like a guard at attention. As Papa removed the pheasant from his rucksack and we all applauded, my mother most enthusiastically of all, Neptune raised his head even higher. He knew he'd done well. My parents would head outside to prepare my mother's freshly marinated chicken on the hibachi and I'd dash over to Grandma's for tea.

Walking under the pergola, fragrant honeysuckle drooping overhead, I hummed a march, imagining my wedding in this sacred spot. I opened the two sets of doors, which no one ever locked because there was no crime in this part of the world. As I entered the foyer, the grandfather clock chimed the hour with four solemn gongs. I walked across the cool terra-cotta tiles, past the powder room with its scent of rose glycerin soap, to the living room, where

Grandma sat in her usual rocking chair with swan's heads for arms. Valentin would bring in the tea caddy and the tea.

"*Bonjour, Mademoiselle Susan.*"

"*Bonjour, Valentin,*" I answered, smiling. I sat in the straight-backed Hepplewhite chair opposite Grandma, its seat hard as concrete. None of Grandma's furniture was built for comfort, another unworthy and decadent pursuit.

Grandma loved to tell me about her childhood education. How, for example, her governess required her to sit perfectly still every day for an hour, "practicing repose." It's a feat I knew I couldn't manage.

I heard of her cross-country train trip with the poet e. e. cummings.

"What was he like?" I asked, excited. "We've just read some of his poetry in English class!"

"He was very odd, a bit rude, really. And I never cared for his poetry, all that strange punctuation. It's silly. What does he have against capital letters?" she said.

I admired Grandma as much as I did my mother and all her flamboyant, perfumed friends. Although Grandma was more reserved of manner, and wore not a stitch of makeup, she was equally regal, beautiful, and silently powerful. Like my mother and her friends, she didn't complain about life, she got on with it. She never raised her voice, she never acted rashly. Everything about her bespoke dignity. She taught me about working for the things you want by repeatedly telling me the story of the gold bead necklace she spotted in a shop window when she was seven. "If you want it, you must earn it," her father said. And so she mended napkins for a penny apiece for seven years until at last she could buy the necklace. On my thirteenth birthday, she gave it to me. It was as though she has given me the Krupp diamond. Grandma didn't give presents she thought one hadn't earned. She wanted me to know she was proud of me. She wanted me to have a piece of herself. Every-

one in the family said we resembled each other, differences in coloring notwithstanding. My temperament and mannerisms even reminded my father of hers, which did not bode well for our relationship.

From an early age, I dreamt of reliving my grandmother's life, albeit a happier version. I envisioned myself presiding over a property of my own, raising three bright, accomplished sons who freely roamed our fields and forests, safe from crime, tragedy, and the judgments of an unjust world. It didn't occur to me that my grandmother's class and era had confined her to a very limited existence. The most she'd been permitted to aspire to was "marrying well." I didn't yet realize how many more options were open to me as a child of the twentieth century. I didn't know then the depths of misery she'd plumbed as an unloved wife in the midst of her estate's bucolic splendor. I could never have imagined it. Even as an adult, if anyone had asked me to describe a utopia, I would have answered with just one word: Faleton.

Over the years, Grandma and I maintained a correspondence. I wrote her letters about my schoolwork, the progress of my reading, the plays I went to see. I addressed the letters quite simply Mrs. DeCoursey Fales, Gladstone, New Jersey, no street address. Everyone knew where she lived. Like an estate in an Austen novel, Netherfield Park or Northanger Abbey, Faleton was known throughout the county. Grandma's final letter to me, written during the fall of my freshman year at Harvard, said simply: "I know you will excel. Whatever you do, know that you always have the support of your old Grandma." Then, one day, quite suddenly, our nineteenth-century idyll ended.

My mother and I received the call early in the day. "I'm afraid Grandma's feeling poorly." Aunt Kak's voice quavered, betraying her panic. We hired a car for the hour-long drive. Papa was away on a ship. I didn't know what my mother's conversation with him had been.

We arrived at the house in the late afternoon and rushed upstairs. There she lay in the guest room, on the same narrow canopy bed I slumbered in as a small child, her hair immaculately pulled back as always, her arms stiff at her side. I burst into tears and kissed her forehead. "I love you, Grandma." Somehow, seeing her was helpful. It made her death very real and concrete.

The funeral took place at Saint Luke's. Papa did not attend. I didn't discuss with my mother whether or not he could get off his tanker. She did not invite questions on the subject, but presented it as a fait accompli. If his absence upset her, she certainly didn't show it. While the family filed into the stone church, the pallbearers carrying the casket high, as per Grandma's instructions, Papa was out in the middle of a vast ocean in the Middle East, miles from home, looking out into the night. Upon his return, we never discussed Grandma's passing. If he had anything to say, he certainly didn't share it, the man behind the crossword puzzle.

A year or so later, he entered my room one night. "I have something to tell you," he began in French with uncharacteristic awkwardness. He didn't seek me out in my room very often.

"What is it?" I asked apprehensively.

"Faleton's been sold. Everything but Uncle Hal's eighty acres." The day I'd dreaded for ten years, since watching Chekhov's Ranyevskayas cling in vain to their past, had finally arrived. Papa stood awaiting my reaction, prepared for the worst.

I didn't disappoint. I burst out crying, asking, "Why?"

"It's unaffordable. It makes no sense to keep it. You'll still have this apartment," he offered, desperate to console me.

"It's not the same," I protested.

My mother had made the most of our home on West End Avenue. But in spite of her bravura and the illusions she created with fabric, our apartment stood as an emblem of my mother's outsized dreams deferred. Back in 1964, after a full year of pounding

the pavement and having doormen laugh in her face and real estate brokers insult her, ours had been one of the few buildings my mother found that would rent to a person of color. Enrico lived in the maid's room; roaches and mice infested the kitchen and bathrooms. I knew we were making do. Often my mother would fantasize aloud about someday having a truly splendid home where each of us, even she, had a spacious room of our own, a home to which Enrico and I could return for visits as she and my father grew old together. Now Faleton, our refuge from a less-than-perfect reality, had slipped away from us.

As the tears streamed down my face, Papa stood in the middle of the room, looking about, lost and embarrassed. For once in his life, his wit deserted him. He was not my sardonic, rapier-witted Papa—he was a man who couldn't make his daughter's dreams come true and wished he could. After a few awkward moments, he left me to my grief. Not only could he not buy back Faleton, he couldn't buy back the promise it held that our family would live happily ever after.

Intimations of
Mere Mortality

CHAPTER FIVE

Someday My Part Will Come

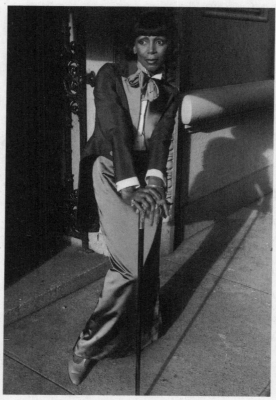

My mother, ready to make her entrance,
Bubbling Brown Sugar, *1977.*

"People used to dress in this town."

—JOSEPHINE PREMICE

Actresses spend their lives waiting for The Call, that magical moment when a director or casting agent singles them out from among a camera-ready crowd of "thousands" to play the role of a lifetime. It's the secular and thespian equivalent of an annunciation, or heavenly voices summoning Joan of Arc to lead a great army. Of course, rather than an army, the thespian Maid of Orléans leads a great cast to immortality, or at least to good reviews. My mother received such a call in the late winter of 1978. It had been a bleak passage in her life, marked by the closing of her musical *Bubbling Brown Sugar* after a two-year run on Broadway, and by the death, from lung cancer, of her beloved father, Lucas.

Though as usual she refused to cry or complain, she spoke of my grandfather often, of his expressions and his beliefs. "A woman must always have something of her own," he would tell her as he slipped his grown daughter a fifty-dollar bill years after she wed.

In quiet moments, eyes wide and dark with sorrow, my mother admitted she missed Grandpère every day. She'd retell the stories of his old-fashioned fatherly protectiveness. "A young man phoned your grandfather's house looking for me. 'What's your name?' your grandfather asked. The young man refused to leave it. 'Why you no give your name?' Grandpère said. 'FBY after you?'" Lucas mispronounced, in his heavily accented English. She'd laugh and take a puff from her cigarette. "He continued to smoke till his final days, you know. Right there in the hospital. The nurses couldn't control him. Terrible."

My own father had returned to the merchant marine as an officer, then a ship's captain. "You and Enrico will head off to college soon. Your father wants to earn a larger income than his investments and his trusts provide," my mother explained as Papa sailed on oil tankers in faraway places for months at a time. She casually mentioned that Grandpère had helped her make peace with my father's career choice.

Years later, she confessed that it devastated her, that my grandfather had convinced her that the only way to keep her husband was to let him pursue his dream, though she had sacrificed many of her own. Unlike their mundane spats, she and my father held their fierce arguments over his absenting himself from the family not in front of Enrico and me at the dining-room table but behind the closed doors of their burgundy bedroom. Once my mother accepted her husband's decision, she acted as if she'd loved it and supported it all along. "The captain's gone to sea, he's off finding himself," she'd announce sunnily when people asked of his whereabouts. When he returned home, she'd welcome him like a conquering hero, making a virtue of his idiosyncrasies. "Isn't it incredible that your father falls asleep for twenty minutes at a time at the table, then awakens and picks up the conversation exactly where he left off? That comes of not sleeping through the night on his ships." As a teenager, I took her cheeriness at face value.

Since we lived in a Manhattan apartment, not in a Nantucket whaler's house with a balcony, my mother's "widow's walk" consisted of the trek between the kitchen and her bedroom. She made this perambulation often, releasing the kinetic energy that instantly melted any fat cell deluded enough to think it might find a permanent home on her wire-thin body. Back and forth, back and forth she would stalk, vocalizing or letting out a sudden explosive "Laaaaaaaa!"

With no husband to greet and no role to play, she still painted

on her full Cleopatra eye makeup every day. She draped herself in flowing black pants to camouflage her spindly legs and silk blouses with billowing sleeves, raising the collars to frame her face. As usual, she brandished personal adornments as her shield against sadness and frustration. She stood apronless at the stove, preparing elaborate meals for Enrico and me. "How about steak au poivre tonight, or would you prefer fried chicken and mashed potatoes?" Our culinary wish was her command. In her spare time, she smoked and transformed scraps of fabric into throw pillows of every shape known to geometry, tablecloths with appendages of pennies encased in cloth for side tables, and curtains with voluptuous silk-cord fringes.

Enrico, then eighteen, pursued interests appropriate to a heterosexual young man in his prime. Fifteen, prim, and terminally virginal, I happily filled the role of "mother's companion." On weekends, if I didn't have disco plans with my friends, we would snuggle together on the little Louis XV–style love seat in my mother's bedroom, watching old movies late into the night. Bette Davis in *Dark Victory* or *Now, Voyager* made her speak dreamily of love, its pain and its glory. She had been reared on these films and believed in the concept of the "Great Romance," that one would end one's days in a large home with a sweeping staircase and a loyal, handsome, well-coiffed man steadfast at one's side. She'd point to Manderley, Laurence Olivier's enormous stone manor in *Rebecca*, and say, "There's our house, Susan." Then she'd dissolve into girlish giggles, smiling like the naughty nine-year-old imp she had once been. I'd laugh too, but somewhere in my heart I believed that one day we really would have a Manderley of our own. It seemed perfectly within the realm of possibility to my fifteen-year-old imagination. After all, we still had Faleton then.

My parents' marriage struck me as a very romantic affair, the stuff of silver-screen legend, worthy of Mr. Olivier himself, had

they allowed white men to court black women in Hollywood's never-never land. They didn't even allow mixed couples on television game shows, let alone the big screen. Still, I didn't see why my parents' saga shouldn't end in a house with a sweeping staircase, an eternal embrace captured in cheekbone-enhancing lighting with symphonic music swelling from an invisible orchestra to punctuate the key moments of their life. Papa would stop going to sea and take my mother grouse-shooting in Scotland as he once stated he wanted to do. And someday, maybe soon, I too would meet a well-coiffed prince and learn the meaning of the word *love* in its most passionate connotation.

Finally, in January 1978, six months after *Bubbling* closed, came the call that interrupted Josephine's "unemployed Broadway star cum seafarer's widow" routine. She swept over from her settee à la Loretta Young to answer the shrill *prrrrring* of the phone. "Hel-looo!" she bellowed, rallying her dormant enthusiasm.

"Come do this show with me, Josephine," my mother's old friend and former *Jamaica* costar Lena Horne demanded in her naughty, girlish drawl. "This show" was a revival of the musical *Pal Joey*, with Aunt Lena in the role of Vera, the "mature" woman experiencing sexual renaissance; Clifton Davis—of *That's My Mama* sitcom fame—as the bewitching, bothering, and bewildering gigolo Joey; and my mother as the salty sidekick.

My mother beamed. But for the fact that it was in California, it was just what she'd hoped and prayed for, just what the Diva Doctor ordered: Work! As she'd once told David Merrick, "I don't get sick when I work, I get sick when I don't work."

"Yes, Lena. I'll talk to my agent. . . . How's Sherman? . . . See you in Los Angeles." My mother plunked the receiver back onto its cradle. "Mommy's going back to work! Rehearsals start in a few weeks. It's at the Ahmanson, the Lincoln Center of Los Angeles,"

she gushed, then realized: "I'll need a driver!" My mother had never bothered to learn to drive. "All the television producers in town will see the show. They have plans to take it to Broadway."

I imagined my mother winning a part on a comedic series, just as Aunt Diahann had been offered *Julia* after starring on Broadway as a fashion model in love with a white photographer in the controversial 1962 Richard Rodgers musical *No Strings*. Like millions of other American families in the seventies, my parents and I faithfully watched Norman Lear's groundbreaking offerings *All in the Family*, *Maude*, which starred Bea Arthur as TV's first bona fide feminist, and *The Jeffersons*, in which he had even included an interracial couple. Though none of these shows (even the interracial couple on *The Jeffersons*) or any others on television mirrored our family life, we appreciated their originality and intelligence. I knew from a young age not to expect to find my reflection in the offerings of the small screen or the movies. As far as those mediums were concerned, we didn't exist. But perhaps Norman Lear would create a show for my mother, and though it would not duplicate her real-life experience, at least her essence would grace the airwaves. Just as *Julia*, the first series to feature a black female lead, had catapulted Aunt Diahann to superstardom in 1968, a series would restore my mother to what I considered her rightful place in the acting firmament.

I'd seen her sit at home in full makeup, vocalizing and sewing pillows, enough to know how rarely such offers came along. For months, I'd welcomed her home from auditions where people had loved her performance but didn't think she looked like "someone's mother." I'd then watch her try to shake off the disappointment as she resumed the mind-numbing tasks of an Upper West Side housewife. Little did casting agents know that the skinny woman with the manicured hands scrubbed floors, packed our lunches, cooked our dinners, and did her own manicures—and in her spare

time managed to fabric the walls of entire rooms, just for the fun of it. Little did they know she'd dash home after a matinee of *Bubbling Brown Sugar*, whip up sautéed shrimp, fresh broccoli, and savory rice for Papa, Enrico, and me, then rush back to the theater to do the evening show. Little did they know that she'd come home—by bus, no less—from Philadelphia every night during out-of-town tryouts just so she could wake Enrico and me in the morning and serve us our breakfast shakes. If that's not mothering!

But Josephine Premice was an original, and the world was not kind to those who did not fit a cookie-cutter mold. She wasn't a plump, grinning, Beulah type and she wasn't an unthreatening all-American mom. Her brand of comedy did not involve Amos and Andy's bug-eyed, hand-on-hip, neck-wiggling, loud-mouthed "sass." She'd go up for parts and get turned down in favor of someone more "regular" looking. She'd lose commercial voiceovers to her equally husky-voiced white friends Lauren Bacall and Tammy Grimes, the noted stage actress. Until the eighties, Broadway producers did not often risk casting black actors in roles written for whites. So unless there was a black musical—or even rarer—a straight play, opportunity knocked infrequently at best. My mother had the same training as any white actress, having been put through her paces by Lee Strasberg himself. She could sing, she could dance, but she couldn't get a job. Even her best friend, Diahann, who'd put her career ahead of family, hadn't been offered a single feature film role since her Best Actress Oscar nomination for *Claudine* in 1973. My mother *had* to take this job.

I knew performing gave her a chance to express something deep within her, something no amount of cooking, bargain hunting, and home decorating could ever satisfy. Over the years I had come to understand that she lived onstage and experienced an intensity of feeling she couldn't realize even with us. I knew it as surely as I knew my own name; performing was indeed the only

thing my mother could do and breathe. Whereas as a small child, I had been frightened by her transformation into a different person, over the years I had grown to relish what she became under the footlights: Josephine Premice, the artist.

On countless Saturday nights from age thirteen to age fifteen, I had sat in a narrow velvet seat in the Anta Theatre listening to the orchestra play the overture for *Bubbling Brown Sugar*. Behind the scenes and onstage, the show featured giants of black Broadway history. It was conceived by Rosetta Le Noire, who'd acted in the first production of Kauffman's comedy *The Royal Family* and went on to found her own theater company, the Amas. The cast featured veterans like Joseph Attles, who'd appeared in *Blackbirds of 1928*, and Avon Long, who'd performed in Duke Ellington's *Beggar's Holiday*, one of several Broadway musicals of the forties that practiced colorblind casting. The *Bubbling* overture, a medley of Ellington and Eubie Blake tunes, transported me to a jazz-era world of elegance and style, to the golden age of Harlem and the black musical of the twenties. I would wait in the dark, staring at the gargantuan velvet curtain, my heart racing in anticipation of the moment when my mother's electric energy would galvanize the hundreds of strangers around me. As I clutched my seed-pearl-and-coral necklace, the curtain rose, revealing the cast and my mother, shimmering in white bugle beads and a long white fishtail skirt, reborn, triumphant, happy, and whole. She strutted and tapped her way around the stage, "making a feather boa come alive," as Clive Barnes wrote in his review.

At intermission, I would wander the loge, sipping my Coca-Cola as I overheard comments. "That Josephine Pre-myce is amazing! How old is she?" I'd beam, thinking to myself, *She's fifty. If I stopped to tell you that, you'd faint.* The gong sounded, warning us to return to our seats. The restive crowd simmered into silence as the orchestra began to play, and the curtain rose on Act Two. My

mother emerged from the wings transformed from an ice queen in white to a sultry chanteuse in a slinky red satin gown gleaming with thousands of hand-sewn bugle beads. "Every honeybee / fills with jealousy / when they see you out with me / You're confection, goodness knows / Honey—Ssssssuuuuckle rose!" she belted out, seductively dragging the *ssss* like a silk stocking over a lover's bare chest, accenting her sounds with an occasional roll of her hips. The sounds emanated from the depths of her soul as she poured forth the power of a woman who'd given birth, raised her children, fought, loved, and survived. "You're my honey"—the horns blew two staccato beats—"You're my HONEY, SUCKLE ROOOOSE!" Josephine would thrust her hands on her hips and stare out at the house as the audience burst into applause.

At the end of the show, I would rush backstage, past the beer-bellied, cigar-smoking doorman, up the narrow staircase with its peeling cream-colored paint on brick. Dancers and other cast members clattered up and down the stairs, their tap-shoe-clad feet colliding loudly with the concrete. "Hey, Susan, how are you tonight? Are you getting taller?"

On the second floor, I knocked and entered my mother's dressing room, a long narrow space with a frosted window looking out over nothing. She had tented the room in a multicolored print fabric and covered her mirror with telegrams, notes, and my drawings. "How's my beauty?" She'd slip into her civilian clothes and we'd take off for Sardi's.

On the way out of the theater, small clusters gathered waiting to see the stars of the show up close. One night a particularly eager young man rushed up to us. "Miss Josephine, Miss Baker! Can I have your autograph?" he asked, mistaking my mother for the Missouri-bred hoyden whose gyrations across a Paris stage in an infamous banana skirt in 1926 had made an entire nation swoon.

"Of course you can't!" my mother answered. The man looked

crestfallen. "You can't, because I'm dead." With that, we jumped into a car and headed off to Sardi's on Forty-fourth Street.

My mother had patronized Sardi's since she started in show business. It served as one of our family restaurants. All the waiters knew us—"Red," whose hair no longer was, and George, the tall, attractive, Serb-looking headwaiter, would come to pay their respects and offer me a complimentary Shirley Temple, as I sat in my white woolen slacks and blonde mink jacket, a hand-me-down from Aunt Diahann, thinking myself very worldly and sophisticated indeed. My mother held court on the burgundy leather banquette at the front of the room, under the toothy grins of the actors' carica-tures—during *Bubbling* she finally earned hers—as I feasted on "roast beef bones," a hearty combination of breaded red meat and creamy mustard sauce. The front section operated like a private club. People table-hopped and held conversations across the room. All my mother's actor and producer friends stopped by to say hello. There didn't seem to be anyone she hadn't met at some point in her life. And those who didn't frequent our home all seemed to have known me as a baby in Rome.

"I used to sit in this corner with Sidney Chaplin and your Uncle Richard [Burton], watching them get smashed. One night they got so drunk, Sidney challenged Richard to teach a class in performing Shakespeare first thing in the morning. He was con-vinced Richard would sleep right through it or be far too hungover to function, but the next day, there was your Uncle Richard, just as clear and brilliant as ever, showing us how to deliver a monologue."

My mother loved reminiscing about the good old days in the fifties. "That was the Golden Age of Broadway," she'd tell me. "*West Side Story* had just opened. Tennessee Williams had just written some of his greatest plays. Brando was in *Streetcar*. The Lunt Fontannes were an incredible acting team, not just the name of a theater. Broad-way was alive," she'd say wistfully. She made it clear she'd had the

privilege of living through an artistically remarkable era (at least for white actors), one that, because of the advent of television and the commercialization of Broadway, would never be recaptured or re-created. She felt sorry for my generation for missing it.

I felt far from deprived. A new universe opened when my mother performed in a show. I traveled to visit her in Philadelphia and Washington, D.C., during out-of-town tryouts. She thrived on the work. She had boundless energy and would curtail her usu-ally constant smoking. She also relished the freedom of earning her own money, the freedom of not having to stand in the doorway of my father's study while he diligently wrote out the check for the week's groceries and asked, "How much do you want?"

"Just some money," my mother would respond, never one to get specific with anything as vulgar as cash.

On the rare occasions she rode the bus, she'd ascend the stairs and ask in a booming voice, "How much is it, these days? The fare I mean."

One afternoon, we were halfway to the grocery store when she looked at the check and discovered Papa had taken her at her word. On the line indicating the amount of the check, he had writ-ten "some money." He loved playing practical jokes, and had prob-ably grown weary of his prodigal wife's willful vagueness on matters of finance.

Now six months after *Bubbling* closed, eager to perform and earn her own paycheck again, my mother decided to do *Pal Joey*. She summoned Bruna, our old governess from Italy, to stay with us during the spring. Then in the summer, we'd all join my mother in California. Papa was away at sea. I heard rumblings that he was not pleased about this game plan, something about taxes. He didn't want her to do the show. My mother ignored my father's objections to follow her dream. For nearly twenty years, she'd made sacrifices for her husband and children, putting us ahead of her ambitions.

Though she loved singing, she refused to travel far away from us to do the nightclub circuit. She'd unquestioningly followed Papa to Rome when they first wed, leaving on the very crest of stardom and passing up six full years of career building in an industry not known for its long-term memory. This time, Josephine stood firm, doing what she wanted to do.

My parents moved to Europe just after *Jamaica*, which had proved my mother's big break in Broadway musical theater, establishing her undeniably as a force with which critics and directors alike would have to reckon. She earned rave reviews from nearly everyone but Noël Coward, who described her in his diaries as "an over-vivacious coloured lady . . . who carried on like a mad spider." "But Miss Premice, beyond her snake-wiggles as a dancer—and those wiggles are tremendous—runs away with the show whenever she speaks or sings in that dry, clear voice that carries a mile," gushed one critic. "[W]hether she talks, sings, dances or flirts, the temperature in the house rises perceptibly," panted another.

Much to her manager George Greiff's dismay, she chose to ignore the reviews and the brilliant predictions for her future and follow the man she loved. She would never know how far her career might have gone had she stayed in the United States. She often mentioned her manager's horror, but never any regret of her own. Then again, true to the lyrics of the Edith Piaf song she loved to sing—"*Rien de rien/Je ne regrette rien*"—she never directly admitted remorse over any of her life choices. Now, twenty years into her marriage, she refused to pass up another opportunity. She was fifty-two years old, but looked so young people would see her and exclaim, "Josephine, you look too fine. We know you've got a portrait aging in your attic." It was her turn. A musical starring Lena Horne marked the beginning of her marriage. Another musical starring Lena Horne marked the beginning of the end of her marriage.

She flew to Los Angeles to begin rehearsals while Enrico and I remained at home. One night, I sat in my blue flowered room at the oval table that served as my desk, reading about Napoleon's conquests, when Bruna summoned me to the kitchen phone. "*È tuo papà*, ship to shore," she explained as she handed me the receiver.

"Hello, Papa!" I chirped.

After a few niceties, he launched his missile: "I think your mother and I are going to separate."

I struggled for words as I twisted the long telephone coil. "Why?" I asked, disoriented.

"Because I phoned your mother late at night and she wasn't home." Was he implying what I thought he was? That my mother, of all people, was out tripping the light fantastic with another man, having some tawdry, back-street affair?

"Mommy wouldn't do that," I shot back, knowing I was right.

In all my fifteen years, I had never seen my mother so much as look at another man. On the other hand, I'd seen Papa look at hundreds of women. It was the only thing that impaired his excellent driving skills: a passing girl, no matter what shape or size. All female creatures great and small garnered his attention. And God help us if the "she" in viewing range should be wearing shorts and riding a bicycle, her buttock cheeks spilling over either side of the seat. It was a miracle we'd all lived to tell the tale. "Keep your eyes on the road, Timothy," my mother would deadpan, utterly unfazed, insulted more by his indiscriminating taste than by his wandering eye. It became a game between them, or perhaps she made it one to render it tolerable. I couldn't easily read my mother's emotions beneath her mask of perfect command and immaculate makeup. "Timothy, you've never seen an ugly black woman," went her constant teasing refrain. Whether it was a barefoot island woman with a generously round behind or a slender, sophisticated New York black princess, they all attracted his gaze.

I also had a vague but dawning sense that when Papa traveled, his roving was more than visual. I could finally finish my mother's sentence: "Leo and Timothy, the men who can't say no to . . ." Since I hadn't had sex yet, and was far too prissy to read dirty novels, I still didn't have a clear mental picture of the activities that "yes" encompassed. What I could envision with crystal clarity, however, were the offspring of these dalliances. Sometimes, while daydreaming in my room, I'd imagine that one day, a half Indian, half Pakistani, or half Yemeni child with huge black eyes would turn up on our West End Avenue doorstep claiming to be our sibling. In these "daymares," I listened to the stranger's tale, then slammed the door in his or her face, utterly refusing to accept the interloper as a member of my family.

During one of Papa's sojourns, my mother was watching *Captain's Paradise*, as she stirred a pot in the kitchen. In the movie, Alec Guinness, a sea captain, maintains a wife in every port. My mother turned to see Enrico grinning at her from the doorway of his bedroom. "What are you smiling at?" she asked.

"I was just thinking about Papa," he responded offhandedly, then retreated to his room.

She recounted the episode to me as though it were the most hilarious story in the world. "I had to shut off the film after he said that with that grin identical to your father's. I just couldn't watch anymore," she'd say, laughing. I bought her bravado and laughed with her, though the tale didn't amuse me nearly as much as it seemed to amuse her. Now my father, the proverbial Captain, accused my mother of cheating?

"Mommy wouldn't do that," I insisted.

"I called and she wasn't at home," Papa repeated. "I'm sorry to tell you this."

Somehow, I felt he wasn't. It was only after we hung up that I realized my father was using me as a pawn in a high-stakes game

against my mother. I knew in my heart, as certainly as I knew she was not out carousing with some strange man, that he wanted me to call her crying and beg her to come home, to give up an extraordinary opportunity. Only one thing terrified me as much as the breakup of my parents' marriage: my mother swallowing her vision of her future the way the Fales family swallowed emotion.

I called her immediately at the rehearsal studio in Los Angeles. By now, the tears had started, halting at first, then full-on gushers. "Your father's being silly," my mother said, her voice calm and steady, my mother who could make the most dramatic moment of my life look like a tempest in a teapot.

"So, you're not going to get a divorce?" I asked, the clouds parting.

"We're not going to get a divorce," she laughed.

"I don't want you to stop what you're doing. I want you to keep working!" I cried.

"I will, darling, everything will be just fine. You'll see," came the soothing purr. Whatever rage she felt toward my father for gambling with my emotions she held in check. She didn't want me to worry or grow to dislike him, so she made light of the incident. "He's being silly. I don't have a phone in my apartment yet. He had to call Lena to come and wake me, and when she came, I was sound asleep. I'm exhausted; we rehearse all day. Now, don't give it another thought. Go do your homework so you can come and see me. Good night, my beauty. *Belle pitite mama li!*"

Having set the world back on its axis and made life beautiful once again, she hung up to return to her work. But now I knew that though Papa loved me, he would, at will, shift the very ground beneath my feet.

That summer we joined our mother in Los Angeles and moved into the house in Beverly Hills, glass-and-concrete seventies mon-

strosity with a night-lit pool high atop a hill. With its shag carpeting, mo-deerrrn furniture, and early-lounge-lizard décor, it was a far cry from our home in New York, but it was well-situated and spacious. Papa, who had returned from sea, commandeered a room at the back as his study and spent much of the summer buried in there. He and I moved along as though nothing had occurred. I was reading *Tom Jones*; he had much to say on the subject. We made up mock classical dramas, spoofing Corneille's *Le Cid*. We wrote soliloquies in iambic pentameter, then recited them daily over breakfast. We "bonded with the classics" in our usual "father and daughter that satirize together stay together" way. We never discussed The Call.

The bright, irrepressible sunshine and bougainvillea stood almost as a rebuke to our family tensions. Enrico had opted not to apply to college, much to my mother's frustration. Having transferred from the lycée to a more progressive American school, he had finally lived up to his intellectual promise. The Elizabeth Seeger School faculty thought the world of him and encouraged him to apply to Bennington. He had other ideas. Though she had, in her own words, spent only a "hot minute" at Columbia University and the New School, my mother fully intended for both her children to attend college. She badgered Enrico about it, asking him what sort of future he planned for himself. He did his best to ignore her and took up with a beautiful half-black, half-Japanese dancer in the show five years his senior. Having been reared in the Haitian tradition of young men being brought to brothels at thirteen by their fathers, uncles, or godfathers in order to learn the fine art of lovemaking, my mother encouraged the relationship while scolding Enrico for "losing his focus." She did not snap at him when she and I returned from an outing one night to find him and the dancer shirtless in the living room.

Papa, too, liked the beautiful Christina. He'd happily emerge

from his study when she came to the house. He'd kiss her hand and greet her with a caressing "Hello, Christina, you pretty thing. Can I fix you a drink?" as he sized up her long-legged physique.

"I'll get the drink," my mother would smilingly intervene, then suggest, "Christina, why don't you join Enrico on the patio." Once Christina had left the room, she'd turn to Papa. "Timothy you're incorrigible." But this time, beneath her grin, I could see her anger simmering. The mask of command was slipping.

Papa remained flinty for the three months of our stay. He'd drive us down the hill in our rented Cadillac at seventy-five miles an hour, treating Trousdale's roads like the Moyenne Corniche.

"Timothy, you're driving too fast. This isn't your Ferrari," my mother would admonish.

"Damn piece-of-shit American car. I didn't want to come to this damn place anyway!" he'd shoot back.

She'd turn and look straight ahead, not arguing the point. When we found ourselves alone and I'd ask if everything would be all right between them, she'd say, "Of course. All marriages go through difficulties. That's life." But a rash that no amount of pancake makeup could disguise erupted on her neck giving the lie to her enthusiasm and good humor.

I occupied my time with ballet classes and books, determined to develop a sound mind in a sound body. I worked to expand my vocabulary by memorizing new words, which I meticulously recorded in a large spiral notebook. During a visit to my uncle DeCoursey and aunt Iten in Cambridge the year before, I'd set my sights on Harvard, where generations of Faleses had preceded me. The ancestor after whom my father had been named, Captain Timothy Fales of Bristol, Rhode Island, had graduated in 1711.

When I told my uncle Hal my intentions of following in the family footsteps, he'd quipped, "Some of us didn't finish," referring to his own departure from the school to serve in the navy in World

War II, and my father's to enter the merchant marine as a young man. "You'll have to restore our reputation," he had joked.

In true mulattoness oblige foot-soldier fashion, I resolved to do just that. I would spend the summer sharpening my mind so that I could earn the junior-year grades necessary for admission to the college's hallowed halls. Simultaneously, though I'd inherited my mother and father's lean physique, I became obsessed with dieting and followed the high-protein Atkins plan, which required eating half a grapefruit before every meal.

"You're going to burn your stomach lining. It's unhealthy," Papa warned, concerned.

"*Oui, Papa,*" I'd obediently reply, then secretly consume the highly acidic fruit anyway. A demolished stomach lining seemed a small price to pay for a slender waistline. And hadn't my mother always decreed, "We must suffer for beauty"? I swam a hundred laps every day, determined to make my budding body "perfect." I wasn't anorexic, just desperate to control something in my environment. Somehow, I reasoned, if I kept my figure just right, everything else in life would fall into place. At night, after my exercise, in the floodlit pool I'd dream of my Prince Charming and my own great romance.

As the summer wore on, it quickly became apparent that the show had no "legs," as they say in the theater. In a vain attempt to fluff up a dated piece, the director, Michael Kidd, a veteran dancer of some of the great musical films of the fifties, had set it in a discothèque rather than a nightclub. Some of the production numbers he staged on roller skates. My mother's big number, "Zip," a tongue-in-cheek mock striptease in which the stripper makes learned references to reading Schopenhauer, left the Los Angeles audience baffled and wondering, "Who's this Schopenhauer guy and what screenplays has he written?" Hoop skirts would come back in fashion and pigs would fly before this lemon made it to

Broadway. My father did not let his wife forget that she had dragged him out to Beverly Hills against his will to do a substandard show. It wasn't her fault, but it was her problem.

Through it all our family laughed, socialized, and entertained. My mother would lend me one of her gowns and a pair of heels and she, Papa, and I would head out to a glamorous soirée, or maybe a discothèque. The town had changed considerably since my mother had done her nightclub act at the Bar of Music and gallivanted with her friend, the already popular pianist Bobby Short, at Café Gala, a chic rendezvous on Sunset Boulevard run by a baroness. Technically, the nightspot didn't admit black patrons back then, but the twenty-six-year-olds went in anyway and hobnobbed with socialites and movie stars. The chic clubs of her youth had vanished and been replaced by "in" restaurants where the dress code seemed to be, "If the dry cleaners didn't deliver your clothes on time, just come in your underwear." At the most elegant restaurants pinup girls sauntered by in spandex minidresses that barely covered their silicone torpedo breasts.

One night at Le Dôme, a beautifully decorated French bistro, Rod Stewart came in wearing striped shorts and sneakers. "I remember when people dressed in this town," my mother commented flatly.

During this trip, we spent many evenings with her old friend Sammy Davis, one of the kindest, most courtly men I've ever met, in the home he shared with his wife, Altovise. A burly, unsmiling armed guard let in guests through slow-moving electronic gates. The home had a large sofa covered in Gucci fabric with the signature *Gs*. In the sprawling mansion we encountered an eclectic assortment of people, ranging from the elegant and still beautiful Loretta Young to Linda Lovelace, the porn actress.

Other nights found me watching *Chicago* with Gwen Verdon and Chita Rivera at the large theater across the piazza from the

Ahmanson. As usual, I did my backstage-baby routine, getting to know the beautiful and young dancers—Melanie, a buxom blonde; Dingo, a gorgeous Hawaiian. Clifton Davis, then about thirty-five, seized every opportunity to whisper in my ear, "When you turn eighteen, it's I-U-D and me." Heat rose to my cheeks each time he said it. Though embarrassed, I felt titillated and strangely flattered. Other than these verbal assaults on my chastity, however, I came no closer to a romantic experience worthy of the name, my brother's example notwithstanding.

At summer's end, the show moved on to San Francisco, and the household, consisting of Papa, Enrico, me, and our Brittany spaniel, Neptune, returned to New York. My mother arrived home in late September. *Pal Joey* had not proved the high road to fame we had so hoped. It led her, however, to one guest appearance on *The Jeffersons*, which even twenty years later would cause people to excitedly stop her in the street, screaming "You're that lady!", and various meetings with television executives who found her fascinating but never phoned her agents again.

That winter, Papa took a six-month leave from the merchant marine to travel to Brazil and study Portuguese. My mother seemed unperturbed, so I too took the move in stride. Papa loved languages. He studied them with a meticulousness verging on obsession, mastering every dialect and the nuance of every word. It struck me as perfectly normal, even admirable that he would absent himself for four to six months to immerse himself fully in a new idiom. He invited only Enrico to join him in Rio for a few weeks. My mother exuberantly billed it as "father-son time." That left us to huddle at night on her bed, cuddling and watching our beloved old movies. I focused on my dance, my dieting, my schoolwork, and getting into Harvard. Josephine turned once again to her pillows, her cigarettes, and her unvanquished daydreams of a bigger, brighter future.

At Long Last, Obsession

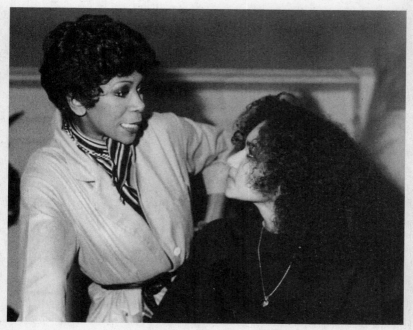

The years of adolescent angst and unfortunate hairdos. My father says I'm the spitting image of the French author Colette. Not a compliment.

"Savour à chaque festin de ta nouvelle vie ta déchéance."
[At each banquet of your new life, savor your fall.]

—Colette

I sat in the back seat of the limousine with my mother; my nineteen-year-old body, bloated by thirty pounds as a result of compulsive overeating, straining the seams of my cocktail dress with its regulation 1980s taffeta flounce. I looked for all the world like a gargantuan Jones sausage in black velvet casing and I felt—though it hardly seems possible—even worse. Ten months and many pounds earlier, I had arrived at Harvard as a freshman and frozen in my tracks, unable to focus, study, or discipline myself to follow a schedule. Intense dieting gave way to incessant gorging on Wheat Thin crackers, pints of ice cream with candy mixed in, or whatever happened to lie in the path of my seemingly insatiable appetite; diligent studying gave way to compulsive procrastination. Though I had clearly lost control and fallen into a depression, it did not occur to me to seek help. I'd never needed it before. Hadn't I always played my part as the little mulatto Atlas of the Timothy Fales clan, upholding the family honor with my grades and my unimpeachable conduct? I'd never been drunk, never taken a single drug—surely sometime before finals my former organized self would appear, deus ex machina style, and rescue me from the precipice of academic disaster. Months passed, and no such miracle occurred.

I spent endless hours alone in local pastry shops and knocked back croissants and cakes the way alcoholics down bottles of Night Train. I handed my papers in four, five days late. My expository writing teacher took off one letter grade per day. A-minuses quickly

devolved into Ds. The racial dynamics of an American college campus also threw me off course. Within my first week, many of the black students labeled me an "incognegro" and a "long-haired, light-skinned girl who thinks she's white" because I associated with white students, who, after all, comprised 80 percent of the student body. I'd never thought of myself as light-skinned. Compared to my white family members, and even certain black relatives, I wasn't. Nor had I ever felt anything but proud of my black heritage. It had never occurred to me that unless I pledged allegiance to Harvard's black community by sitting at a segregated table in the dining room every night, I would stand accused of denying my roots. I had flouted the unwritten protocol of racial loyalty and as a result found myself the subject of painful stereotyping and gossip. At first it was averred I slept only with white men, when in fact I wasn't sleeping with anybody on campus. When the gossips could not find any man who had "sampled my wares," they surmised I was a lesbian who would only date white women. "Never mind what people think. You know who you are!" my mother would insist when I phoned to share my sense of isolation. But in this strange and new environment, her words rang hollow.

On the eve of my first final exam, I discovered I was pregnant by the first and only man I had ever slept with, my long-distance boyfriend, Greg. Without telling my parents, but knowing full well they would approve, I had an abortion at a dreary women's clinic, with my best friend Nanon holding my hand through the whole operation. I knew I had made the right decision. I couldn't even manage to get my schoolwork in on time; how on earth could I raise a child? Nonetheless, I berated myself for having landed in such a cliché predicament as a result of one night's carelessness. After my catastrophic first semester, the Harvard authorities respectfully suggested I take a one-year leave of absence, after which I would have to apply for readmission.

I had never done badly in school before. I had never been a size twelve-fourteen. And in this case, I hadn't merely failed two courses—I'd failed two nations, the United States and Haiti, three continents, North America, Africa, and Europe; both my families, and all my ethnic "constituencies." When and where I entered, to paraphrase Anna Julia Cooper, the whole race had entered and fallen flat on my oversized behind with me. The day Papa drove up to bring me home, a bigoted Boston Irishman in my dorm, Eddie, had stood with another group of Massachusetts rednecks watching us load the car and laughing as if to say, "Now there'll be one less of them."

I wanted to yell out, "I didn't fail for lack of intelligence—I failed because I'm totally screwed up right now!" Naturally, I kept my outburst to myself and watched the boys mock me, knowing I'd return one day to wipe the smug grins of white superiority off their faces. In the meantime, I spent my days typing up divorce summonses in the civil division of the New York Legal Aid Society and my evenings waiting by the phone for a call from Greg, my twenty-four-year-old first beau, the man whose constant criticism and careless disregard had crushed my adolescent self-esteem like an empty soda can under a combat boot.

"After the show, we'll go to the opening-night party at Tavern on the Green. I haven't seen Michael Bennett in ages. Everybody's going to be there," my mother announced as I looked out the car window, snapping me out of my reverie.

"I can't go," I objected.

"And why not? This is a very important night. I was looking forward to spending it with you. There's never been a black musical on Broadway like this one. There's no tap dancing, no jazz, the sets are supposed to be incredible. The producers have spent a fortune, three million dollars, it's the most expensive Broadway show ever.

This is going to be as revolutionary as *A Chorus Line* was." Not having worked steadily in the three years since *Pal Joey '78*, my mother lived vicariously through the triumphs of other black performers. Whenever a new door opened, it gave her tremendous joy and hope. *Dreamgirls*, which dealt with the dark side of the recording industry, marked the culmination of a decade of black musicals written with a black audience in mind, by contrast with the light-hearted and gay entertainments of the twenties and fifties. But at that point, I didn't care about either my mother's career or Broadway history; I cared about the moments I could spend with the elusive object of my obsession.

"I'm supposed to go down to Greg's at ten," I admitted, looking away.

I could feel my mother's fury mounting like lava in an active volcano. Straining her neck, she stopped short of full eruption and seethed, "Susan, this is our evening."

"I'm seeing the show with you, then I'm going to his house," I insisted. For months, my mother had had to contain herself as she watched her daughter go from a slim, confident, academically disciplined virgin to an insecure, overweight, depressed girl-woman who had flunked out of the university she'd dreamt of attending since the age of fourteen. She had to bite her tongue to keep from saying "What's the matter with you? You'd rather spend the evening with an egomaniac who berates you, cheats on you, and uses you than with the person who loves you most in the world!" Instead she said, "You're so selfish!" I turned to look at her, stunned. In all my nineteen years, she'd never accused me of that. "If I were lying in the gutter dying, and you had something to do, you'd just step right over me!" *Where on earth did she get that scenario? An outtake from* Mildred Pierce, I thought to myself. It was nothing short of lunatic, and yet her words stung.

"That's not true!" I cried lamely.

"Yes, it is!" she yelled back.

We retreated to our respective dark corners and passed the rest of the journey down the West Side Highway in abject silence.

An hour and a half later, we sat in the front-row mezzanine of the Belasco Theater, watching the magic of *Dreamgirls*, the thinly veiled story of the Supremes, unfold. Jennifer Holliday, then a twenty-one-year-old unknown, took center stage to belt out the song no other singer has ever sung so wrenchingly, "And I'm Telling You, I'm Not Going," the character Effie's lament to her lover, a ruthlessly ambitious record producer, when he fires her from the group and tells her their affair is over. Tears streamed down my mother's face and mine. We looked over at each other in the dark and clasped hands. When the song ended, we rose to our feet with the rest of the house, weeping uncontrollably and applauding wildly. In true Drama Queen and Drama Queen Junior fashion, we fell into each other's arms and said almost in unison, "I'm sorry! I'm sorry! I'm so sorry, I love you!"

"I wouldn't leave you lying in the gutter!" I insisted.

"I know," my mother assented, "I know." We spent the rest of the evening holding hands. I canceled my plans with Greg. But it would take me three more years to break his choke hold on my eminently breakable ego and muddled emotions.

Greg was tall and chiseled to perfection. In keeping with the family catechism that "handsomeness is next to godliness," I had chosen a perfect specimen. He had a body so flawless that if Michelangelo had seen it, he would have modeled his David on him and dismissed the other fellow. Muscular caramel shoulders led over a washboard stomach to a tiny waist, all flowing together to form a perfect, utterly victorious V, which would prove the undoing of countless women the world over. The magnificent torso sat atop a pair of long, sinewy legs and a dimpled rump as high as a Roman pedestal. He was so handsome that even Grandma Fales,

whom Puritanical propriety prevented from commenting on any-
one's appearance, could not resist pronouncing him "awfully good-
looking." When I introduced him to Lena Horne in her dressing
room after a performance of *The Lady and Her Music*, she whis-
pered in my ear, "Don't let go of him." Only the "guardian divas"
closest to me failed to be seduced by my prince's charms. "I don't
like his eyes," Aunt Diahann offered when I asked her what she
thought of my Adonis.

I had met him at a photo session, my hairdresser having asked
me to model for head shots he could use in his portfolio. Though
Greg and I had never set eyes on each other before, the photogra-
pher, a middle-aged man named Lenny, literally threw us into each
other's arms in an attempt to create a more provocative portrait.
There I stood, a high-strung sixteen-year-old virgin, quivering in
the bare-chested embrace of this beautiful twenty-three-year-old
model and Ivy League college graduate in economics—a combination
of intellect and pulchritude destined to awaken my deepest urges.
Months after this initial meeting, Greg took me to dinner at a Chi-
nese restaurant in my neighborhood. I had just turned seventeen
and entered my senior year in high school. He listened to me prat-
tle on in skittish schoolgirl fashion. He made astute observations
about my behavior, noting that when I was nervous, I averted my
gaze from his and spoke staring straight ahead. He did it amusingly,
teasingly. I felt wholly vulnerable and focused on, utterly "seen." I
relished being a tiny creature under the microscope of his gaze. Lit-
tle did I know that those powers of observation would soon turn to
vivisection.

"Of course your parents' friends think you're beautiful, they're
your parents' friends. You're not classically beautiful. Your nose is
too big, your lips are too thin, and I can't see your cheekbones for
your cheeks. You do have great hair and one of the best bodies I've
ever seen . . . if you lost some serious weight. When the girls in my

agency want to lose, they have lemon juice and water for three days." Thus my lord gaveth and my lord tooketh away while casually leafing through a modeling agency "face book" or standing me in front of the bathroom mirror as he itemized my many imperfections.

I didn't question his motives or the truth of his assessments, but I reveled in the uncertainty of his opinion and eventually became addicted to winning his approval. A compliment from such a discriminating being seemed the ultimate prize, and he bestowed praise with perfectly timed erraticism. He would verbally pulverize me, then just as unexpectedly raise me up with words of praise for my intelligence or caring nature. He'd turn into a tender little boy professing deep and abiding love. His opinion soon outstripped all others in importance, including my mother's.

I didn't know it then, but life with a moody father had prepared me perfectly for my role as a dancing poodle. Greg wasn't nearly as deep a thinker or as erudite as Papa, but he was smart enough to follow the Mark Twain method: "remain silent and be thought a fool" rather than "speak and remove all doubt." Whenever I waded past the confines of his intellectual depth, he'd simply stare at me impassively. Fearing I had bored my beloved, I'd immediately retrench to topics he enjoyed: how well a certain model wore vintage clothes, how to live and travel on a shoestring budget, how to win on America's racially uneven playing field.

Like me, he came from a biracial family. I'd never focused much on the meaning of my racial identity when it came to my romantic life, because up until that point, I had had no romantic life. Having grown up in a multicultural household, picking someone from the "same background" struck me as ludicrous, if not somewhat difficult to achieve. Suddenly, though, I felt an ethnic kinship I hadn't realized I craved. A budding adult, I was beginning to experience the inescapability of race in America, whether in the

form of the "identity" question on the SAT or the insistence of a Wellesley College representative at a college fair that I check an ethnic box.

"I don't see how it's any of the school's business," I declared as I walked away. When I took the SAT, I found myself confronted for the first time in my life with having to declare in writing one identity to the absolute exclusion of all others. As I reviewed the neat, compact classifications, which acknowledged no mutual kinship, no spillover, no nocturnal visits from the big house to the slave quarters, no interbreeding of any kind, I wondered what revisionist historian or science-fiction writer had concocted this list. I thought of my mother's advice: "Check them all. You won't be lying." Instead, I checked "Other" and by way of explanation wrote in "Human." Like me, my amour refused to be placed in a neat little box, but enjoyed living as an ethnic nomad, at home "everywhere and nowhere," just like the Premice-Fales clan. In philosophy class, we had just learned about the Platonic notion that men and women had originally been created as one being; then later the gods had decided to sever this hermaphroditic creature. Throughout their lives, men and women desperately sought their "missing half." With the impaired vision of the besotted teen, I saw in Greg all the elements of my spiritual complement, my "other half."

He'd led a far less sheltered life than I. His father had a Darwinian approach to childrearing. He believed in letting his offspring fend for themselves in the world's jungle. Consequently, Greg had been responsible for most of his own finances since the age of fourteen. All I'd done all my life was homework. What were straight As to a succession of odd jobs? Suddenly I felt ashamed of my haute bourgeois life. Could I pass his father's test? Was I one of the "fit" or merely a pampered princess marked for obsolescence in a survival situation, like a war or a natural calamity? Sitting with my Superman of Adaptability, I realized that I was like Mrs. Man-

tello, my parents' Jewish-Hungarian friend who ran through the war-torn streets of Budapest in her high heels and sable coat to retrieve the Limoges china she had left behind. I was that pathetically pampered woman, "the Limoges chaser," so impractical she clung to her *objets* while bombs exploded all around her. But this man, this older, wiser, latter-day Heathcliff might redeem me yet. Under his tutelage, I could become a "real woman," capable of surviving anything from poverty to a nuclear holocaust.

He was so mature, so manly, I felt afraid of nothing in his presence. An experienced man, he lacked the sexual desperation of boys my age. He didn't go in for puerile brassiere snapping, or awkward, avid fumbling over my breasts and thighs. He gave no slobbering kisses that made me feel I had entered the rinse cycle of a washing machine. He did not lunge at me, but instead let me set the sexual pace. With infinite patience, he waited for me to unfold myself to him. He did not laugh at my sexual inexperience, even when I interpreted the vernacular expression for fellatio literally and proceeded to puff away on his "manhood" as though playing reveille on a bugle.

My hero arrived on the set of my life with perfect timing. Papa was leaving for several months to captain a ship, as it had been his custom to do in the four years since he'd returned to the merchant marine. After the "season of tension" caused by my mother's stint in Los Angeles, his relationship with her seemed to have returned to "normal." As I hugged him the night he left to board his vessel bound for Southeast Asia, I knew it was the last hug I would ever give him as an innocent, untried girl. I knew the next time I saw him, it would be with the eyes of "experience." I did not relay any of these thoughts to him, of course. That would have broken the rules of our bantering relationship, a relationship in which we were voluble on matters of intellect, but emotion was communicated only through hugs of great intensity and the occasional laconic note

accompanying a cherished gift and signed, "Your father who loves you." We had one of those intense hugs, in which all the unexpressed passion of the years is contained. I felt a pang of sadness at the thought that a chapter of my life would soon close. Kate Bush even composed a song to fan the flames of my youthful infatuation and underscore the *Wuthering Heights* melodrama of it all. I'd sit on my narrow turn-of-the-century pewter frame bed and listen for hours as she caterwauled, "Heathcliff, it's me, I'm Cathy. I've come home and I'm sooooo cold, let me in your windo-ho-o-o." It was utterly Bette Davis, deliciously dramatic. I was no longer a child, observing "love" like a spectator in a darkened movie house. I had become the heroine of an epic romance. At last, my film had begun.

My mother did not care for my casting choice for this "first love." Actually, that is a monumental understatement. She positively loathed my costar in the bad B-movie that became "Susan's First Romance." There were times in which Greg's cruel, hypercritical treatment of me drove her into paroxysms of rage verging on the homicidal. I just never witnessed any of these Vesuvian eruptions. I heard about them years later from my mother's ultimate diva confessor, Diahann.

"Mommy didn't hate Greg," I naïvely told Aunt Diahann once.

She laughed a hearty laugh. "Oh no. She just wanted to kiii-illl him," she corrected me. "Fortunately, your mother's never learned to shoot a gun."

"But she was always very calm about him around me," I pointed out.

"Yes, then she'd call me," Aunt Diahann added wryly. "And let loose what she *really* felt. It wasn't pretty, darling."

Indeed, in my presence, my mother had always maintained a cool, collected, perfectly rational façade. The mask of command never slipped. She didn't criticize, she didn't comment, she didn't

exhibit in any way her rage and utter horror. Instead, she quietly plotted to eighty-six Greg from my life once and for all.

As a tactician, my mother fully understood the value of losing battles and winning the war. She'd had many loves before my father. She knew firsthand the magnetic hold a perfectly chiseled chin and words of love whispered in one's ear, in the dark, could have on a young girl's imagination, heart, and newly awakened libido. She had no objections to my having a romance, just to my having one with this Narcissus more concerned with how he appeared to the outside world than with my welfare. When I returned from Harvard with huge hips and a behind that merited its own zip code, he refused to be seen in public with me. He would meet me at clubs or parties rather than arrive with me, then spend the evening at a safe distance, flirting with other women. Even before my freshman debacle, my mother hated the way he constantly chipped away at me, criticizing my sheltered perspective on life, my "spoiled rich friends," my fashion sense, my "imperfect" facial features. But she knew that, like communism, this relationship, this all-consuming first love had to be dismantled from the inside. The key was to plant the seeds of revolutionary thought in my fevered teenage brain. Josephine waited patiently for her opening, the breach in the fortress.

It came one day several months after the romance had begun. My high school had selected me and two other young women from the senior class to represent them in the prestigious *Concours Général,* the French national academic competition for top students in various disciplines. I was to sit exams for philosophy and literature. I had told Greg I couldn't see him for a week because I needed to study. On the Sunday at the end of my week of cramming, he and his father and mother planned to join us at my parents' house for brunch. My mother went into a state of shock when his father arrived on roller skates and demonstrated a figure 8 on her newly polished parquet floor. I watched her look at him as if to

say, "I'm going to serve my finest food to this overgrown child in yellow cotton knickers and red-and-white-striped knee socks last seen on the pages of *How the Grinch Stole Christmas*."

"What's that circle on your neck?" she asked aloud after offering him a rum punch.

"It's my tattoo," he answered. "It says, 'cut here.'" He laughed.

My mother did not. Even Papa, who had a more tolerant approach to eccentrics, looked less than pleased. He clearly did not relish the prospect of being related to this strange albeit very accomplished man, and his even stranger ex-wife, a fifty-year-old latter-day hippie with long blond Heidi braids and a perpetual grin. Papa had an expression for such women—he termed them "depressingly well intentioned and sincere." Greg himself arrived last, escorted by a beautiful Anglo-African model with an improbable French name. The model's presence flustered me a bit, especially given the fact that with her chiseled doll-like features and thirty-two-inch hips, she far more closely conformed to Greg's Sacred Canons of Beauty than I. But after the initial jolt of insecurity, I reminded myself that he had assured me on many prior occasions when we contemplated her picture in a modeling catalogue that though she was flawlessly pretty, he found her somewhat lacking in sensuality. I on the other hand, though I fell far short of the classical ideals celebrated in the Ford, Elite, and Click modeling agency books, did at least possess "heat." Besides, as a male model, Greg maintained "friendships" with many magnificently beautiful women. Par for the course, I told myself. I greeted both the model and Greg with great warmth. But each time I tried to speak with Greg alone, he stood at an aloof distance and answered my questions in monosyllables. I grew more and more rattled as the afternoon wore on, particularly since Greg laughed and conversed animatedly with everyone else.

My mother watched the proceedings in silence, moving back and forth between the kitchen, living room, and dining room.

When Greg huddled in a corner with the model, my mother's right eyebrow rose and her back pulled up as a current of outrage shot through her body. She cleared her throat, let out a vocalizing "Laaa!" and swept out of the room, no doubt to prevent the army of Furies raging within her from leaping out and throttling my beloved. Somehow she made it through the three-ring circus of a brunch without dropping her attitude of graciousness. Her only comment after the family departed: "Strange people." Ever the mistress of her emotions, she maintained a perfect silence on Greg's behavior.

That night, she found me sobbing in my room. She asked to know what was the matter. I told her I'd phoned Greg to ask why he'd been so distant and he'd told me that our relationship was cosmetic and refused to explain further.

"You mustn't think about this, you have an exam tomorrow," she said.

"But I love him, I want to marry him," I cried, echoing the mantra of every teenage girl lobotomized by first love.

Once again, my mother's back went ramrod-straight. She tossed her head as if to chuck the awful notion of my marrying this man into the nearest wastepaper basket. Then she said in ever so calm and measured a tone, "I don't think that would be the best idea." I'll never know how she managed such a cool, collected pronouncement when really she was thinking, *Have you lost your mind? I have not sacrificed my life and career to see you end up with that megalomaniacal asshole! I will kill him before I let you piss your life up a rope, young lady!* No, she didn't say any of that, she just "pulled up," as per usual, and took a puff from her ubiquitous Pall Mall Gold. This was the first time I'd heard her voice any objections to Greg.

Perplexed, I asked, "Why not?" It never occurred to me that anyone could have any objection whatsoever to so all-knowing and flawless a being as my inamorato. With my crooked, oversized

nose, my overly thin lips (as he described them), and my utter lack
of experience in the world, I felt I was most fortunate to be allowed
to breathe the same air as my brilliant Adonis.

My mother paused a moment then coolly replied, "It would
not be good because . . . that young man is totally . . . about himself."

"What do you mean?" I asked, baffled. How else, but under
his tutelage was I to evolve from pampered "Bourgie princess-
dom" to true womanhood and ultimate hipness?

At this point, it was a miracle my mother did not scream and
shake me till her Miriam Haskell pearls came unstrung. God and
her cigarette comforted her. In a dead-calm monotone she
declared, "You have an important exam tomorrow and he arrives
here with another girl and treats you coldly. Even if she's just a
friend, that is *not* nice." I knew she was unwilling to explain herself
further. Facts, my dear, just the facts. Having spoken her piece, she
made her way to the kitchen, leaving me to ponder her summation.

In my obsessed state, I disagreed with her assessment of my
Beloved as self-centered. But the clarity of the example, and the
utter lack of editorializing, defied any attempts at rationalization.
There the fact stood bald, brief, irrefutable. The truth of her words
began to gnaw at me. If Greg meant well, I knew my mother
meant even better. I hated to admit it to myself, but her every
action in my regard was motivated by love, fierce, passionate, over-
protective love. I also knew the depth of her wisdom. It had been
earned at a high cost. "Don't ever try anything," she used to say to
my brother, "because every trick you'll ever try, I've tried myself—
twice." No naïve, angel-virgin of the hearth she.

Traveling the world in her twenties, singing in nightclubs,
she'd experienced every type of advance in a Casanova's repertoire,
and also known her fair share of rejections. She'd met the great
Porfirio Rubirosa—he of the famously large genitalia and the mar-
riage to Barbara Hutton—and found him charming. She'd been

ignored by men for whom she pined. As a seventeen-year-old, she'd dropped her bongos in front of Harry Belafonte at a concert in which they were both performing, but he'd never expressed an interest beyond friendship, preferring her friend Julie Robinson, the lone white dancer in Katherine Dunham's company. She'd ordered hamburgers ad nauseam from the little fast-food stand Harry and his friend Sidney Poitier, a recent arrival from the West Indies, had set up in the village. To no avail; Sidney took an interest ultimately in Diahann. Once a famous Hollywood director invited my mother to a luncheon at his house in Beverly Hills. When she arrived, she found the *soi-disant* luncheon was a tête-à-tête, and she was the meal. "Where are the other guests," she asked the middle-aged German as he mixed her a drink. "There aren't any," he answered. Whereupon twenty-seven-year-old Josephine walked out the man's front door and down the long hill to the flats to find a taxi. Incidents like these earned her the title "Miss Tough Drawers." It was a pickiness she and Aunt Diahann had in common. They were far from virginal, but that didn't mean they were available to anyone who asked; on the contrary.

My mother set no great store by chastity. In fact she often told me that if I were heading down the aisle a virgin, she would personally stand up in the middle of the church to object. Papa often seconded her emotion. It was important not only to know the between-the-sheets talents of my intended, but also to have had a series of romances before choosing the person of my life. My mother made no secret of the fact she had enjoyed many relationships before Papa. She didn't spill it out all at once. Information would emerge in dribs and drabs. There had been the married Frenchman Eddie Barclay, who told her she had the most beautiful face he'd ever seen. Then there was Richard Burton, who told her she had the most ridiculous face he'd ever seen.

I learned about Burton, whom I knew as "Uncle Richard," by

accident as an adult. I was lunching in a restaurant in Studio City in the early nineties when I was introduced to the comedic actor Tom Poston as Josephine Premice's daughter. "Oh, yeah, I knew your mother when she was dating Burton."

Dating Burton? I raced back to the office and called my mother. "I didn't know you had dated Uncle Richard," I screeched.

"Darling, you don't know everything about me," my mother responded sphinxlike. Once the secret was out, she shared little anecdotes. She and Richard Burton had remained lifelong friends. But the great love of her life, other than my father, was Lionel, a young Haitian political journalist she met in her father's house. She fell in love with him at fifteen. He would have nothing to do with her till she came of age. She did not confess this fact to me right away. I had once asked her when I was sixteen how old she'd been when she had her first sexual experience.

"Oh, I was very old when I lost my virginity," she declared holding her cigarette and squinting her eyes as she strained to remember.

"How old?" I pressed.

She frowned, took a puff, and then said, "Twenty-one."

A year later I asked the same question.

Without skipping a beat she replied, "Eighteen."

"Eighteen?" I repeated, then confronted her with her fib.

She giggled and broke into her little-girl grin. I asked her why she'd lied to me. She shrugged, still grinning, then turned more somber as she began to recount the affair. How mad for Lionel she had been. She didn't say it, but she implied that he left her. Years later, she was a married woman living in Rome with her husband and infant son. Her father phoned her from the States and asked, "Are you alone?"

"Yes," she replied.

Her father proceeded to tell her that the news he was about

to deliver was something from which she would need to recover before her husband returned home. Lionel had been killed in Algeria, covering the war against the French. My mother's eyes went dark as she described her knees buckling, the brief afternoon of mourning before she had to pull herself together to greet Papa.

"You never love again like you did the first time. There's never another love like your first love," she declared. I rebelled against this depressing thought, though I didn't even fully grasp her meaning.

At every step of my romance with Greg, her words dogged me. "There's never another love like your first love." As my first romance deteriorated into an exercise in misery, I began to understand her pronouncement. I could never recapture the sense of complete trust in another human being, the ecstatically blind leap of faith and willingness to "plight my troth" with no thought of the future, nor fear of the consequences.

Finally, over the course of my college career, my romance with Greg petered out, largely as a result of physical separation, leaving a legacy of insecurities behind. For years, when I looked in the mirror, I still saw myself through Greg's eyes. No longer the beloved child in my mother's arms, I saw a girl with insufficiently plump lips and cheeks in dire need of thinning. I saw a spoiled "black princess" who functioned well at cocktail parties but wouldn't last five minutes on the "mean streets" of an inner city. I saw the girl who sang out a cappella in the middle of an Erie Lackawanna train car headed to Faleton, desperately trying to hit the "right notes" of an Aretha Franklin tune Greg had asked me to sing.

"Louder! Come on, louder! Put some heart into it!" Greg commanded as I struggled to belt out "You Make Me Feel Like a Natural Woman" and he stepped further and further away from me. Finally he gave up and, plopping down beside me, concluded, "You just don't have any soul. My mother's right, you're a white girl in brown face."

Though completely demoralized, I did wonder what qualified

his mother, AARP Heidi, to render verdicts on "true blackness." But only time, maturity, several tours of duty on a shrink's couch, and the self-assurance that came with career and life accomplishments finally drove Greg's voice out of my head.

Many years after the affair sputtered to its close, I was in New York on sabbatical from my work as an executive producer and head writer of situation comedies. Greg also happened to be in town and asked to take me to dinner. He came to my mother's to pick me up. I wore a body-skimming Hervé Leger cocktail dress, more as a symbol of a victory over myself than an attempt to make him eat his heart out; though if the latter proved an ancillary effect, I had no objection. We sat, having drinks in the living room. He reminisced about the many dinners he'd enjoyed at our home, the people he'd met, the food my mother had prepared. He showed great respect, even deference, to both my mother and me. I tried to remember what it was about him I had found so appealing. He wasn't evil, just miscast. I had created a fantasy lover and projected his image onto him, like a hologram. I couldn't blame him for not living up to my romantic ideal, nor could I blame him for the time I'd wasted clinging to a misguided dream.

My mother sat on her enormous sofa, smiling, a mother feline in a Scalamandre flowered tapestry jungle, taking it all in. "More wine, Greg," she offered ever so graciously, a triumphant Mrs. Danvers smirk on her face.

I returned after dinner and sat on her bed. "That was lovely," she said. "And the best part was watching him look at you, marvel at you, and you didn't even care." She reveled in my indifference. There was no loathing on my part, no desperate bid for validation, just amused distance. Josephine had lost many battles to the enemy, but in the end, she had won the war. She knew I would never again allow a man, any man, to stand me in front of a mirror and tell me what to see.

And They Said
It Wouldn't Last

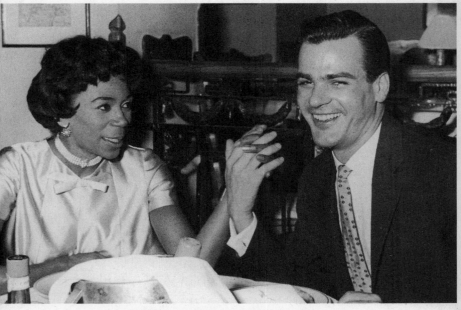

*My parents in a Rome restaurant in 1959,
just before my mother gave birth to Enrico.*

"No one's going to give me wrinkles."

—Josephine Premice

In the leafy courtyard of Adams House, the graduates' parents basked in the early June sunshine and the glory of having Harvard diplomas bestowed upon their offspring. Presidents Derek Bok and Matina Horner had already inducted us into the Society of Educated Men and Women at the university-wide commencement ceremony. Now we waited to receive our diplomas from our house master, Professor Robert Kiley. I sat up on the little promontory in front of Master Kiley's residence in my black cap and gown, which I wore over a champagne-colored silk Givenchy dress, purchased during one of many big-game bargain-hunting expeditions with my mother, and looked out at the families. My parents stood solemnly at the back with my father's eldest brother, bespectacled Uncle DeCoursey, who had made the trek from his home on Hilliard Street to watch the proceedings.

My parents looked strangely subdued for such a festive occasion; after all, this marked an end to massive tuition payments, among other causes for champagne-popping. After beginning my college career in ignominious failure, I had gained readmission and gradually, over the course of three and half years, become a solid, disciplined student once again. My fall from academic grace and the attendant shame had put the fear of God and Failure in me. Never again did I want to sink so low and drag the "whole race," not to mention our family honor, down with me. The representative of the District of Mulatto was back on duty. I was graduating with honors, having shed not only my excess college poundage, but also Greg, my

inamorato nefarioso. My parents should have been jubilant. Instead I saw my father looking as stone-faced as a hired pallbearer at a stranger's funeral, and my ever beautiful and ebullient mother looking tired, drawn, even haggard. The light seemed to have been extinguished from her incandescent eyes. My brother had opted to remain in New York. His absence did not really surprise me, since neo-medieval pomp and circumstance had never appealed to him. Nor did he wish to applaud yet another of his baby sister's—the family-appointed mascot and goody-two-shoes—accomplishments. Still, I wondered about my parents' somber demeanor.

Usually at such events, they instantly became naughty coconspirators, giggling and carrying on with one another. Papa would whisper witty barbs about the pompous speakers into my mother's ear, cutting the bloviators down to Lilliputian size. She'd fight to stifle her booming laugh. Solemn ceremonies awakened their innate irreverence and sense of the ridiculous.

Papa, the instigator, had always been better at keeping a poker face than his wife. He would make his sardonic commentary, leaving my mother struggling to contain herself, then affect an air of intense concentration on the proceedings at hand. Those of us who knew him could see the mockery and mischief in his eyes, and that only redoubled our laughter. My father had used this tactic countless times with the austere spinsters and would-be Napoleons who constituted the faculty at the Lycée Français, addressing them in florid, obsequious terms as Chère Madame, or Cher Monsieur, hanging on their every turgid word as though listening to the Sermon on the Mount. One eyebrow raised in mock seriousness, he would nod at appropriate intervals and even bow in agreement, uttering an earnest "You couldn't be more right." Once we were alone at home, he would offer a wicked impersonation of the bombastic speaker.

"And you sat there listening to that boring man like he was

really saying something," my mother would reproach, laughing. "I had to keep a straight face."

I felt certain my graduation would occasion the same sort of family memory, which we would revisit and replay in conversation the way others gather to turn the pages of a cherished family album. My parents did not believe in commemorating "grand" occasions and milestones by noisily snapping away on an Instamatic. Moments like these were our family pictures, the shared recollections that formed our family lore. I knew my father's wit would be at its height at Harvard, bastion of WASP supremacy. But only on Class Day had he launched the verbal darts which I adored. No "family album" seemed to be emerging from Susan's college graduation.

On this day, Commencement 1985, my parents exchanged not a glance, a giggle, or a whisper. For the first time in my life, I watched my father stand parallel to my mother, but not beside her. Their uncharacteristic sobriety perturbed me, but I did not dwell on it. It certainly never occurred to me that there had been another fissure in the Rock of Gibraltar that was—in my naïve mind—my parents' marriage. They had weathered the "temblor" of Los Angeles and the taxes my mother's work there occasioned. Why, just a year before, she had been a presenter at an awards ceremony in the Imperial, the very Broadway theater in which she'd performed the musical *Jamaica*. She had proudly proclaimed, "My husband first saw me twenty-six years ago, on this stage. They said we wouldn't make it, that it wouldn't last, but here we are. Still together, still in love." She had taken such joy in making that public statement, and sharing it with me later on the phone. The thought of their having real marital problems didn't even cross my mind. They must be tired, and sad to see me grow up, I mused.

This image of them at Adams House came back to me five months later as I sat in our family living room on West End Avenue one

November afternoon, waiting for my mother to explain to me why she didn't want me to go visit my father in Paris. After graduation, I had spent the summer in Los Angeles, working as a writer's apprentice on *The Cosby Show*, the groundbreaking, though oft-criticized situation comedy about a well-to-do, well-adjusted, standard English–speaking black family. Papa had left several months before to do some work in Paris. In early September, having finished "preproduction," I returned to New York, where *The Cosby Show* was shot, with the rest of the writing staff.

I spoke to Papa regularly on the phone, and during our last conversation, he had invited me to come to Paris, to be introduced to his "new life." The idea of a trip to the City of Light enchanted me. I shared the proposal with my mother.

"I will not send you there!" she exploded. I was baffled. Since when did my taking a trip to the Continent strike my Europhilic mother as a bad idea? "There's something you must know," she began in a tone that indicated this information would best be received sitting down. I took a seat and looked up at her as she paced. "Your father wants you to understand his new life," she repeated, scorn and thinly veiled rage in her voice, doing her best to keep all her emotions from erupting. "His new life, as he calls it, is a twenty-one-year-old girl from Senegal that he met at the Café Flore on the Boulevard St.-Germain!"

I sat dumbfounded, shell-shocked. As the minutes passed, my mind began to gather and process the shards of information that had exploded within it and rebuild them into a coherent whole. I had just graduated from college, and my father was with a girl one year younger than I. He was fifty-eight. He had met this . . . "person" . . . at the Café Flore. He had left us, his beloved Phi-Phi, Enrico, me, and his treasured second hunting dog, Sabiq, successor to Neptune, for some *twenty-one-year-old stranger* he'd picked up in a café. She was only *twenty-one*. I was twenty-two.

My mother had torn the veil off my fantasy of my parents' twenty-seven-year union, the great interracial hope. She might as well have told me God was dead. I continued to listen, almost dazed as she spat out errant facts. Born in Senegal, the girl had lived in Paris since the age of nine, in an immigrant enclave aptly named "Trappe." My mother insinuated in her rage that this girl, Iris, was one step removed from a prostitute. She had a large family who eagerly welcomed Papa, the "wealthy" white American, into their midst. "They sat him in the right chair!" my mother bitterly scoffed.

I suddenly envisioned my father in a squalid living room, surrounded by a whole family of Senegalese Uriah Heeps sidling up to him with their sly smiles, plying him with their delicacies. "Fish soup, Monsieur?" My intelligent, nay brilliant, father so easily seduced.

"When did this happen? When did he tell you?" I asked, as if dates and times would help me get my bearings.

"This happened just before your graduation. We decided not to tell you. We didn't want to ruin your day. Enrico helped us make the decision." My brother, the family secret-keeper and sacrificial lamb, had been at the eye of our parents' storm. Stoic, brave Enrico. He had advised my parents not to ruin my graduation, or my first months in the professional world. His absence from the graduation now made perfect sense. He had not had the stomach to take part in the charade. He would leave the acting to the experts, our parents. This time he refused to destroy my "pretty picture." In my sadness and bewilderment, I felt immensely grateful to my brother, and very guilty that I had been spared where he had suffered. My job had taken me away to Los Angeles for the first three months of the summer. There I had toiled, trying to earn the respect of the all-male *Cosby* writing team, blissfully ignorant of the family drama unfolding back home. Even during a four-day visit in the land of sunshine and oranges my mother had said nothing.

Once she'd revealed the truth, though, my mother could not hold back. "Your father told me that through Iris's eyes, he had seen himself clearly for the first time," she sputtered. Again my brain tried to process this assault of information. My father had lost his mind. He had become a middle-aged cliché; missing were only the leather jacket and the motorcycle.

The night before I left for the West Coast, he had sat on my parents' bed weeping, telling me my mother was a queen. I now understood why she had listened nonplussed, as if to say, "Yeah, yeah, *yum yum caca chatte* [an expression that means cat dung in Creole]. Enough already!" My rage against my father on behalf of my mother began its meteoric climb.

My mother didn't tell a soul for the first two months after her husband left. She had seen Aunt Diahann on the very afternoon she had accompanied Papa to the airport. "I put your father on a plane to Paris. I said good-bye." She had wanted to do this, to carry twenty-seven years of love to its conclusion. Then she had gone to Aunt Diahann's on Riverside Drive to drink champagne, never breathing a word of what had happened, never revealing to her best friend that her marriage had just ended with a walk to an Air France gate at Kennedy Airport. She finally told Aunt Diahann during her visit to Los Angeles. As she revealed the truth to me, I kept thinking it was a cruel joke. I was certain at any moment she would take it all back and our life would return to normal. But she didn't.

I did not have my mother's sangfroid, her restraint and aplomb. My father was in Paris with an exotic Lolita. The relationship I considered the bedrock of my existence and identity, my parents' marriage, was over. I burst into uncontrollable sobs. My mother did not reach out to hug me as I cried. Perhaps she feared my tears would snap her tenuous hold on her own emotions. And she refused to break, even now. She couldn't even really look at me,

as I sat hugging myself, tears gushing down my cheeks. She resorted to humor. "When he first told me about this girl, we were sitting in bed, and I hit him so hard, I knocked him right out of it." She laughed with a strange sort of pride. The image was indeed ridiculous: my six-foot-two, two-hundred-pound father knocked off a bed by a tiny one-hundred-and-ten-pound woman with arms the size of pipe cleaners. I smiled through my sobs at the power of female rage. "One night," she continued, "I looked over at him as he was sleeping and thought to myself, I could go into the kitchen right now, get that long bread knife, and kill him. I had to sit out here in the living room all night, right on that blue sofa, and talk myself out of it. Now, Josephine, if you stab Timothy, you'll go to jail, and then you won't be around for your children. You'll ruin your own life. By morning, I was over the idea. But it did take all night."

I completely understood my mother's murderous urge. I knew, even at twenty-two, that had I been in her shoes, I would have felt the same. My sympathy for my father vanished completely. In my partisan, highly dramatic imagination he had metamorphosed from "Papa" to the utterly selfish, supernaturally cruel, pathetically misguided villain of this piece. And I sat down to write a letter telling him as much. With all the superiority and judgment of the morally untried, I told him over the course of four pages that in my opinion, he had made this ridiculous and destructive choice because he had never found his true calling in life. I signed with a Victorian flourish, "your daughter, Susan Marya Fales," like a melodramatic heroine out of the nineteenth-century novels I adored.

Over the next few months, my mother did her best not to poison Enrico and me with her rage. She refused to divulge all that Papa had said to her, and always reminded us that whatever was happening between them, he was still our father. Unlike me,

Enrico needed no such encouragement to fairness. He never crit-
icized Papa, yet kept a close eye on our mother in his new capacity
as man of the house. Though he'd moved out several years before,
he visited and dined with us often. My mother managed to main-
tain her humor and a defiantly positive attitude, constantly declar-
ing, "No one's going to give me wrinkles!" She never cried in front
of us, not even once. Nonetheless, I knew that beneath the brava-
do and the loudly professed indignation, she was in great pain. For
six months, she left Papa's study completely untouched. And if,
God forbid, Enrico and I should enter it to borrow a book and
leave the door open, she would grow hysterical. "Who left this
door open?" she'd yell, as though a crime had been committed. "I
want it shut!"

On only one occasion did she offer me a glimpse of the depths
of her anguish. The dog, who since Enrico and I were both of age
had become the "custody child," chewed one of her many evening
shoes to smithereens. "Damn dog! I'm sending him off to a kennel,"
my mother vowed.

"You can't do that," I pleaded. "He'll die of a broken heart."

"How many times have I died?" my mother yelled, then
catching herself, walked briskly out of the room. Her admission
stunned me, and there I stood, powerless to help her. All that win-
ter, late at night, as I lay in my bed, I'd hear her footsteps padding
across the living room, and then the tinkle of the glasses on the bar,
the clink of a liquor bottle against crystal. Strong as she was, she
couldn't endure this agony without anesthesia.

In spite of my mother's restraint, I was hardening into an indig-
nant junior man-hater, an avenging Diana. I felt women got the
short end of the stick, and the more exceptional they were, the
more the male of the species felt the need to punish them and keep
them down. The sexism I encountered at work exacerbated this

paranoia. At Harvard, I had scoffed at the feminists with their "take back the night" marches as whining victimhood mongers with horrendous taste in footwear. I felt as my mother did—"I was born liberated." I didn't need a pack of irate and screaming females to fight for my rights, thank you very much. I never encountered a professor who dismissed my opinion because I was an "ovary-bearing mammal."

This all changed when I arrived, eager and bright-eyed, at the Viacom offices in Los Angeles, where the *Cosby* writers worked during the summer months preparing the scripts for the upcoming fall season, to report for duty as their first apprentice. Suddenly, I understood what the feminists were screaming about. The writing staff was entirely male. My colleagues assumed my "nice legs" precluded me from having a functioning brain or a sense of humor. For the first six weeks, they ignored me completely, never allowing me into their exclusive preserve, the writers' room. I couldn't entirely blame them. They hadn't chosen me for the job. Bill Cosby, and the producers, Tom Werner and Marcy Carsey, had thrust me upon them. Cosby had met my parents at a dinner party during my senior year at Harvard, and my mother had mentioned that my father and I wrote spoofs of French classical tragedies . . . for fun. This "intellectualism," combined with my Ivy League education, intrigued him. He asked to interview me. Rather than arrive empty-handed with nothing more than compliments from friends of my parents to recommend me, I wrote a script parodying "Lifestyles of the Rich and Famous," titled "Lifestyles of the Poor and Miserable," and sent it to him along with a cassette recording of the piece, in which I played all the characters myself. Mr. Cosby loved it, and decided on the strength of this submission that I should inaugurate the apprenticeship program. The writers were seriously displeased. Their jobs were hard enough without having to train some neophyte who for all they knew was little more than a perky, skirt-clad spy for their bosses. Nonetheless,

I showed up early every day smiling and resolved to do whatever they asked—short of purchase drugs or perform sexual favors (mercifully, they requested neither).

One of the writers, Matt Williams, who went on to create *Roseanne*, took pity on me and began assigning me scenes. One bright day, another of the producers, Carmen Finestra, a whip-smart former actor who'd been dubbed the resident jokemeister, because of his facility with one-liners, asked me to do some research on car insurance laws in New York for an episode they were writing about Denise (Lisa Bonet) buying a car. It was as though they had asked me to find the Ark of the Covenant. Within a day, I handed in five typewritten pages with every nuance on New York car insurance law. Impressed, they finally allowed me into their midst to act as the official scribe. They instructed me to jot down their various pitches as they rewrote the scripts together. As they called out suggestions for lines—"And Cliff says, 'Well, Claire, for me, getting ready for an evening out takes five minutes, with you, it's urban renewal.'"—I scribbled furiously, careful to separate the wheat from the chaff, the "house numbers" and "spit-balling" from the definitive words. The work was secretarial, and they thought nothing of making offhanded comments about professional women, how dreadful, unfeminine, and tough they found them. Nonetheless, they had extended me a rare privilege, in that in the writer's room I could listen and learn. I chose to ignore their unflattering comments. It was more important to succeed in the job, and prove them wrong in the doing, than to deliver impromptu lectures on female equality and end up free and equal on the unemployment line.

Over time, my strategy worked. They began to realize I was serious, not a dilettante dabbling at a job while waiting to find a suitable husband. They respected the fact that I never repeated anything they said about the cast or the director while blowing off

steam after a bad rehearsal and that I never took the bait when other show staffers tried to egg me into criticizing them. I also learned to leave my ego and my "highfalutin'" Ivy League cultural baggage at the door. In the early weeks, I'd made the deadly mistake of referring to Marcel Proust and tacking my summer reading list up on my billboard. I may as well have pinned a "kick me" sign on my back, for they seized every opportunity to mock my intellectual pretension. "How's *War and Peace* coming along? That Tolstoy's quite the funster." Eventually, though, they stopped greeting my every pitch with barbs like, "Maybe that's funny at Harvard" and "That joke's so obscure, you'll have to sell it door-to-door with an instruction booklet to go with it." The head writer in particular stopped leading the attacks, becoming a mentor, and ultimately, like Matt Williams and Carmen Finestra, a valued friend.

My work rapidly became my lifeline, a source of immense stability just as the world as I knew it had fallen to pieces. Bill Cosby reached out to help. During a taping, I had dissolved into tears at the sight of Cliff reading a Shakespeare sonnet to Clair. I cried because I knew I would never see my father read a love poem to my mother. Then again, I admitted to myself, the poems he had recited to her tended to be naughty limericks rather than romantic sonnets, but whenever I saw them laugh together I knew how much they adored each other. Growing up, I had perceived my parents as an "ideal" couple. Yes, they argued and drank a good deal more than the pristine Huxtables. Yes, my father had a wandering eye and what I believed to be discreet foreign dalliances and he didn't always treat my mother with kindness. But that was my "normal." My image of love was one of a tempest, of two people who yelled, screamed, smashed plates, and slammed doors, but then could be found giggling in each other's arms, sharing a private joke. Having seen me dissolve into tears on the soundstage, Mr. Cosby summoned me to his dressing room.

"What's the matter with you?" he asked as he took a puff from his ubiquitous cigar.

With eyes and cheeks red and puffy from crying, I haltingly explained. "It's my parents. It's very hard."

He handed me a tissue, and poured one-hundred-year-old Armagnac into a paper cup. "Drink this."

When I told him that I didn't drink, he assured me I could make an exception. I took a sip; the fumes alone startled me into sitting upright. One sip of the potent topaz-colored liquid nearly burned my throat. I swallowed hard.

"Now, you've got to stop this," Mr. Cosby continued. "I understand that it's painful, but it's not your life. It's your parents'. You've got to pull yourself together. You're gaining weight, you've worn those black stretch pants every day for the last two weeks."

My back went up. His words may have seemed harsh, but he knew precisely what he was doing. He had picked exactly the right image to spur a diva's daughter to action. Being depressed was one thing, but slouching toward frumpdom was unacceptable! He reminded me of what I already knew. I could not let events in my parents' life drag me down. I was an adult, or at least as old as one. I had to forget my parents' life and get on with my own. Mr. Cosby saw to it I was too busy to fall into the slough of despond by appointing me co-warm-up person. Every week, in addition to my usual duties in the writers' room, I had to stand in front of an unwelcoming audience of four hundred and entertain them between takes. Almost invariably, they greeted my entrance with groans of disappointment. Thankfully, the studio forbade food in the bleachers so the audience could not pelt me with rotten fruit. Instead they lobbed hostile questions at me. "When are we going to meet the stars? How long is this going to take?" they'd ask testily. They didn't understand why a half-hour show took two hours to film. I'd engage them by explaining the process, and their vital role

in it: laughing no matter how many times they watched a take. We rehearsed the different kinds of laugh—the titter, the chuckle, and the full-out guffaw—as if practicing musical scales. I'd banter with them as though meeting them at a cocktail party: "Where are you from?" I'd ask. Like narcissistic dinner companions, audiences invariably brightened up when asked about their personal histories. I learned to play to a crowd that initially had no desire to see me, a skill that would serve me well in Hollywood and in life.

During that first year, Mr. Cosby cast my mother in a cameo role as a jazz singer. She hadn't performed since the separation and arrived at the set excited but quite nervous. The jazz combo of distinguished musicians including famed trumpeter Dizzy Gillespie played "Bye Bye Blues" in a key that didn't suit my mother. She struggled along, chasing the melody rather than dominating it, not daring, to my surprise, to ask them to change keys. She lacked the boldness and looseness, the command I'd always seen in her stage performances.

"You'll never make it as a *chanteuse*, that's for sure," the director had chided her with uncharacteristic cruelty after the second taping.

"A *chanteuse* is exactly what I was for many years, in Paris and around the world," my mother corrected him. Still, she knew she hadn't done her best.

I wanted to smack the director. More important, I wanted to stand in the middle of the sound stage and tell the audience, "My mother can do much better than this. She's incredible, you just don't know." I refrained from that deranged impulse, but resolved to one day create roles in which my mother could shine.

Spring brought much-needed renewal. I met a wonderful, loving man, a ballet dancer who showered me with tenderness, affection,

and encouragement in all I did. From the moment I saw Hugues—a magnificent Frenchman of Indian, German, and African descent—leap across the stage to the strains of Gershwin's "Rhapsody in Blue," man-hating became a distant memory, supplanted by heady, life-affirming lust and love. After dating for four months, we moved in together. I left my childhood home for a charming one-bedroom in Brooklyn on the garden floor, that is to say, the near basement of a nineteenth-century brownstone. I later learned that my mother did not want me to go, both because she thought moving in with someone a big step and for fear of losing me. With her usual considerate reserve, she never voiced any objections. Instead, when the big day came, she helped us load the van, offering us china and other treasures from her home. As we pulled away, she fought back tears, waving at us, not moving until we disappeared from view.

For her part, my mother finally threw open the door of Papa's study, shipped all his books off to him, and began the task of redecorating the apartment that had been the primary set of their marriage. "I'll keep the best of him and throw out the rest," she declared. She replaced the somber blue tones of the living room with her favorite color, dusty rose. The turquoise dining room also went rose. The almost macabre burgundy bedroom turned putty and gold. She consigned the golden dove of peace above the matrimonial bed to storage. Most important, she tore from its hinges the door of Papa's study, the room in which he had hidden from the entire family, the door at which she had stood asking for grocery money, and I had stood hesitating to enter and say, "*Bonjour, Papa*" at the end of a school day. She replaced it with a curtain and transformed the study into a high Victorian boudoir full of interesting and decorative bric-a-brac. A Chinese export porcelain vase with silk dogwood blossoms, and a diminutive bronze sculpture of Hermes, sat on the bookshelf beside turn-of-the-century leather-bound

tomes. My mother reclaimed the apartment, and her life, after the long night of what she called "my personal holocaust." Years later, when I asked her if losing her mother suddenly, at the age of eighteen, had proved the most difficult passage in her life, she replied, "No, losing your father was. Timothy was my obsession."

Though they went to the trouble of hiring attorneys and setting up terms, my parents never actually divorced. Long before my father left her, my mother used to say to me, "I told your father, 'We married in a casket,'" by which she meant she would remain his wife till the day she died. Over the course of a year and a half, they reached an *entente cordiale*. Papa continued to call my mother on her birthday, their anniversary, the anniversary of their fateful first date of April 15, 1958. Sometimes he called just to complain about his work on his ships. And my mother listened patiently, still the wife. She flirted with others and carried on with her life, but she never again let another man close. "I've had the best. Timothy is a hard act to follow," she would declare as she fingered a cigarette in her bedroom with the red, green, and pewter Scalamandre drapes. The door was off the study, and she ceased her midnight forays to the living-room bar. But she would repeat almost ritually until her final days, "I always know what time it is in Paris." And the light never quite returned to her eyes.

CHAPTER EIGHT

That Was Yesterday

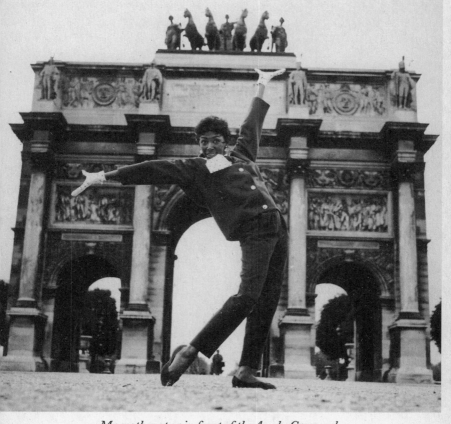

My mother at 25 in front of the Arc du Carrousel,
shooting the album cover for Josephine in Paris.

"In every divorce, there are three stories: his story,
her story, and the truth."

—TIMOTHY FALES

Paris, 1951. In the tiny smoke-filled *boîte de nuit*, the bejeweled and Dior New Look–clad crowd listened, unamused, to the skinny, barefoot, brown-skinned girl belting out her calypso tunes. As she finished her final song with a long note and definitive rap on her conga drum, the Parisians applauded anemically. Josephine exited the stage shaken, unused to such a lukewarm response. At the Village Vanguard and the Blue Angel in New York, she had brought the house down with every number and sent male pulses racing. She'd had sophisticated socialites in the palm of her hand. But she left Le Tout Paris underwhelmed. One young man in the Parisian audience, though, was intrigued by the slim creature with the short-cropped hair and the huge brown eyes. He made his way backstage to her tiny dressing room and rapped on the door. "*Entrez*," the deep voice invited.

The man introduced himself to the twenty-five-year-old Josephine. "Good evening, I'm Jacques Fath." Josephine recognized the name as that of a famous designer. "You're very talented," he continued, "but your look and your act are all wrong. You're sophisticated, you should be dressed like a lady, not an island peasant woman." With that he invited her to his *maison de couture*. The next day Josephine stood in the middle of the Fath atelier, her eighteen-inch waist awash in yards of *peau de soie* as Jacques transformed her from exotic oddity to glamorous *chanteuse*.

* * *

Paris, February 1986: I stood on the granite-gray, rain-soaked Faubourg Saint Honoré, peering into the glowing window of the Jacques Fath boutique. Golden silk brocade suits with glittering semiprecious-stone buttons lay beside sumptuous orange silk cocktail dresses. I entered and asked if Mr. Fath was available.

"Mr. Fath is no longer alive," the middle-aged saleswoman informed me with a condescending smile that told me she found me quite ignorant. I had wanted to shake Mr. Fath's hand, to ask him about my mother, to tell him I'd worn his corseted ballgowns as costumes in school plays. Instead I thanked the lady and walked down the street thinking of the young woman my mother had once been.

I thought of the fearless, independent twenty-five-year-old in her lace, slim-fitted Susie Wong dress with the ample satin overskirt, and her necklaces improvised out of pilfered hotel-chandelier crystals. I thought of the gamine sitting in her favorite restaurant enjoying succulent *filet mignon* and weightless *pommes soufflées* with a coterie of bright young things, which included at various times the novelist Françoise Sagan, a young actor with green eyes and auburn hair named Alain Delon, the elegant expatriate black performer Jimmy Daniels, and Bobby Short, already the darling of the supper club circuit.

One night at a restaurant in Paris, a maître d' announced that the duchess of Windsor longed for a good martini as only Josephine could mix them. "I'll mix it," the girl who would one day be my mother replied, "as long as the duchess comes to ask me herself."

Moments later, the former Wallis Simpson stood before them, having emerged from behind the screen erected to shield her, the duke, and their guests from the prying eyes of the other patrons. "I hear one of you makes an extraordinary martini. I'm longing for one. Will you oblige?" My mother did.

I thought of my mother smoking and drinking late into the night at Bricktop's, the expatriate haunt named after its proprietress, the light-skinned black woman singer and lover of Mabel Mercer, who'd sometimes been among the revelers at my parents' late-night soirées on West End Avenue. I thought of the young woman singing at Chez Florence, the club owned by a famous lesbian, Fred, who always dressed in pinstripe pantsuits, shirts, and ties. I thought of her splitting watermelons in half on the balcony of the hotel room she shared with her bookworm and autodidact of a roommate, Eartha Kitt. I could see the two of them munching on the succulent red slices as they watched the passersby down below.

I thought of all the romances my mother had living in this city, at the charming Hotel Busson (also the Parisian residence of that infamous fictional occupant of New York's Plaza Hotel, Eloise). Many of her haunts hadn't changed in the intervening thirty-five years. The Brasserie Lipp still served its famous *choucroute Alsacienne* with sauerkraut and knockwurst, the *choucroute* my mother would prepare for us. Large, impersonal supermarkets had not replaced charming little specialty food shops, the *épiceries*, the *boulangeries*, the *charcuteries*, where shopkeepers showcased their edible wares like precious jewels against backdrops of gold-leaf paper. I heard my mother's voice in my head. "In Paris, one does one's shopping every day, so that all the produce is fresh." It was as true in 1986 as it was in 1951, and yet a lifetime had passed, and everything had changed.

Just a few months before, my once intrepid mother had collapsed in heaving sobs in front of me, burying her face in her hands after her agent phoned her for an audition. "It's been so long since anyone's wanted me," she'd admitted. As I held her tight, she felt suddenly small and frail, like a sparrow quivering in my arms. I wanted to take her pain away. I'd never thought I'd see her so wounded and bowed. Much had happened to the defiant young woman the French called "La Bombe."

* * *

I had come to the capital of my mother's youthful glory to see my father and meet the young woman for whom he left her. I stayed at the tiny Hotel de l'Université in the Sixth Arrondissement, on the Left Bank. A fourteen-foot ceiling redeemed my shoebox-sized room's claustrophobic proportions. Upon my arrival, on a very gray winter day, my father arranged for a cozy lunch *à trois*. To visit Paris in February, with its hoary sky so low you feel you could run your hands through the clouds, is to understand why the poet Baudelaire suffered from acute depression and wrote such downbeat verse. The spleen-inducing weather mirrored my maudlin mood. *The last time I visited here*, I thought to myself, *I was a callow girl of twenty-one, preparing for my final year at Harvard.* I had married parents and a pampering father who said, "Quit your silly job in the perfume shop. I'll take care of your bills." I had ignored his advice and continued to work, a choice I attribute in part to Greg's lingering influence. With all his faults, at least he'd given me an appreciation for the importance of making it on my own. Now my once pampering Papa intended to introduce me to his twenty-one-year-old mistress. The word "angry" did not begin to describe my state of mind. As I walked through the rain, I fancied that I finally understood the agonies of that famous "French blues" singer Edith Piaf.

We met for lunch at one of Papa's favorite bistros in the Fifth Arrondissement, Le Petit Zinc. It's on a crowded, tortuous pre-"Baron Haussman of the Boulevards" street. I arrived at the top of the stairs and there *she* sat with my father. I surveyed her in one sweeping glance. In fewer than ten seconds, I could offer a full tip-to-toe physical description. Relatively tall, brown-skinned, with a short-cropped misshapen Afro badly in need of a trim, she wore a gray pinstripe pantsuit. When she smiled, she revealed very white but unevenly spaced teeth. She positively reeked of a combination of rose, vanilla, and ylang-ylang. It was a

new designer scent and by the smell of her, she'd had the misfortune of falling into an entire vat of it. An ordinary-looking girl, she carried herself with the haughtiness of an extremely unpleasant, extremely pretty one. She compensated for a less-than-perfect figure with flawlessly manicured hands and flashy accessories. She sported the obligatory seven points of jewelry: gold ball earrings, gold chain necklace, probably 14 carat, imitation tank watch, and bangle bracelets. I couldn't help but wonder if my father had given her the Cartier pinky ring. I seethed at the thought of his gifting this undeserving home-wrecker with jewelry. No doubt my back went ramrod-straight like my mother's as I sized up the "hussy." With her high-pitched voice, she had the studied manner and speech patterns of someone trying—with some desperation—to pass for a debutante from the reservedly elegant Sixteenth Arrondissement. But like Eliza Doolittle at Ascot, she said all the wrong things in all the right tones. She mentioned to me over dinner that one of their good friends was a gynecologist—"So if you have any problems while you're here in Paris, Susan . . . " *The woman is invoking images of me having a vaginal exam with my feet in metal stirrups as we delve into our first course. In front of my father. Charming,* I thought to myself as I flashed her a stiff, horrified smile.

Biased to the core, I couldn't believe my father left my extraordinary mother for this utterly ordinary-looking, vulgar girl. I had expected a stunner, a sculptural beauty to rival Iman, a sylph of the catwalks. Instead I saw a girl who needed to lose fifteen pounds and the at-ti-tude, gain some charm, and stop acting like someone crowned her Queen of Sheba. My mother, true to snobbish form, had asked Papa if this young woman was *"sortable,"* i.e., presentable in society.

He had indignantly replied, "Absolutely."

This is his idea of sortable? I thought to myself with

unabashed haughtiness—the ultimate refuge of the embattled black princess. *You might be able to pass her off as the graduate of a local stenography school, but beyond that,* bonne chance!

Somehow, for that afternoon at least, I managed to contain my horror and utter indignation and make pleasant conversation over the admittedly delicious *tarte fine aux pommes*, though I'm certain my face flashed disapproval in shades of crimson. The luncheon was successful, however, in that it passed without bloodshed. Day two of the father-daughter-mistress summit found us visiting Versailles, at my behest. If World War I could be brought to a close there, surely it would bring harmony to our interactions. I decided to pay for the entry tickets.

Papa turned to Iris and said proudly, "You needn't take out your wallet. My daughter paid."

"I know she's your daughter!" she spat. *Ooh, temper, temper,* I thought.

In one of the state bedrooms, I stood admiring a glorious Louis XVI daybed over which loomed a gilded crown and cascading yards of purple silk damask. Off in a corner, Papa closely scrutinized a Poussin painting. The Viper slithered toward me. "This bed reminds me of my childhood," she declared. I raised an eyebrow, skeptically. "I had one just like it at my grandmother's."

She's got to be kidding, I thought to myself. I knew of the glory and majesty of African art and civilization, but at this point, they were far from my mind. I stopped and looked Iris square in the face. If it had been a UPN sitcom, I would have planted my hand on my hip and said, "Oh please, Miss Thing, you had a mosquito net over a cot." Instead, I flashed her my "where's my Kalashnikov when I need it" smile and moved off. As we left the château, Papa suggested that one night we dine at home at their apartment.

"Yes, I'll cook," Iris offered. "But we'll have to get the maid in. I certainly can't be bothered to clean up!" She then delivered—in

her high-pitched, false upper-crust tones—lengthy disquisition on her aversion to housework. It was simply beneath her. Already my civility hung by a thread. Now this kept woman claimed she was too good to wash dishes. I thought of the hundreds of thousands of dishes my mother had washed, the floors she had scrubbed. *My mother*, a great singer, *an artist*, not just some trollop picking up stray married men at the Café Flore! *If she could wash dishes, so can you, you bitch!* I thought, but said nothing.

Later, when I found myself alone with my father as he dropped me at the door of my hotel, I made the very rational and realistic announcement that I *refused* to be in the presence of *that woman* again. I had come to Paris on my own dime to see him. I had not come all this way to be subjected to the likes of her.

Papa let out a frustrated sigh. "You're not making this very easy," he said, suppressing what he was really thinking.

"I don't care," I rebutted petulantly. *Why should I make anything easy for him*, I thought to myself. *He hasn't made anything easy for us in the last year.*

"This is the woman I've chosen to spend my life with," Papa countered.

I protested that I was ashamed, mortified, to walk down the street with the two of them. To feel the stares of passersby wondering if we, this white man and these two young women of color, formed some sort of strange *ménage*. "It's humiliating!" I screeched. Papa dismissed this as sheer paranoia. I may well have imagined the stares, but I didn't care. I felt like I was sitting next to a woman wearing a sign that read, "Will 'ho' for Cartier trinkets." Finally, I just said it out loud: "I think she's dreadful. Furthermore, she's been rude, very rude. How dare she invite me to dinner, then tell me what a bother it would be to clean up. I will not spend another moment in her presence!"

Papa sighed as he looked out his car window. "Fine," he con-

ceded through gritted teeth. "But it means we will have less time together. I can only see you during the day. I can't just abandon my life."

You abandoned us. What made that so easy? I thought but I composed myself, and blurted out, "Fine. The daytime." I stepped out of the car with as much dignity as I could muster, my shoulders high about my ears and stiff as a Nutcracker soldier's. Once in the safety of the hotel, I rushed upstairs to my little room, threw myself on the bed, and cried.

I had no reason left, only rage, indignation, and pain. I couldn't believe he'd left our life, the dinners when we'd argue and debate and laugh till someone rang the African cow bell above the breakfast-room table. I couldn't believe he'd left the after-party 3 A.M. supper sessions when my mother, clad in her evening best, would transform Ronzoni pasta, eggs, cream, and bacon into a fresh pasta carbonara and she, Papa, Aunt Diahann, Uncle Roscoe, Uncle Bobby, who'd finished a set at the Carlyle, and whoever else was on hand would debate politics, race, and the future until a new day dawned over West End Avenue. I couldn't believe he'd left our forays to theater openings and nights at Orsini's restaurant on Fifty-sixth Street with Elio and his entire staff fussing over us. I couldn't believe he'd left our family outings to New York's discothèques, the soirées at Club A and Studio 54, the summer nights at Faleton when my mother would walk to the vegetable garden in her stilettos to pick fresh tomatoes for our salad. We'd sit at the table in the cottage he and my mother had remodeled from scratch, laying every tile together, painting every wall. He'd built the kitchen counter, she'd shellacked the wood. Together they'd transformed a five-room flat above a garage into a charming country pied-à-terre. Most of all, I couldn't believe he'd given up the woman he called "Phi-Phine," the mother of his children, the woman he'd hug from behind while she stood at the stove and whisper naughty nothings

to in Creole. She'd smile, then tell him to let her be, she was cooking, did he want her béarnaise sauce to curdle? "Ah, you reject me," he'd joke as he pinched her nonexistent bottom. She'd smile back and laugh. It was their routine, along with his calling her "Blithe Spirit" every time she left the house.

Unbeknownst to me, Papa had wounds of his own. My letter to him had struck him to the core. *"Tu t'es permise de dire que tu trouvais ma vie absurde* [You had the gall to tell me my life was absurd]," he blurted out the next day, as we sat in the glass-enclosed section of Les Deux Margot, watching the parade of models, rumpled intellectuals, and chic Parisiennes in their slim skirts, cashmere sweaters, and massive gold-link bracelets. I felt suddenly mortified. It had never occurred to me that my letter might actually cause my father pain. I was so busy expressing my indignation and opinions, venting what I considered my righteous rage, that I never stopped to reread it, or consider the impact of my words, their power to wound. His outburst reminded me that, though to my mind *he* was the villain of the piece, he was still a human being. Even though he had walked out, he was not immune to pain, and his departure did not come without a price. I suddenly felt regret, honest regret, at having sent the letter. Naturally, my pride prevented me from telling him so, or asking his forgiveness. I just looked away, too ashamed to speak, in classic Fales manner.

After a moment's silence, Papa made a comment about my mother's poor budgeting abilities. There went my contrition. Aside from the fact that I had yet to experience my mother's childish irresponsibility toward money, I did not want to hear about her so-called faults and shortcomings. As far as I was concerned she didn't have any, not a one. Whatever happened between them, I felt convinced the fault lay entirely and completely with my father. I lit into him like a Fury avenging my mother's pain while outside a handsome, dark-haired man in a Mercedes winked at me and cir-

cled the block in the hopes of picking me up. Suddenly the absurd-ity of life struck me, bringing a smile to my face. There I sat having an argument to the death with my father, while some playboy in an expensive car, utterly oblivious to our high dudgeon, made love to me from his vehicle. My mother would have appreciated the sub-lime ridiculousness of this scene.

Thus the days passed with heated arguments followed by silence, then temporary truces. We never apologized. I was young, immature, self-centered, and in pain. At the end of the day, I really had just come to Paris to vent. To vent on behalf of my mother, to vent my own terror of one day being abandoned, left at my most vulnerable, once I'd given my youth, my best years, my all, left to subsist on the ashes of my memories.

Papa attempted repeatedly to explain his reasons for leaving. "I was tired of being a sacred monster, a symbol." I had no patience for that line of argument. Standing for something, being emblems, was our birthright, our sacred duty as a family. Since when did we have the right to just abdicate?

We walked past the Intercontinental Hotel on the Rue de Castiglione. "That's where I stayed on my first visit to Paris," he explained to me. "Right after the war, in forty-seven. I loved it so much, I knew then I wanted to live here." I had no interest in his reminiscences, his youthful romantic dreams and idealism. I could see this city and he were made for each other. In Paris he could dis-cuss his favorite writers and philosophers in any one of his five lan-guages, see his beloved French plays every night, and taste the latest offerings from the finest vineyards in perfect anonymity. But noth-ing would shake me off the pedestal of self-righteousness, the moral high ground of the daughter scorned.

We walked through the gardens of the Tuileries on the last day of my visit. Yet another gray day had dawned, with clouds hanging above us like udders full to bursting. Papa attempted yet

again to make me understand his decision. I didn't listen to what he said, and if I did, I certainly didn't hear him.

Blah, blah blah, I thought to myself, *more intellectual rationalizations for bad behavior*. I was too young to realize how important it is for people, even fathers, to be truly seen by their children. When he'd finished, I looked at him skeptically.

Finally, he gave up explaining and sighed, "In any divorce, there are three stories: his story, her story, and the truth." This one simple statement managed to pierce my armor of indignation, my shield of injured pride. I could not admit it to him, at least not verbally, but I knew he spoke the truth. There were no heroes and no villains in this story, only two flawed human beings.

I would never know or understand exactly what drove my father to leave. Perhaps even he didn't know, and if he did, he didn't care to share the reason. Perhaps it wasn't any of my business. The man at home everywhere and nowhere exiled himself from America and our family. I would visit him annually, and for a few fleeting weeks re-create the bonds of father and daughter. But these were brief interludes, and I just a visitor passing through. More than ever, it felt as though Papa were many leagues away, on his own in the middle of a vast, unfathomable ocean.

Writing the Invisible Women

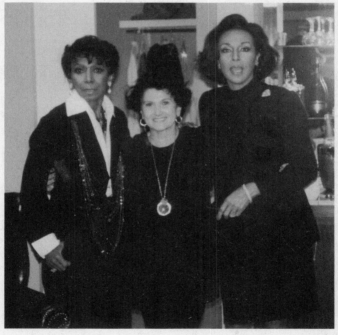

Two supremely chic warhorses, my mother and Diahann Carroll,
flank a friend.

"Dear Josephine, the world will never understand us.
But we understand each other."

—AUNT DIAHANN,
in a letter to Josephine

"I've got Simon Legree making passes at me. And you
want me to play Topsie?"

—from the song "Can't You See the Bergman in Me?"

This family isn't black, they're Jewish!" the fifty-something executive with bifocals and graying hair exclaimed over my shoulder as I viewed an episode from *The Cosby Show*'s first season in the Viacom conference room. I hardly knew this man; he worked on the syndication side of things, and I as a writer's apprentice. Yet here he stood telling me, a virtual stranger, a black stranger, no less, that the Huxtable family had no counterparts in reality. I sat for a moment speechless and stunned by the double-barreled assault of his arrogance and his ignorance. I then calmly asked him what he meant, curious to see this self-appointed arbiter of American negritude defend his point of view.

"Look at them," he answered agitated, "she's a lawyer, he's a doctor, they live in that . . . house!"

To follow his logic, there were no black dual-career couples and black people did not live in townhouses. Period. His statements echoed newspaper reviews that criticized the show for creating a fiction and refusing to address the plight of the urban underclass—clearly the first duty of any and every situation comedy about black people. I didn't recall anyone leveling that accusation at *The Jeffersons*, perhaps because George Jefferson, with his perennial discomfort with "the man" and Stepin Fetchit antics, posed no real threat to our country's power structure. He might have "moved on up to the East Side," but with his rough-hewn ways, he wouldn't be movin' on up to the country club, the corporate boardroom, or the designer-decorated boudoir of a socialite trophy wife any-

time soon. The Huxtables, on the other hand, could give any upper-middle-class white person a run for their money. Therein lay the danger.

"There are plenty of families like this," I told the ad hoc critic, remembering the blocks in Sag Harbor, Long Island—a summer retreat of the black bourgeoisie since the early 1900s—where you couldn't walk more than a few feet without running into a black person with a minimum of two advanced degrees, dentists and lawyers to the left, judges, educators, and surgeons to the right. "My mother grew up in a house just like that. In Brooklyn, in the thirties and forties," I informed him. I envisioned my grandparents' second-floor parlor with its grand piano, a VanDerZee assortment of elegantly dressed black people gathered for Sunday tea, and Aunt Adèle and Josephine's concert on piano and violin. I thought of holiday dinners with the Haitian relatives, Cousin Jacques, an avant-garde playwright; his auburn-haired wife, Marie-Cecile; Aunt Adèle, assistant to the editor of *Scientific American* magazine; Tante Françoise and Lolotte—all arguing about the virtues of the latest Haitian leader, or the merits of a new work of literature.

This middle-aged white man who'd probably grown up in a neighborhood of de facto segregation had the audacity to tell me that such scenes did not exist, never took place in the entire course of the history of the United States. He looked at me quizzically, then did what many people do when you confront their preconceptions with the truth—he dismissed my statement with a wave of his hand, shook his head as if to say, "You don't know what you're talking about," and walked away. In such moments, I always wished I could import family members and school friends—black men and women from the Lycée or Harvard who'd gone on to distinguished careers as architects, investment bankers, entrepreneurs, reporters—as visual aids to prove my point.

My mother and her coterie of black friends in the acting pro-

fession had prepared me for such myopia. When my mother, James Earl Jones, Zakes Mokae, the noted South African stage actor often featured in Athol Fugard plays, Ellen Holly, and Gloria Foster appeared at Joseph Papp's Public Theater in the all-black production of *The Cherry Orchard*, one critic smirkingly titled his review "The Black Cherries." John Simon flatly stated, "On the evidence of this deplorable production, there are no great black classical actors as yet." Indeed there were, Mr. Simon, and they congregated over the years in my mother's living room, sometimes in an attempt to create their own vehicles, and other times merely to laugh away their troubles over wine and good food.

Growing up, I sat through many a Dom Perignon–soaked post mortem held by my mother in the wake of auditions for which she and several of her female friends had been called and then rejected because they were judged insufficiently "down home," "urban," or "maternal." Translation: they didn't fit a white producer's image of "typical black womanhood." Whose black home had these television, commercial, or movie producers visited, anyway? my mother and her friends often wondered. What "typical black women" did they know, other than their housekeepers and the occasional assistant? When told she didn't look maternal enough, my mother would respond, "I have two children, no dishwasher, and a dog. Is that maternal enough for you?" But it was useless to preach to the ignorant. My mother, beautiful blue-eyed Ellen Holly, Carmen De Lavallade, the former prima ballerina with the caramel coloring and deportment of a Madagascarian queen, earthy Rosalind Cash, elegant Jane White, and majestic Gloria Foster would often lose roles to women who more closely resembled that plump, smiling, and utterly reassuring avatar of black womanhood, Aunt Jemima. If only the decision makers knew how many thousands of hours my mother had clocked slaving over our four-burner stove in her high heels and false eyelashes! Still, I never saw my mother or her friends cry

or complain. They'd flock to our living room and make light of the rejections. They'd swap stories of their auditions the way others swap recipes and Tupperware. "They told me I was too light." "My features are too keen, and I'm too dark." "That casting director just looked at me like I was from the moon." They would deflect their pain with brash, bold laughter. They would swat the insults and the bad memories away with their wit, and perhaps a session of evening-gown bargain hunting. If the motto of the Marines is *semper fidelis*, the motto of these women is *semper* fabulous. They faced all of life's challenges and injustices with humor and irrepressible glamour.

One afternoon in the early eighties Aunt Diahann made the nine-block trek from her apartment to ours in sneakers, no makeup, mod sunglasses, and a bell-bottom pantsuit from the previous decade. "This thing has been in my closet since 1975. Please don't tell anyone you saw me wearing it!" She laughed as my mother poured her a glass of white wine. Then she announced, "I'm tired of being a black woman. I want you to know, Josephine, that I'm resigning."

The producers of a new television series thought she was perfect to play the head of a modeling agency. They knew she was an Oscar nominee, a Tony and Emmy award—winning actress, an acclaimed nightclub performer, a great beauty, and a member of the International Best Dressed List, yet they needed to see film footage in which she was both glamorous and dramatic. Aunt Diahann informed them, "That part hasn't been written for a black woman yet." She had no such footage. Not surprisingly, the part went to a white actress who could provide the necessary method actress-slash-glamour-puss footage. No one can ever accuse the acting profession of being a hotbed of affirmative action. Aunt Diahann and my mother commiserated over the phone upon receiving the final rejection.

My mother told Aunt Diahann to look on the bright side; at least her phone was ringing. "Mine is growing cobwebs." Then, as per usual for these couture-clad Christian soldiers, it was "Upward and onward!"

I first fully grasped how much my mother and Aunt Diahann hid behind the mask of their irreverence when we went to the screening of a movie by a brother of the great novelist James Baldwin in August 1980. I was eighteen and escorted by my "first cad," Greg, who was then twenty-four. Clad in matching linen suits, the ladies were in high spirits as we strolled up Ninety-seventh Street with Papa to the now defunct Mikell's Pub. Lawyers, doctors, and living legends had gathered to see this epoch-making cinematic effort about revisiting the famous sites of the civil rights movement some twenty years after Bull Connor's bloodhounds had panted their last. My mother's former costar in *Jamaica*, Ossie Davis, and his wife, Ruby Dee, sat at the front. "Jimmy" himself held court in the center of the room, the ultimate ebony eminence. We went to pay our respects to him—my mother had known him since their teen years in the salon of Anaïs Nin—before proceeding to the glass-enclosed patio. The proverbial hush fell over "Jerusalem" as people took their seats to watch this *very important* exposé on no less a topic than the black experience in America.

My tall, handsome white father, a habitué of the Upper West Side watering hole, positioned himself right by the bar, as usual, the better to refill if the movie grew dull. As the film began to roll, my boyfriend and I sat spellbound watching footage of the hosing of the marchers in Selma, Alabama. Since we were mere toddlers when these battles were raging, these images were nothing short of a revelation to us. They brought home the fact that people had fought and died for the rights we enjoyed so cavalierly. For us, this was a powerful moment of epiphany. For my mother and Aunt Diahann it was a moment of profound self-recrimination: Why on earth had they

decided to sit so far away from the bar?! They had zero interest in the Black History Moments unfolding before us, even less in the dour commentary of various civil rights workers. They huddled in their corner, giggling like two naughty schoolgirls, jeering the pundits on screen, deploring their lack of fashion sense, and jealously eyeing my father, who stood watching with his feigned air of profound interest while downing yet another refreshing cocktail.

I found my mother and Aunt Diahann's behavior appalling. How superficial they could be! Here was an important film, and all they could do was a running Diana-Vreeland-meets-Mr. Blackwell commentary. As the film ended and the house lights went up, my mother sprang to her spiked heel–clad feet, applauding wildly and loudly proclaiming, "Jimmy's done it again"—what "it" was, I don't know, since he hadn't made the film—as she made a beeline for the bar.

Once outside the establishment, I could no longer keep my peace. "Ladies, I was ashamed of the way you were acting. How could you ignore that incredible film?"

A long silence ensued as both my mother and Aunt Diahann turned to give me a long, withering stare. Papa and Greg stepped back to give the Furies room. "How could we?" they repeated, their voices dripping sarcasm. I was in for it. Another beat of silence, then: "Listen, young lady, Miss I-went-to-private-school-my-whole-life-and-I'm-on-my-way-to-Harvard-on-my-parents'-dime, we don't have to watch a movie, we were *there*! *We lived it.*" I had my second epiphany of the evening. Their juvenile behavior, their apparent insouciance, were rooted in deep rage and pain. They had hated the downbeat message of the film, the downtrodden "woe is me," "ain't nothin changed, ain't nothin ever gonna change" pessimism it expressed.

"We're here to tell you things have changed," they declared emphatically, even angrily. "It may not be perfect, but it certainly is

better." They declined to elaborate further; they didn't have to. Images of the indignities they had suffered flashed across my mind. The time my mother had broken every glass and bottle in the bar of the Las Vegas club in which she'd just performed because the bartender refused to mix her a drink, informing her, "We don't serve niggers here." The four years my mother spent in the seventies trying to sell a black soap opera and being told that middle-class black people didn't exist. The constant daily affronts to their dignity. The time a white female casting agent had told my mother to "be as black as you want to be," assuming my mother—who could set people straight in five languages—was forcing herself to speak standard English, instead of her "native" *Porgy-and-Bess*-style "youz ma woman" dialect. Knowing that, in spite of their gifts and talents, they would never be offered the roles they deserved. There was no *Sophie's Choice*, no *Annie Hall*, not even an *Out of Africa*, for them. Now at fifty-something, the best they could probably hope for, other than theater or nightclub work, was an earnest television movie about a noble black charwoman who ages to a hundred and makes a long cross in her walker to the "whites only" water fountain. Still, they felt, nothing was to be gained by sitting around contemplating their navels and the wounds of the past. They kept their attitudes upbeat, and their eyes on the future. As long as they were alive, there was hope. *Semper* fabulous!

From the time I could listen, my mother had taught me that I stood on the well-padded shoulders of extraordinary black women. Civil rights leaders may have won me the right of full citizenship, but it was these women—my mother, her sister, her cousins Françoise and Lolotte, Diahann, Eartha, Lena, Carmen, Gloria, Diana Sands, and Cicely Tyson—who through their optimism, strong sense of themselves, and defiance had taught me that I was the equal of any other human being, prince or pauper, black or white. They taught me I was entitled to the best in life by refusing

to settle for less themselves. They had forced the world to accept them on their terms. I had a responsibility not to squander the opportunities they had helped to create. I owed them.

When in my second season as a writer on *The Cosby Show* the producers Tom Werner and Marcy Carsey suggested I go and work on the show's spin-off, *A Different World*, in Los Angeles, my mother was crystal clear: I had no choice but to accept. I, on the other hand, was loath to leave New York and my newfound live-in love, Hugues. My mother gave a rare piece of unsolicited advice. "You must go."

One Saturday, not long after I was offered the job, the *Cosby* writers and I slogged through the rewrite of the following week's script, devouring our takeout meals like pigs at a Styrofoam trough. During our infrequent recesses I retreated to the bathroom and wailed like Violetta in *La Traviata* when Alfredo's father asks her to leave his son. How could I leave this wonderful love? Just when my family had exploded before my eyes, a fully loving man, a beautiful man, had appeared out of the blue to love me and share my life. Now I was to tear myself away to go to a city that represented a very unhappy chapter in our family's past. I felt my mother was asking me to make a sacrifice she had not made, at least not in the course of her marriage. Other than the spell in Los Angeles, she had steadfastly refused to leave Papa's side. Then there was Aunt Diahann, who had seemingly sacrificed all her relationships to her ambitions. Both women now found themselves alone. My role models may have been dazzling, but they all paid enormous prices for the choices they made. I admired them but had no desire to suffer as they had. I didn't have an example of balance as my best friend, Nanon, did. Her mother had built a media company with her father and raised three happy, healthy, well-adjusted children in the process. They were the French-Canadian Huxtables. To my

mind, at this juncture, my mother and her friends seemed the black Miss Havershams, wielding their daughters like so many mulatto Estellas in the world.

I phoned my mother during one of these tear-drenched breaks. Angrily I told her she didn't understand the sacrifice she was asking me to make. I accused her of having not a clue about the pain I was feeling. I had the nerve to tell a woman who a year and a half before had escorted her husband of twenty-seven years to the airport and put him on a plane to go and join a woman less than half her age, that she didn't "feel my pain."

Calmly, patiently, my mother assured me she did know how difficult a separation this would prove. "You're too young to sacrifice this kind of opportunity to romance. If your relationship is meant to be, it'll survive." Even in my petulant hysteria, I knew she was right. Frustratingly, irritatingly right. She knew firsthand what it meant to give up your career for a man. She'd made an enormous sacrifice, left the States on the brink of stardom and ended up with neither a marriage nor a flourishing work life. Even though at that moment in time I could imagine spending my life with no one other than my beloved, I was being handed on a silver platter the chance to join, at its inception, a television show with one of television history's best time slots. I would receive not only a title bump, but also have the opportunity to shape this new series about life on a black college campus. I would have the opportunity to create characters modeled on the extraordinary people of color I'd known my entire life. It was the sort of break people wait years to receive. I was two years into my career, twenty-four years old, and here it was, the proverbial offer I could not refuse. I owed it to the *semper* fabulous who along with my father had provided the education and training that had won me this opportunity. I hung up, wiped my tears, and resolved to tell Tom Werner and Marcy Carsey that I accepted their offer.

That was February 1987. By March I found myself living in an apartment in a hideous bubble-gum-pink-and-bile-green prefabricated building on the edge of the seediest stretch of Hollywood Boulevard, racking up long-distance phone bills and terrorizing my fellow Angelenos with my dubious driving skills. The show got off to a rocky start. Within eight weeks of beginning production, Tom Werner and Marcy Carsey scrapped the first four episodes and fired our kindly executive producer/head writer. They replaced him with a thirty-seven-year-old woman who'd been one of the only female writers on the staff of *Saturday Night Live* in its glory days in the late seventies, no small feat. After years of fighting to prove herself in a tough, male-dominated industry, she'd developed a brusque, sometimes cruel manner. She also held a somewhat narrow view of the black American population. In our first encounter, a "save your ass" interview she insisted on conducting to see whom she would keep and whom she would discard, she asked me, "What is a black bitch?"

"I have no idea what you mean, what that question means," I retorted. "A bitch is a bitch."

She proceeded to tell me that our star, Lisa Bonet, aka Denise Huxtable, might as well be a white girl. Everyone on the show lacked soul, in her opinion.

"Just because someone isn't hoisting a boom box and speaking in the vernacular doesn't mean they're not really black," I informed her. Within five minutes she shooed me out of the room as though I were a chicken in a barnyard.

Somehow I survived her hatchet and became one of her favorite writers, though she insisted I was not a "real black girl." To that I would respond, "There are many ways to be black."

Having left the relative safety of the dignified "Cosby cocoon," I found myself on my own in a world and a city that had no frame of reference for me whatsoever. I resigned myself to being

seen only in part and never fully understood. I drew strength from the lessons of my parents, and of the *semper* fabulous. "You know who you are." "Lose the battle, win the war." I remembered my mother's "charm offensive" techniques for besting the enemy. For moral support, I would call my friend Nanon or my mother or spend weekends with Aunt Diahann who lived in Los Angeles at the time. We'd sit around her spacious kitchen with her daughter Suzanne, whose intelligence and beauty I'd always admired, and discuss our ambitions and our experiences with men. As Suzanne and I breathlessly recounted our exchanges with black men who claimed to want to marry black women but found themselves attracted to white women in spite of themselves, or conversely, with white men who professed fascination but feared marrying someone "of color," Aunt Diahann would deadpan, "You're still talking about that. Your mother and I had that conversation in 1952." I would think of my mother, Aunt Diahann, and Eartha alone in their hotel rooms around the world as young women pursuing singing careers, leaving family, boyfriends, and the familiar behind. I thought of how often they had found themselves the only black person in a crowded room. I thought of all the pillows, curtains, and tablecloths my mother had sewn as a wife and mother in order to express her frustrated creativity. It was important that I succeed, because if I did, I could create parts for women like them. They had blazed trails as performers; it was my turn to blaze a trail, however small, behind the scenes.

We worked twelve- and sixteen-hour days, six and seven days a week in our headquarters, the former Edith Head bungalow on the Universal Pictures lot. The team toiling within the walls of Ms. Head's former command post was a far cry from the seamstresses and draftsmen creating the costumes of legend for the likes of Elizabeth Taylor and Audrey Hepburn. Our behind-the-scenes staff boasted a Dickensian assortment of characters. There was the

Pulitzer Prize–winning journalist who would sit glassy-eyed for hours on end, then suddenly spring to life with a comment about a line we'd written twenty pages earlier. Staffers joked that he must have taken a few too many acid trips in the sixties. In my naïveté, upon first meeting him, I'd asked him what the double As on his ring stood for, thinking he was a member of a Masonic lodge rather than Alcoholics Anonymous.

There was the script supervisor with flaming red hair, the disposition of the Wicked Witch of the West, the work ethic of a sloth, and a tendency to snap viciously at anyone who dared ask her to do anything vaguely resembling her job. She was studying for her master's degree in social work. I pitied the poor souls who would constitute her caseload. Engaged in a passionate romance with a very handsome and intelligent runner, she would slip off into the loo, then emerge a half hour later loudly complaining of having torn her fishnet stockings.

There was the middle-aged producer with the round face of a porcelain cherub and the lecherous manner of a dissolute Renaissance pope. As he sat beside me during his first rewrite, he gruntingly told me, before the entire room, how much I "turned him on," and that he found me "delicious." I smiled and let him know that if he continued in this vein, I would kick him in the groin. Would that succeed in turning him off? He never made another advance on me.

Our executive producer hired and fired people with such alarming speed and frequency, she should have installed a revolving door at the entrance to the writers' room. I survived by throwing out ideas incessantly and turning in scripts that didn't need much rewriting. Nonetheless, like the other writers and the cast members, I was exhausted and demoralized. While the head writer treated me with respect, it was agony to watch her torment others. "You played that scene like you had PMS!" she'd bark at an actress during one of our communal notes sessions between tapings. "That's a terrible

idea," she'd snap at a junior writer who'd finally summoned the courage to make a pitch.

"How do we get to work? On a gurney!" This line, coined by Cheryl, a member of the writing team, became our gallows refrain. I resolved not to continue working under such conditions. If our head writer returned for year two, I would leave the show. Fortunately, I did not have to. By the end of the season, Marcy Carsey and Tom Werner asked this talented but tortured soul to resign. To her credit, she had learned a thing or two in her time there. She invited me to breakfast a year or so later and asked me honestly and humbly what she had done wrong. I told her she mistreated those around her and showed great arrogance in thinking that she knew more about black people than the three black people in the room. In subdued tones, she thanked me for my honesty. I thanked her for having the humanity to ask.

In the course of four years, I rose from story editor to executive producer, eventually running the show with the incomparable dancer-actress-director Debbie Allen, who had just finished a long stint producing the series *Fame*. Debbie belonged to a generation of young black Broadway stars who admired my mother and felt grateful to her for opening doors. Like my mother, she refused to accept second-class citizenship and pushed to change the image of people of color. You didn't say no to Debbie.

When she first came on board, in the show's second season, she insisted to Mr. Cosby in the course of a breakfast meeting at his New York home that unlike *The Cosby Show*, which took place in the confines of a private home, *A Different World*, which took place on a college campus, had a duty to address racial issues head on and to be topical. Mr. Cosby agreed, and so we tackled subjects the Huxtables could not. We did episodes on date rape, apartheid in South Africa, AIDS, the true role of the Mammy in pre–Civil War America, the little-known history of free blacks who owned slaves,

the Los Angeles riots. The network did not always appreciate our forays into social relevance, to say the least. In the case of the AIDS episode, they threatened not to pay our "license fee," that is, to cut off our financial support for the episode. We had to submit the script to several advertisers for their approval. In the end, because we cast Whoopi Goldberg in a key role and agreed to put in a parental disclaimer, they allowed us to proceed, and it became our second-highest-rated episode ever. In its aftermath, we received letters from Planned Parenthood clinics around the country informing us that the day after the episode aired, thousands had come in seeking information and testing.

Responses like these quelled my doubts when, as the rest of the writing team and I spent endless hours arguing fiercely over the lives of fictional people, I wondered, *Why didn't I go to law school? What the hell am I doing with my life?* One day we even received a call from the district attorney of Bucks County, Pennsylvania, about our date-rape episode. An eight-year-old girl in the area had been raped by a neighbor while selling Girl Scout cookies door to door. Not understanding what had happened to her, she didn't tell her parents about the incident. Six months later, she saw our episode, understood she'd been violated, and shared her trauma with her mother. We weren't performing rocket science or brain surgery, but we were proving that a television comedy could be more than an elaborate excuse to foist new brands of junk food on the American public.

I also had the satisfaction of affecting lives more closely connected to mine—I could provide gainful employment and prime-time exposure to my mother's friends. Uncle Roscoe played a professor on *A Different World*. Gloria Foster played a dean. Lena Horne honored us by playing herself. I was able to write Aunt Diahann into the show as the mother of our spoiled Southern belle, Whitley Gilbert. We depicted the black bourgeoisie whose exis-

tence producers and critics had denied. *The Cosby Show*, with its rainbow of blackness—the actors ranged from very dark to extremely fair—had made it possible to cast actors once shunned by white producers as "too white-looking." We took great pride and pleasure in showcasing a full range of looks and modes of being. We gave America a glimpse of the infinite variations of blackness.

Aunt Diahann almost cried after working on the set. "When I came to this town, twenty-five years ago, I was the only one on my lot. You young people walk this lot like you own it. *You're* running this show!" She shook her head in disbelief. "I never thought in my lifetime . . . " She couldn't even finish the thought. The change in the course of one generation left her speechless. She had never seen so many talented young black people behind the scenes, from our stage manager to the producing ranks. Yvette Lee Bowser, who went on to create four series of her own, Gina Prince, and Reggie Bythewood, now directors and screenwriters, all wrote for the show. Diahann also enjoyed showing her full range as an actress, her natural humor and comedic ability, her drama, and yes, her glamour. Her performance earned her an Emmy nomination. These weren't epic movie roles; the *semper* fabulous weren't playing tragic heroines, but they were dignified and fully human.

My mother had been cast in a featured role as the neighborhood grande dame in a new ABC series set in a beauty parlor. After three episodes, the network executives, who hadn't wanted to cast my mother in the first place, decided, against the vociferous objections of the writer-creator, the director, and the entire cast, to fire her. They claimed, based no doubt on their vast experience as patrons of black beauty shops, that she "didn't fit."

"I'm so tired of 'not fitting,'" she said to me when she got the news. Her frustration was heightened by the knowledge that with all she'd been through, she had reached a place in her life when she could do some of her best work as an actress. A year before they

cast her in the sitcom, she'd played Amanda Wingfield, the genteel Southern mother of two with an aversion to the truth, in the first black professional production of *The Glass Menagerie* at the Cleveland Play House. I'd gone to spend the weekend with her at the shabby Spanish colonial hotel the out-of-town cast called home. I'd rarely seen my mother so utterly fulfilled. She didn't just play the part, she became it in every way. Aunt Diahann had also flown in to see her and at the end of the performance came backstage in tears and said, "Josephine, I've waited all my life to see you give that performance." But mastery of classic roles mattered little to Hollywood television executives whose idea of inspired casting was to find funny black children with growth disorders and *Playboy* models who could cross their eyes.

For once I could do something more than listen to my mother's troubles. We cast her in *A Different World* as a sophisticated international dean. She immediately became Auntie Mame to the whole cast and to Debbie herself. They would seek her advice on everything from their clothing to their romances and marriages.

In 1991 I received a Special Recognition Award from the Friends of the Black Emmys, an organization created by two black entrepreneurs to recognize black actors, writers, directors, and producers and bestow upon them the statuettes they, in all likelihood, would not receive at the mainstream ceremony. As I stood onstage in the black lace John Anthony gown my mother had scoured countless salons to help me find, she and Aunt Diahann sat holding hands at a front table, drinking in every word of my acceptance speech and every drop of their cocktails. They had both invested so much in me in my twenty-nine years. To them this moment, this award, and my career were proof their hard work was paying off.

Earlier in the evening, Lynn Whitfield, who was being honored that year for her extraordinary portrayal of Josephine Baker in

the HBO film of the same name, had acknowledged Aunt Diahann and my mother as the "wind beneath her wings." She spoke of the inspiration they provided her throughout her career, and how often she thought of them while she was shooting in Budapest. I knew what she meant. Thinking of my mother and Aunt Diahann had carried me through torturous rewrites with drunken head writers, the breakup of my relationship with Hugues, my true first love, earthquakes, bad dates, and many a lonely Los Angeles night. When I felt frustrated or discouraged, I remembered going with my mother to hear Lena Horne sing at a gala. At the end of the performance, she stood up with everyone else to applaud her seventy-something friend. But she looked pensive.

"What is it?" I asked.

"Susan, I have so many songs left in me . . ." She didn't finish the sentence. She didn't have to, I squeezed her hand. She smiled and changed the subject: "Dinner at the Russian Tea Room?"

On the night of the Black Emmys, I looked out at the crowd of three hundred industry peers and told the audience, "I became a writer so that I could give my mother and all her friends jobs." I acknowledged my mother as a brilliant performer, incredible woman, exemplary wife. "You gave up a lot so that I could stand here tonight," I said. At that point, I saw tears rolling down my mother and Aunt Diahann's cheeks. They refused to weep at their own misfortunes, but this public show of gratitude delivered the coup de grace to their defenses. The *semper* fabulous sat in the romantic glow of the Versailles Room and cried.

In Search of
the Eternal City

Sunny days at the beach, Porto Ercole.

"Your baby is beautiful. His father was white?"

—ROMAN WOMAN, to my mother

"I don't remember."

—MY MOTHER, to Roman woman

Cunts! You're all just a bunch of cunts!" Jack, the male half of our executive-producing team growled at us, the female writing staff members, the veins in his neck popping above the collar of his pink Izod Lacoste polo shirt. We stood frozen in stupefaction, like figures from Madame Tussaud's Wax Museum or victims of the volcanic eruption at Pompei, trapped in midtask. Jack stormed out of the conference room and locked himself in his office to nurse his beloved bottle of Bombay Gin with the rendering of the Dowager Queen Victoria on the label. Her majesty would never have approved of his having just called all four women on the writing staff "C-U Next Tuesdays" simply because we'd opted to go to lunch without the men. Though accustomed to this extremely talented, if tautly wound man's frequent outbursts, we never expected him to resort to such profanity. He usually chose a more genteel mode of expressing rage, such as revving up the motor of his Jaguar and speeding off the CBS/MTM lot, only to return a quarter of an hour later, perfectly composed, pleasant, and full of creative ideas. And so on this occasion, we wandered around the outer office stunned, repeating, "He called us cunts," in tones of dumb amazement, then bursting into fits of disbelieving laughter. We worked on a network sitcom; what most work environments deem actionable harassment, in the confines of a writer's office falls under the rubric "This ain't Miss Porter's finishing school. Get used to it, honey."

A Different World had entered its third season. Then twenty-

seven, I held the position of supervising producer, the post just below executive producer, on the staff of seven. "Shall we continue the rewrite?" Mary, a former schoolteacher from Massachusetts, the female half of the executive-producing team, suggested, rousing us from the shock and stupor of having had one of the lowest insults in the English lexicon hurled at us, and by a man we genuinely liked and considered a friend.

"Oh, yeah, I'm feelin' funny," deadpanned Adriana, our producer, an Italian-American raised in the hills of Virginia, as she finished writing on the storyboard, "Comedy should not be life-threatening."

"I'd like to get out of here. I have a date tonight," groused George, a five-foot, five-inch sitcom writer whose tiny size belied no "immensity of soul" whatsoever, as he dumped the now wilted and brown contents of the *crudité* platter into a Ziploc plastic bag.

"What are you doin' with those?" asked Adri in a voice that rendered megaphones superfluous.

George announced his plan to use the peppers in the pasta sauce he would prepare for his date that night.

"Have you lost your ever-lovin' mind? Those things have been sittin' there all day. Half the fruit flies in Southern California have relieved themselves on those vegetables!" Adri objected.

"Peppers are expensive," George rebutted, utterly unfazed. *This is what passes for an eligible man in this town*, I thought to myself. *No wonder I haven't had a real relationship since I moved here.* Adri and I exchanged a glance across the table that said, "What hell are we living in?" I looked out the window to avoid eye contact with "The Miser." My eyes fell on the strip mall across dreary Ventura Boulevard. Cheapness to the left of me, insults to all the laws of aesthetics to the right.

Christmas was coming. I needed a break from Los Angeles, a break from men with surgically altered ski slopes for noses, men

who wanted to bed you, then represent you as an agent. A break from a city where people thought my license plate, marked "M. Bovary" in honor of the Flaubert novel *Madame Bovary*, stood for "Mighty Big Ovaries." I needed a break from the writer's room, from the battles to the death over the placement of the punch phrase in a sentence. A break from negotiating the commercial expectations of the network—"It would be really great if you could have Whitley [one of our main characters] lose her virginity for February sweeps"—and from the responsibility we had to our audience of over twenty million to give a dignified and varied portrayal of The Black Experience, all in the twenty-one minutes and fifty-six seconds between soap ads. I needed a break from being a spokesperson for The Black Experience, as if there were only one, and I, the "demi-WASP," the most qualified person to speak on the subject. Though I loved my job, I had grown weary of trying to eke three jokes per page out of the issue of race in America. I longed for the freedom to be Susan, Human Being, rather than Susan, Black Female Writer (BFW) in television.

I found myself approached by people who'd never read a word I'd written, simply because I fit a demographic, "BFW under thirty." The producers of what eventually became the extraordinary dramedy series *Rock*, starring Charles Dutton, phoned to interview me for the opportunity to write the pilot. I knew they didn't really watch *A Different World*; they'd just heard I was the latest and one of the few BFWs in television. In their great hurry, they wanted to skip a face-to-face meeting and pitch the idea to me over the phone. "It's a show about a black couple, struggling against urban poverty. And being black, you know all about that," they declared with utter certainty.

Oh yeah, I thought to myself. *Girl in the 'hood, that's the Susan Fales story.* Apparently they suffered under the delusion that the evening news with its constant parade of teen criminals and wel-

fare queens gave an accurate and thorough portrait of every single black person in this country. "If you'd just leave the confines of Westwood and Beverly Hills and drive to Baldwin Hills, or Ladera Heights, you might actually meet a bona fide middle-class black person," read the bubble above my head. "I'd have to do a lot of research," I responded calmly. I found myself amazed, once again, by the willingness of certain white people to believe in the existence of extraterrestrials, of which they had no concrete proof, while maintaining utter blindness to the existence of blacks who pursued white-collar careers, attended professional schools, and pursued the capitalist dream right under their noses, in their own cities. Didn't these executives know that Los Angeles Airport, the Beverly Hills Hotel, the legendary Shrine Auditorium, where the Oscars were held, and many of the stately homes they coveted in Bel-Air, Hancock Park, and Holmby Hills had been designed by the black architect Paul Revere Williams in the thirties, forties, and fifties? Had they never visited Baldwin Hills, the suburb inhabited since World War II by affluent blacks? Had they never driven past the African Methodist Episcopal church in Pasadena, worshipping place of black tradesmen, schoolteachers, lawyers, and doctors since the nineteenth century? Didn't they realize they had a black mayor, Tom Bradley? Life in my family's enlightened cocoon had not prepared me for this willful ignorance. Now I knew how Plato's cave dweller felt when he returned to his subterranean dwelling after experiencing life above ground. "It's dark in here," he kept repeating, while the other cave dwellers looked upon him as a madman.

I longed to leave Hollywood, but a desire not to end up in my mother's situation—closets bulging with beautiful gowns and bank accounts bereft of funds, utterly dependent on the financial mercy of a man (and thank goodness my father had been merciful to her)—kept me in television's golden handcuffs. I would not leave

Los Angeles until I had built a small nest egg. In the meantime, I could raise my flagging spirits with a trip.

I'll take my mother to Italy, to Rome, I thought to myself as Ken pitched a joke ending in a word that contained many *k*s, following a hallowed canon of sitcom hackdom that decrees that *k* words (e.g., Kookie) automatically send an audience into paroxysms of hysterical laughter. A trip with my mother to Italy, and specifically to Rome, the place of my birth, seemed the perfect antidote to color-line weariness. Being grossly overworked and grossly overpaid did have its rewards. At the first break in our nearly interminable rewrite session, I phoned my mother.

"Hell-llo, darling," came the enthusiastic and reassuring purr. "How's my beauty?"

"Fine, Mommy." Though I'd worked in the professional world for five years, I turned into a child whenever we spoke.

"Are you having a wonderful day?"

"Everything's great," I fibbed. "I'm calling to tell you I'm going to take you to Rome for Christmas. Just you and me."

My mother fell silent for a moment, then quietly said, "What a wonderful idea."

We had never traveled to Rome together in the twenty-six years since we'd left. I had journeyed there on my own and with friends, but never with my family. I'd heard so much over the years about my parents' time there, at the dawn of their marriage. Mementos of their Roman era filled our home; everything from Papa's meticulous photographs of the city's architectural details, to the hand-painted Louis XV chairs in our dining room, to the portrait of my mother resplendent in a pink cocktail sheath, her eyes gazing out on the world with sadness and wonder. My parents had purchased their pewter bed in one of the flea markets that my mother would visit weekly, bringing home forgotten treasures, which my father would deride and antique dealers would later val-

idate. Half the dishes in her extensive culinary repertoire she'd learned to make from their Roman houseman, Vincenzo. Hand-rolled potato gnocchi in fresh tomato and basil sauce, pasta primavera, and osso bucco with polenta had often graced our family table. In the summer at Faleton, my mother always delighted at finding zucchini flowers in the vegetable garden. She would stuff them with mozzarella and anchovies and fry them to golden crispness. Italy and Rome served as the true birthplace of our family, of the Premice-Fales civilization. Now that that civilization was in decline, I wanted to see the site of its apex. I wanted to go and experience the Eternal City through my mother's eyes.

We boarded our Alitalia flight on the eve of the Gulf War. We appeared to be the only Americans traveling to Europe. *Do my compatriots know something I don't?* I wondered. Our concerns notwithstanding, we boarded our plane with high hopes and bulging suitcases. My mother's packing motto had always been, "If you can't decide, take it all." Not for her the space-saving color-combining tricks touted on morning talk shows and in fashion magazines for the practically minded. She wanted a change of clothes for every day *and* every evening. This may have been the result of her having learned to travel in the days of steamer trunks and ubiquitous red caps. No one weighed her luggage on the ocean liner *Ile de France* when she boarded on her way to a nightclub engagement. One of her ballgown's crinolines alone would take up an entire traveling case. We were prepared for every occasion, with the possible exception of meeting His Holiness, the pope. Such an audience was not on our schedule, nor would we have cared to attend even if the Vatican had asked. My mother had shed her Catholic faith along with her training brassieres.

To us, Rome's most sacred site was not the Vatican, but Palazzo Lovatelli, the former noble dwelling in which both Enrico and I had taken our first steps. I had no clear recollections of this ancient

stone structure, having tottered out of its courtyard for the last time at age one. Since then, photographs had substituted for memory when I occasionally turned the pages of the baby-blue leather photo album my parents had started upon Enrico's birth. Nearly every picture captured my mother—in her early thirties, a beaming young bride with a smiling baby or toddler Enrico, on a bright happy day in a magnificent *Rinascimento* courtyard with a gurgling fountain, or playing on a white sand beach. All my mother's memories of her time in the former carriage house with its vaulted ceilings and huge windows seemed suffused with sunlight. Her mental images ranged from the romantic to the ridiculous. "We didn't have a traditional honeymoon," she would explain to me. "After we arrived in Italy, your father took me on a tour of small towns in Tuscany in our little Alfa Romeo two-seater. He planned all the stops according to the different wines. I don't remember them, of course. But we stayed at wonderful little inns. He'd researched all the towns."

The Italian economy of 1958 had yet to recover from the ravages of war. An American with a modest income could live grandly, with several servants. My mother relished her life as a *signora*. Not finding the Italian rice solid and grainy enough for her taste, she ordered a case of Uncle Ben's from the States. She stood in the kitchen with Vincenzo as he unloaded the boxes.

"What does this mean, 'Uncle Ben'?" he asked as he stared in puzzlement at the picture of the smiling black gentleman presenting a platter of steaming rice almost as white as his teeth.

"*Zio* Ben," my mother translated.

"Ah," said Vincenzo as he looked from Signora Fales to the image on the box back to Signora Fales. Then, after a moment's reflection and thrilled with his discovery, he shrieked, "He's your uncle!"

"No," my mother insisted, then tried to no avail to explain why American Southerners referred to their black domestics as "Uncle"

and "Aunt." She couldn't persuade Vincenzo. He knew that his *signora* was in truth a rice heiress, and felt duly honored to serve her.

"I can't wait to take you to Palazzo Lovatelli," my mother gushed as we snuggled under our meager airline blankets. "It's just a shame I can't show you the apartment. Maybe if we ring the bell . . . " she added mischievously.

We landed the following morning, on a cold but sunny day, and repaired to our hotel, the charming Intercontinental right behind the Spanish Steps. We had no strict agenda; my mother loathed schedules almost as much as she did budgets. We would adopt the *passeggiata*, the strollers' approach to this magnificent city. In Rome, in 1990, my mother did not attract gawkers everywhere we went as she had back in the late fifties and early sixties. Having come late and rather unsuccessfully to the imperial "scramble for Africa," Italy had attracted few nonwhite immigrants. When my parents lived in Rome, the sight of a black woman was so rare that each day the vendors in the neighborhood would wait to see her pass, then summon each other with an eager "*Eccola, eccola!*" ("There she is!") A little boy had once burst into tears upon seeing her, thinking that her dusky complexion resulted from a head-to-toe burning. She stopped to explain to him that God had made her dark chocolate brown. On another occasion, she opened her door to find three utterly confused-looking sixty-year-old black ladies wearing their finest church hats. The local vendors had dispatched them to my mother's, convinced they must be related to the only other black American woman they knew. None of this had perturbed Josephine back in those days because she said it reflected naïveté rather than condescension, cruelty, or willful ignorance.

Now, nearly thirty years later, in a country grown accustomed to immigrants of every shade, it was my mother's turn to stare. She couldn't get over all the mink coats. It seemed as though every other

Italian woman owned one. And not the runty layaway variety, but a full, beautiful coat. This stood to reason in a country where people allegedly spend a quarter of their earnings on clothes. Still, my mother could not get over the opulence. When she and Papa had lived there, such displays of conspicuous consumption were most uncommon. Their houseman, Vincenzo, had grown up so poor he was an adult before he tasted his first piece of chicken. His family subsisted on potatoes. One day his mother came home with a freshly killed bird. The children danced for joy. At long last they would savor their first taste of chicken! Their mother unveiled the animal; she paraded it before the neighbors to show them that, though poor, she and her family could finally afford a real meal. Once back in their own kitchen, the children began to pluck the bird feverishly. Within moments, they discovered beneath the white plumes a substance that bore more than a passing resemblance to that all too familiar staple of their diet: the potato.

"Is this what chicken looks like?" Vincenzo asked, hoping his mother would answer, "Yes." She said nothing. In another instant, the object of desire was stripped bare, revealing not the desperately desired fowl but a large potato riddled with holes where their mother had camouflaged it with feathers. Their long-anticipated feast of poultry was nothing but a sham to impress the neighbors. Vincenzo and his five brothers and sisters would go to bed with bellies full of potatoes yet again. Vincenzo had told my mother this story when she had asked why he insisted on serving chicken so frequently. It was one of her favorite tales, perhaps because she understood all too well the feeling of having one's high hopes and "great expectations" dashed by the realities of life.

As we walked the cobblestone streets arm-in-arm, she recounted stories I had heard for years. Walking past a district where religious uniforms are sold reminded my mother of the day she rushed into a shop, demanding to try on the stunning embroi-

dered cape in the window, only to be told by the horrified shop-keeper that the item she coveted was a cardinal's cloak. We passed La Cicogna (the stork), a children's clothing store on the Via Veneto. We stopped and peered in the window.

"It's so different, so modern," my mother commented. She reminded me of her misadventure, going in eight months pregnant with my brother. Eager to use her newly minted Italian, she said, "*Buongiorno*," then grandly demanded, "*Mostrate mi uno culo!*" ("Show me an ass!")

The store attendants burst out laughing, leaving my mother perplexed by their hilarity. They explained to her that she had sub-stituted the word *culo* (ass) for the word *cula* (crib).

This was not the first linguistic faux pas she had committed while mastering the idiom of Boccaccio and Dante. At one of her first dinners for my father's business associates, she proudly sur-prised her husband with all that she had managed to absorb of the Italian tongue. She prattled on as the guests listened politely, doing their best to contain their horror. Papa left his seat at the head of the table to go and whisper in her ear.

"Speak in English," he begged her. "You're speaking *romanac-cio*. You might as well be saying, 'Dese, dems, and dose.'" She didn't realize it, but she had been learning street slang from local vendors and the staff. The very next day, my mother hired a tutor. She would never embarrass herself or her husband again.

And so the days passed in pleasant recollection of my mother's dolce vita, even though many of its most pleasant sites had changed beyond recognition or disappeared entirely. As we explored the city, I noticed that my mother couldn't walk fast or very far. She paused frequently, on the pretext of peering into a shop window. This sur-prised me because she had always been a championship stroller, the swift trek from Ninety-seventh and West End to Broadway and Seventy-second, about thirty blocks, her daily marathon. It was

doubly shocking since she'd given up smoking that fall, on the advice of her doctor.

"Is everything all right? Are you going to be okay?" I asked.

"Oh, please, of course, I'm fine." She brushed off my concern and hailed a taxi. "Let's go see the wedding cake, that's what we called the monument to King Emmanuele Two. From there, we'll walk through the Jewish neighborhood to Palazzo Lovatelli." And so we set off in a taxi for the high point of our entire trip, a place filled with family history. We smiled at each other, knowing we were headed for a true homecoming. Standing in the courtyard, we imagined, the quarter-century separating us from that sun-dappled time would evaporate in an instant, and we would experience the joy of bygone days.

We traversed the streets of what had been the Ghetto, the Jewish neighborhood. Once again, much had changed. But every so often my mother excitedly pointed out a shop that had formed part of her daily pilgrimage. "That was the *frutto vendola*, that was the butcher." Our anticipation grew with every narrow block. Finally, at the end of a cul de sac, we arrived at Piazza Lovatelli. There stood the building in which I had taken my first steps, the living room where my mother had entertained Gore Vidal, whom she'd met through the circle of Anaïs Nin, the living room in which Papa and Tennessee Williams—a friend of my mother's from Broadway days—had stayed up all night drinking and exchanging Southern aphorisms like "That dog don't hunt" and "Don't pee on my leg and tell me it's raining." The apartment to which Susan Strasberg had come to borrow a dress for her date with Warren Beatty (then in town filming *The Roman Spring of Mrs. Stone*). The garden in which *Ebony* magazine had photographed my parents, Enrico, Eartha Kitt, and her baby daughter, Kitt, having lunch on a bright autumn day. But rather than an open, sun-drenched courtyard with a *puti* fountain, we found a large, smooth, black iron door, locked and

impenetrable, except to those who knew the appropriate code and could punch it into a stainless-steel security keyboard. My mother tried the door, to no avail. We stood back and surveyed the majestic gray building. My mother looked truly crestfallen. Silently, she walked in a circle before the forbidding doors, looking up as if entreating them to open.

"What is it, Mommy?" I asked her gently after a few moments.

"It's not the way I remember it. With your father . . . It's cold and it's sad," she answered quietly, clutching her coat against the December chill. "It makes me sad." She turned her back on the door and walked away. I let her go a few paces before catching up. I knew she hated showing sorrow in front of me. I looked back at the huge iron doors, impervious reminders of all that had elapsed in the thirty years since they'd stood open. My mother's married life had ended; her son, the "prince" for whom they'd hung a blue ribbon over the portal, had yet to find a passion in life or a career that sustained him economically; her phone had ceased to ring with offers of work. And now, the Eternal City had erased our past.

We retraced our steps, my mother still walking a few paces ahead of me, looking around at all the unfamiliar establishments, lost. "Let's take a taxi," she said. As usual, she didn't dwell on her disappointment. She never even spoke of it again, but I knew how deeply she felt the loss. It was as though she had rushed to visit an old friend, only to discover he had died years before and no one had bothered to tell her.

That night, we dined in a bright, elegant restaurant, then went off to the bar at the Excelsior Hotel. My mother had often stopped there as a young woman for an afternoon aperitif. It was the gathering place of chic Romans. We looked around at all the businessmen prowling the bar. Slowly we realized this was perhaps not the most felicitous spot for two unescorted women. "They're going to

think I'm Madame Fleur pimping one of her young flowers," she joked, referencing the procuress role she had played in the 1968 revival of *House of Flowers*. We laughed at the thought of someone mistaking us for "professionals."

We went to a local piano bar. "Whenever I used to walk into a bar with your father, the pianist would launch into 'La Vie en Rose.' They thought they were so clever," she said, rolling her eyes at the thought of lounge musicians mired in cliché.

I excused myself on the pretense of going to the ladies room. When I returned, she'd ordered herself another vodka. We sat smiling at each other, enjoying the atmosphere. Within a quarter-hour, the pianist launched into "La Vie en Rose." *"Quand elle me prend dans ses bras, et j'ai le coeur qui bat, je vois la vie en rose,"* he belted in heavily accented French.

Her face broke into an enormous smile; she pointed her long index finger at me accusingly. "You did this!"

"He must have seen you walk in," I said, feigning innocence.

She hummed along, giggling, enjoying my ruse. I could not unlock the black iron door to my mother's youthful past, but I could see to it that some things in her universe never changed. As the pianist played on, we toasted each other, laughing, singing, blissfully ignorant of the fact that we were enjoying our last trip abroad together and that my mother would never see Rome or Europe again.

PART THREE

Then, Face to Face

The Last Cigarette

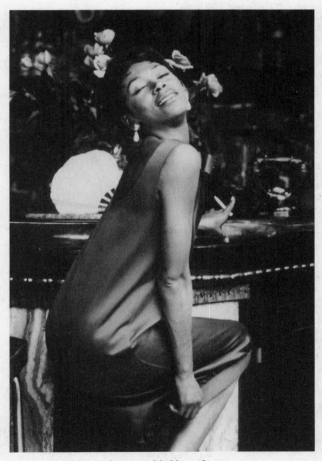

My mother, not thinking of tomorrow.

"Things don't just happen. Things happen just."

—JOSEPHINE PREMICE

My mother had lied to me. As I stood by the settee in her bedroom, ransacking her papers for her insurance cards, the realization struck me yet again, a slap in the face from an icy hard hand. It was 1994, she was not sixty-seven, as she claimed, but sixty-eight. I stared at her passport picture, the passport she had obtained the summer six years before, when I'd surprised her with a trip to the south of France. Why shave a mere year off one's age? It was so unworthy of my mother, so Gabor Sisters. But this was the most benign of the lies; every envelope held a deeper, uglier secret. Utter chaos reigned over her financial affairs.

I knew occasionally she had trouble living within the confines of her annuity from my father, and I'd happily paid the occasional bill. A year or so before, I'd settled a fairly sizable debt she'd accumulated over the course of five years at our furniture storage place. I'd asked her if she had any other such obligations and she'd sworn to me she didn't. I, of course, had believed her. It had never occurred to me that she would recklessly let herself drift into such disastrous straits. She hadn't signed up for Medicare, guild pensions, or Social Security. Envelope after envelope held an unpaid bill, some of them to authorities capable of throwing her in prison. Finally, I fell upon a letter from her accountants of nearly thirty years recusing themselves from ever working with her again, and an income tax extension she'd never bothered to file. She hadn't paid her taxes, not for two years running. "Put money aside for your mother. One day she's going to become your responsibility," Aunt Diahann had warned

me four years earlier over dinner in a Los Angeles trattoria. I'd listened, but waved the thought away.

Even more troubling, my mother had lied to me about her weekly visits to the doctor to care for her emphysema. She hadn't been to see him in a year, thinking that if she paid no attention to the disease, if she "snubbed" it, it would have the sense to realize it wasn't welcome and obligingly withdraw from the scene. But like the unpaid taxes and the unpaid bills, there it was, refusing to be ignored any longer. My mother's whole edifice of denial began its inevitable crumble. Her famed "If I don't look at it, it will go away" approach to life had betrayed her. As I sorted through her papers in search of a Medicare card, she lay in a hospital bed in the intensive care unit of Saint Luke's Hospital in a coma. I looked up at the ceiling, hoping to see the face of God, and noticed the peeling gilding on the crown molding instead. My mother's lush Scalamandre drapes showed signs of fraying. The diva's grand illusion was beginning to disintegrate, leaving me grasping for a compass.

I had come back to New York after ten years in television—nine in Los Angeles—in search of my sanity and perhaps a bit of male companionship. Sanity is not something one loses from one day to the next, like a misplaced purse or an elusive shoe. It slips away slowly and unobtrusively. One bright day as I drove down Beverly Boulevard with tears streaming down my face for no reason in particular, I realized I had lost what little sanity I'd ever had. On my last visit to my father in Paris, I'd discovered, quite by accident, the frequency and flagrancy of his extramarital affairs. He'd casually reminisced about taking one his of paramours to Orsini's, the restaurant where we celebrated special family occasions, birthdays, graduations. The owner, Elio, had reacted with shock and horror when, at age eleven, I'd shown up for lunch dressed in a silk hotpants suit. They made it clear to my parents that they did not wish

to see me, a *signorina*, dressed in so indecent and shameless a fashion again. All that fuss over a pair of shorts, and yet they turned a blind eye to my father's dalliances. Parading one's mistresses for all New York to see was perfectly permissible, but an underdeveloped prepubescent girl showing her legs, *Madonna mia*, a sin. I'd always assumed my father's affairs had taken place discreetly and on distant shores. This in my mind did not excuse them, but at least it showed more respect for my mother and our family.

Now, I struggled to understand how my mother—my strong, independent, self-respecting mother—could have put up with such blatant bad behavior. I struggled to reconcile my father's infidelities with his still frequent declarations of profound love for her. Perhaps this was why my mother had refused to take him back when he had asked several years after leaving for Paris. "Premice women are all the same," she would proclaim. "You can push us very far, *mais quand c'est fini, c'est fini.*" (When it's over, it's over.)

But how could she have let him push her that far, I wondered as I drove Tinseltown's sunny, desolate streets. I longed to ask her point-blank: "How the hell did you put up with that?" But I didn't dare, out of respect and fear of hearing the truth or watching her crumble before my eyes. Instead, I'd ask in oblique or not-so-oblique ways, "How does a wife deal with cheating?" The first time I'd asked, she'd shrugged the question off. "That's men. They can't say no." On another occasion, she just looked away.

"It eats you alive," she somberly admitted one day.

Her long-standing frustration with my brother—who in her words had yet to "find himself"—now began to make sense. "He's just like your father," she'd sputtered since we were tiny. Unable to stop her husband's infidelities, she punished the child who most reminded her of him. Enrico, her beloved son, became her scapegoat, and she didn't even realize it. I had been spared, as usual.

Still, I thought, this must be the price I'll have to pay to live with an interesting and compelling man.

Ten years of working nonstop in television and conveniently avoiding my emotional problems through a seventy-two-hour-a-week schedule had begun to take their toll. If they'd held a contest to pick someone to represent the "nation" of all the successful, workaholic professional women with no romantic life, the way the French choose a famous model or actress to cast in plaster as Marianne, symbol of their republic, I would have won, hands down. One of Hollywood's many "Vestals of Comedy," my life consisted of morning workout sessions with a personal trainer, fourteen-hour days holed up in an office or conference room, and solitary midnight drives home through eerily empty streets. At one point, it had been so long since I'd gone out to a social event that I jumped for joy at the prospect of attending a funeral for a friend's mother. I tipped jauntily down the aisle of the Forest Lawn Chapel, scoping the pews full of bereaved friends and relatives for eligible men, all the while thinking to myself, *I'm glad I wore this outfit.* Only the prospect of having to tell my grandchildren, not to mention the dear friend I should have been consoling, that I'd met my husband while trolling for men at the local mortuary made me realize I had truly reached the nadir. My life had no balance. As a result, I was behaving like a desperate woman and a most insensitive friend.

I had thrown myself into my career without looking back, desperate to escape financial dependence on a man—any man—determined to build a nest egg so I would never have to stand in a doorway asking my husband for a check. Now at nearly thirty-two, I found myself with the desired nest egg, but no nest, the proverbial working woman who scares away more men than Medusa herself. Sir Philip Sidney's line, "They flee from me that at one time did me seek," had become my anthem, the story of my pathetic dating life. Fortunately for me at this critical juncture, God and the

ruling deities at two networks slowed my pace, giving me the opportunity to pause and take stock of my existence.

NBC had canceled *A Different World* a year before. After some deliberation, CBS had rejected the new pilot I'd developed about a black family–owned business. Tired of seeing television's relentless parade of crotch-grabbing homeboys, I had created a piece based on families I knew, or knew of: the Graves, publishers of *Black Enterprise*; the Bob Johnsons, founders of BET; the John H. Johnsons of the *Ebony* magazine publishing dynasty; the Reginald Lewises, who'd purchased Beatrice Food in a much ballyhooed leveraged buyout; and others. Through the "sugared pill" of comedy, I hoped to undercut TV's insidious message that any black man with an education and a decent job—other than Cosby's Dr. Huxtable—was by definition a sexless sellout, devoid of even a scintilla of that precious proof of authentic negritude known as "flava." When had gainful employment, a decent education, and ambition become inconsistent with "black identity"? And white writers were not alone in perpetuating this dangerous message, black writers had too. In a world where black children who strive to achieve in school stand accused by their peers of "acting white," I considered it important to try to create role models, even fictional ones. Naturally, I had drawn a heroine loosely based on the women I knew, an over-fifty and fabulous political crusader in stilettos who could handle all her husband's shenanigans and dalliances. The script had apparently engendered much controversy in the CBS ranks; half the executives loved it, the other half detested it and insisted they couldn't envision any of the characters. What is it they say about not leaving people indifferent? I had elicited cheers and boos, but at least I hadn't bored anyone.

Faced with a choice between another development deal, which would entail a much less rigorous schedule—days that ended at 6 P.M. rather than midnight—and taking a bit of a sabbatical, I

chose the latter. I would write two pilots from the comfort of a rented apartment in New York. I would have the opportunity to live blocks away from my mother and meet men who did not consider me a great mind of the ages because I could make it through the *New York Times* in one sitting. On one ill-fated Los Angelean date with a perfectly sweet young man, a professional athlete, and his best friend, I suddenly realized I had held up the entire conversation for the last half-hour. Actually, conversation is a misnomer; it had disintegrated into a soliloquy, "Susan's symposium on the political situation in Haiti, circa 1993." Realizing the two gentlemen's eyes were glazing over with boredom and total lack of comprehension, I shut up in midsentence. Just as the abrupt slamming of a large tome awakens a student slumbering in the library, so my sudden lapse into silence roused my beau from his torpor.

"No, keep talking," my date—he who had lovingly christened me "Boukie"—encouraged me. "I like hearing you talk." He never did say much, except when he waxed poetic and exclaimed, "You're sexier than a motherfucker!" Oh, yes, the time had come to go home to New York.

Papa's words rang in my ears: "We belong everywhere and nowhere." Other than my evenings with my closest friends and Aunt Diahann, I had spent the better part of the last ten years feeling *nowhere*.

New York proved a balm to my spirit, the cultural Baden-Baden cure a woman with a reasonably well functioning brain craved. Everywhere I went, it seemed, I encountered attractive, engaging, and intelligent men with whom I wanted to have much more than a cup of coffee. As I later discovered, though, the problems in my "sentimental life" lay not so much with the opposite sex, but with my own unconscious aversion to anything resembling commitment. Without realizing it, I had degenerated into the

female corollary to the lotharios I lambasted. I took the feminine approach to avoiding matrimony, or even real relationships. Rather than loving men and leaving them, I continually selected bad boys destined to love and leave me.

My therapist tried to point out to me that I risked becoming a rather pathetic psychiatric cliché, the girl trying to bring Daddy back home by pursuing "unavailable" men. I chose to ignore her, to brush aside her comments with a mental wave of my hand. What did she know? After all, when I had shared with her my concern about my mother's spending habits, she had suggested enrolling her in Debtors Anonymous, a twelve-step program for chronic overspenders. There lay a realistic scenario: Miss Premice, poster woman for keeping your business to yourself, leaping to her feet, clad in a recent wholesale purchase, declaiming, "Hi. I'm Josephine, and I'm a shopaholic," to a roomful of strangers. Didn't my therapist realize black divas don't do twelve-step programs? For them, denial is not a pathology, it's a way of life. Though I continued to consult with my shrink, I chose to ignore her gentle suggestion that I actually give a chance to nice men who knew what they wanted. *Nice*, I thought to myself, *it's nothing but a synonym for* boring. *Besides, I don't look to men for kindness. Women sustain me emotionally; men offer excitement.* Like Scarlett O'Hara at the Wilkes' barbecue, I had no intention of limiting my attentions to one dish; my décolletage and I would sample *all* that New York had to offer.

And so my décolletage and I had gone to my friend and former *A Different World* colleague Adriana's wedding without the courtly, attentive, educated man I was then dating. Adri had created for herself what I couldn't even imagine: a balanced life. She had found a man who accepted her whole: her loudness, her madness, her creativity. I didn't know I needed the normalcy and sanity she had found. Even as she spoke her vows, I scanned the sanctuary for eligible partners in reckless passion, someone "dangerous" and

exciting who would keep me tap-dancing for his affections. Why settle for considerate and stable when you can have brooding and unreliable? Despite what I now knew about my parents' marriage, I longed to be breathless, as my mother had been with my father, even after twenty-odd years. After ten years of sitting locked in a room eating dinner out of Styrofoam containers, I wanted *passion*, soap-operatic, music-swelling, pan-to-the-foam-crested-surf-crashing-on-the-shore *passion*. Funny, I didn't find it at Adri's wedding. Not for lack of well-showcased cleavage—or for lack of flirting.

The day after the wedding, I sat with my best friend Nanon's brother and sister-in-law, having a leisurely brunch. My house guest phoned to pass on an urgent message: My mother's neighbor had called. I should get to my mother's immediately. I raced out of the brunch, my heart marking the passage of every second with a metronome-like thump, and dove into a taxi. Enrico had warned me two days before that our mother was in bad shape. She'd claimed the doctor had paid a visit on Friday and assured her the bad cold she'd caught would pass. Again, I had believed her. Once at 755 West End Avenue, I found the door of my childhood home hammered and beaten; the police had had to break it down because my mother had fainted in her bed. Fortunately, Aunt Adèle had come to visit her, and when her sister didn't answer the door, she called 911. My mother sat semiconscious in her bed, her eyes rolling back in her head. We struggled to get her on the gurney. She resisted.

"I don't want to go to the hospital," she mumbled, almost too faint to speak.

The EMT's walkie-talkie squawked signals and ear-grating static. "We gotta get her to Emergency, she's in bad shape," the young woman said.

After I pleaded with her, my mother relented, and the policemen placed her on the gurney.

The ambulance careened down the street, its siren screeching. Aunt Adèle and I clung to each other, tears streaming down our faces. It was so dark inside the ambulance, it felt like night, even though it was early afternoon, December 19. At the back of the ambulance, my mother lay unconscious, her slim dancer's body strapped to the gurney, like a madwoman in an asylum. "How old is your mother?" the EMT asked.

"Sixty-seven," I answered softly.

From the depths of the ambulance came a sonorous voice, spitting out, with Bette Davis–like contempt, "What a dreadful number!"

I couldn't help but smile. It was pure Mommy, cracking jokes on the brink of death. Maybe she would make it after all. *But once she comes to, she'll never forgive me for letting her leave the house without hair, makeup, and wardrobe,* I told myself.

When we pulled up to the emergency entrance at Saint Luke's, the EMTs attempted to rouse her. "Josie, Josie, wake up," the young Nuyorican woman commanded in the amped-up voice people use with the hard of hearing, foreigners, and the mentally deficient.

"My name is Josephine," my mother corrected, grand even in her prone and desperate state. "Mrs. Fales to you." She was letting the young woman know that just because she lay on the brink of death didn't mean she'd tolerate familiarity. I felt fairly certain at that point that she would not let the Grim Reaper drag her away from Earth's party early. That would break her cardinal rule: arrive late, make an entrance, and after a long stay, depart with a flourish. The seedy emergency ward of an uptown hospital definitely did not suit her as a setting.

The waiting room was Bedlam. Dozens of listless people waited,

it seemed, forever for medical attention or news of their loved ones. Roaches prowled the putty-colored post–World War II tiled walls. An emaciated man clad only in a sheet burst through the steel double doors, scratching his pale, concave behind and yelling, "Leave me alone! You're trying to kill me!" An orderly dragged him back behind the swinging steel doors. Looking around, one couldn't disagree with the poor man. I knew I had to stay to protect my mother from the incompetence and mass indifference. Every hour on the hour, they allowed family members in to see the ailing. I rushed to my mother's side as soon as the clock struck two. They'd stripped her and dressed her in a wrinkled, pale-green hospital gown. With no makeup and her hair in a kinky Don King coxcomb, she looked anything but a diva. She slumbered in semiconsciousness, unsure of her surroundings.

"Mommy, I'm right here," I told her. "Nothing's going to happen to you."

She mumbled incomprehensibly in reply.

The emergency room physician, a five-foot-three white woman, approached. "You the daughter?" She tossed the question at me with her chin as she chomped on a large wad of gum. I half-expected her to blow a bubble, pull it out of her mouth, and stretch it.

"Yes, I am. Her physician is Dr. Anderson. He's in the pulmonary unit of this hospital."

"Uh-huh. How long has your mother been sick?"

"She caught a bad cold this week. Is she going to be all right?"

The doctor snapped and popped her gum, then ignored my question. "What medications does your mother take?"

"Prednizone, mainly. I'd like to arrange for a private room. I'll pay for it."

"That's not gonna make a difference." Her eyes scanned my body. I looked utterly ridiculous in my plaid micro-miniskirt, "Scary

Spice Goes Tartan." The doctor's expression told me she'd mentally dismissed me as some tall, thin, nonwhite bimbo and Mom as just another dark-skinned black woman with no health insurance . . . another one, Jane Johnson number 30,532. She popped her gum again and walked away. I'd never wished so earnestly that my commanding white father was around. The thought shocked me. On no other occasion in my life had I felt the need to play the "white daddy card," except of course when it came to hailing cabs. This instance called for WASP power. I just knew our little five-foot-three physician wouldn't dare treat a patrician white man so dismissively. But Papa lived an ocean and a million miles away, and he was not coming. It didn't even occur to me to ask him. The responsibility of getting these people to treat my mother like a human being lay squarely on my skimpily clad shoulders.

I held her hand and reassured her, "Everything's going to be all right."

The physician returned. "You gotta leave, Miss."

"I'm not going anywhere."

"Hospital rules." She rolled her eyes.

"I'm not bothering anyone here. I'm not leaving!" My voice thinned to a hysterical and desperate screech.

"If you don't leave, I'm calling security."

"Go ahead. I'm not moving!" I rebutted, tossing the dare at her with my chin as I planted myself next to my mother. The tiny part of my brain that had remained rational urged, *Susan, calm down. You're losing it.*

"Take that woman to the examination room," the doctor told an orderly, referring to my mother.

I exploded, "She is not 'that woman,' she's my mother, she's Mrs. Fales!" I screamed like an avenging banshee.

"Get her out of here," the doctor deadpanned to security as she strolled away.

Two policemen appeared at my side. "You better take care of my mother!" I yelled as they dragged me outside and dumped me in the waiting room.

Great, I thought to myself. *First the doctor dismissed me because of my color, and now I've branded myself a madwoman.* After giving Aunt Adèle a progress report, I rushed to the pay phone to call the doctor. His nurse informed me that another physician was on call. I phoned him, certain that since he worked right upstairs he'd rush down to help. I explained to him my terror, my mother's desperate condition.

"There's nothing I can do," came the indifferent reply.

I could tell from his accent that he was from the islands. I thought of telling him we were Haitian, thereby playing the "hey, my Caribbean brother" bonding card, but I shouldn't have had to. "Please come down," I pleaded.

"There's no reason for me to." He hung up, leaving me to take cold comfort in his validation of my parents' worldview. No race held the monopoly on cruelty and callousness.

The hideous night turned into a nine-day vigil as my mother slipped into a coma. Aunt Adèle, Enrico, the Haitian aunts and cousins, and I made the daily pilgrimage to the hospital, which stood right next to the cavernous Cathedral of Saint John the Divine. My latent Christianity fully roused, I stopped frequently to sit in the penumbra, light candles, and pray to Jesus, the son of God I wasn't sure I believed in, to give me back my mother, to deliver us from her unbearable silence. At my mother's bedside, I'd speak to her as though she could hear me, believing that, though she couldn't answer us, the voices of those she loved would summon her back from the brink of death.

Unable to bear just hearing phone reports about her best friend, Aunt Diahann flew in from California a few days before Christmas. Her daughter, Suzanne, understood the deep bond

between her mother and Josephine, and generously insisted that Diahann leave the family to be at her best friend's side. I entered the glass cubicle in the ICU one day to find Aunt Diahann rubbing my mother's feet, which were daintily crossed. My mother still striking poses, even in her comatose state.

"What are you doing, Josephine?" Aunt Diahann asked her unconscious friend. "You're going to have to stop this silliness. And if you saw what they've done to your hair, you'd get right up out of this bed." I looked at Aunt Diahann and smiled. She smiled back, then bit her lip, sighed, and "pulled up" Mommy-style, as if to prevent her tears from flowing and her faith from waning.

A few days before New Year's Eve, the ICU physicians phoned. My mother had awakened from her coma. I rushed to the hospital, thanking God all the way, and found her wide-eyed and smiling. She threw open her arms. I went and hugged her. I stood, holding her hand, looking at her, marveling at the miracle of her survival.

"Aunt Adèle was here earlier. Why did she look so worried?" she whispered hoarsely, completely unaware of the terror we'd endured for over a week. She thought she had just awakened from a beauty nap.

"Mommy, you've been in a coma for nine days," I explained.

"Oh," she answered surprised. She had no idea of the hell we'd all been through. It didn't matter. We were thrilled she was alive, and so was she.

The day we brought her home from the hospital—far more elegantly garbed than the day she left, I might add—we arrived at her battered front door. "What's all this? What happened to the door?"

"The police had to break it down because you fainted," I explained.

My mother's eyes grew wide with terror. Once inside the

apartment, she needed to take a seat. The gravity of the last few weeks' events finally hit her, leaving her reeling and winded. "I'm very grateful to you, Adèle," she said to her sister. "I know I'm lucky to be alive." She dropped her bravado, her Auntie Mame flippancy. Now ninety pounds—twenty pounds lighter than she had been a month before—she knew she'd cheated death, but she was not sure how long her stay of execution would last.

My mother and I knew without admitting it to each other that we had entered the home stretch. I found myself having to take up responsibilities I never dreamed of when I was a child in her arms. At times, when I angrily wondered how I'd ended up as the official elephant-dung sweeper of our family circus, Aunt Diahann would remind me how much my mother's madness had enriched all our lives. Once she'd recovered a bit of her strength, I approached her gingerly on the subject of her taxes, offering to have my accountants prepare them.

"I'll have to think about that," she said holding her head high.

Are you nuts? Let's stop the charade! I wanted to scream. But out of respect for her frail condition, and for the proud black woman who had raised me, I said, gently but firmly, "It really would be a good idea. I insist." I refused to embarrass her flat-out, to call her bluff. She could never perform on a stage again. Her disease confined her more or less to the house. Little had been left to her at this point but her dignity. I could not take that away.

A few days later she announced, as though granting a great favor, "I've been thinking about it, and perhaps I will let your accountants handle it." *Quelle largesse.* I rolled my eyes at her grandiose posturing, but heaved a sigh of relief.

Naturally the accountant asked to see the previous year's forms. "Do you have them?" I asked.

"I'm not sure," she said vaguely, furrowing her brow. Finally, a few days later, she let down her mask and admitted, with great

shame, that she hadn't filed her taxes. She didn't look like my splendid mother, but a frail little girl who'd done something terribly wrong and felt awfully sorry. I told her I'd wipe out the debt on the condition that we set up direct deposit to put money aside every year so she would never find herself in such peril again. She cried and apologized for causing me even a moment's distress, then put the episode out of her mind as she did any unwanted, harmful bit of information.

Over the next year, she ducked in and out of the hospital. Three thousand miles away in Paris, my father remained sublimely oblivious to the seriousness of her condition. That spring he came to New York for a day with his new girlfriend, a lovely, kind, accomplished woman close to his own age. He could spare only a few hours to see us.

Enrico sat, nervously explaining his desire to create Dungeons and Dragons–style games for a living. Papa scowled and barely looked at him. We had dinner in a French bistro and made small talk in our usual evasive fashion.

The next day, I visited my mother. "How was dinner with your father?" she asked.

"Fine," I answered, pursing my lips, not willing to pursue the subject. She sensed my reserve and chose not to probe further.

"*Dark Victory* is on. Do you want to watch?" she offered brightly.

"No, thanks," I answered. I looked at her, ninety pounds, sitting watching an old movie while hugging her bony knees to her chest, a true Amanda Wingfield waiting in vain for a better tomorrow.

She was broken in body if not in spirit. She used Enrico as her unacknowledged at-home care. He ran her errands, cooked some of her meals, picked up her prescriptions. She didn't want to

hire anyone because that would force her to admit the gravity of her illness. And her survival depended on telling herself tall, sunny tales, as she had for sixty-eight years. Enrico looked like my father, sounded like him, laughed like him, and had a similar sardonic wit. The resemblance that had irritated her in Enrico's adolescence now offered comfort. She didn't have my father by her side, but she did have the next best thing.

"You and your brother are being codependent," my shrink would point out. "Why should you pay your mother's taxes?"

"Because if I don't, no one else will," I answered.

"That's not your problem," she insisted. "Your mother's an adult. She has to deal with consequences like everybody else. If she doesn't, she'll never learn."

I smiled to myself. My sensible shrink would never understand. It was far too late to ask Josephine to live in reality, to join us on planet Earth. For all the years of my childhood, as Aunt Diahann pointed out to me, I had reaped the rewards of her unfettered imagination. I had lived in a world of magic. Now the universe presented me with the bill. I resolved to pay it, whatever the cost. But it dawned on me with each passing day, as I helped prop up her charade, that I did not want to follow in her footsteps. Her mad, beautiful, daring, impractical life and love had left her quite literally *à bout de souffle*, at the end of her breath.

Darling, You've Found Your Life

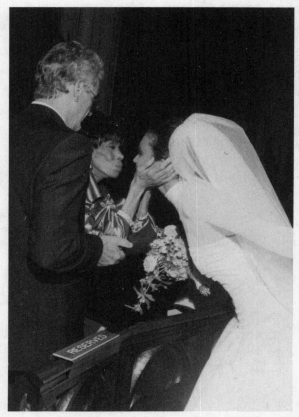

Exiting the church a married lady.

"Never let a man tell you,
'You look so beautiful stirring the soup.'"

—Josephine Premice

My mother wanted more than anything to walk down the aisle of Grace Church at my wedding. At age thirty-four, after years of fearing I would end up a successful but lonely career woman throwing birthday parties for her arthritic schnauzer, I had finally met a kind, caring, and intelligent man who wanted to share my life. And I had found my soul mate without resorting to the Harvard personals: "Do you enjoy Brahms and long romantic strolls discussing cold fusion by the banks of the Charles? Mature Cantabridgian Bachelor seeks sensuous Seventh Sister for . . . "

Throughout my dating years, Josephine had danced a circle of fire around me to make sure I didn't end up with someone who would sacrifice me on the altar of his ego. "Don't ever let a man tell you, 'You look so beautiful stirring the soup,'" she'd say as she removed a pot of freshly made mashed potatoes from the stove. She didn't care about color. Titles, whether professional or noble, left her utterly indifferent. She wanted an educated, secure, and, of course, good-looking human being who would cherish me, not clip my wings. Finally, I had found him, the man who didn't require me to tap-dance and hula-hoop for his affections. Josephine, mother of the bride, fully intended to take her victory march down the aisle of the church on my wedding day.

From the moment she met Aaron, a tall, beautifully man-nered British West Indian from Barbados and Trinidad, but raised in Hanover, New Hampshire, she set her sights on having him in the family. In all my years of dating, he was the first and only man

she ever told me I should marry. My mother liked him instinctively before ever setting eyes on him. Two weeks into our courtship she said, "I think this young man is playing for keeps."

I wondered, *With what forces from the beyond does my mother communicate?*

After my first romantic weekend with Aaron, she looked at me and said, "There's no worry in your face. You're falling in love." She relished hearing how, during this weekend, knowing I had an important pitch meeting for a movie about young black students in law school to prepare for, Aaron sat me on the balcony and came out every hour on the hour to kiss my forehead and refill my water glass, then returned to his own reading. A man who respected her baby's work—my mother had prayed for such a son-in-law the way other mothers pray for a doctor, lawyer, or multimillionaire.

Soon after this escape weekend, Aaron suggested we take my mother to dinner. "Where does she like to go?"

"Le Cirque," I blurted offhandedly, never stopping to think that perhaps a less expensive establishment than one of New York's most famous restaurants might be appropriate for a first meeting, especially since Aaron would insist on paying. I felt instantly remorseful, but Aaron didn't bat an eye. If Le Cirque was my mother's favorite restaurant, then Le Cirque it would be. The extravagant diva devil on my right shoulder stuck out its tongue at the frugal WASP angel on my left as if to say, "See, he can handle it! Stop raining on our glamour parade, killjoy!"

At the end of a long, leisurely meal, Aaron told my mother, "You have a lovely daughter, Mrs. Fales. Susan is the most incredible human being I've ever met." He was playing my mother's song, singing her favorite tune, "Ode to Susan." Someone else in this dark, clueless world had gotten the memo: "Josephine's baby is *divine!*"

"I know. You're very lucky," my mother responded, on cue and

with her characteristic lack of maternal modesty. But to my shock, she continued with, "But I think in this case, she's lucky too." I nearly fell off the banquette. We sat in silence, absorbing my mother's comment as she stared at Aaron with all the intensity of her ebony eyes. When we rose to depart, she walked slowly, as a result of her emphysema and her emotion.

No sooner did I step into my apartment than my phone rang. It was my mother. "I think you've found your life. That's all I called to say." She hung up.

I took a deep breath, feeling the joy and terror of having my fondest wish fulfilled, and while the most important person in my life was still alive to see it.

Aaron proposed three months later, when we found ourselves alone after a dinner celebrating his parents' fortieth wedding anniversary. He would not allow me to announce the engagement until he had obtained my father's official benediction, in person. This was no small feat since it required Aaron to make an eighteen-hour plane trek from New York to Guam, where my father was then stationed on a ship. I suggested he write a letter, rather than going all that way, but Aaron insisted on asking for my hand properly. I knew such reverence on his part would appeal greatly to my father, who loved being treated like the monarch of an unofficial kingdom.

I also knew the situation would allow my father to give full play to his rascal tendencies, and torment his future son-in-law. He took Aaron out scuba diving with the crew and encouraged them to make macabre jokes. "Six went out, but only five returned." He delighted in pulling out a saber, of the three-foot Indiana Jones /Temple of Doom variety, and decapitating bottles of champagne, then smiling at Aaron by way of suggesting, "You could be next, if you don't play your cards right."

Aaron noticed that the walls of my father's cabin were cov-

ered with pictures of my brother and me as children. Perhaps he felt nostalgic for a less complicated time in his life and our relationship.

At the end of Aaron's three-day visit, my father, whom I hadn't seen in a year and a half, called my mother, full of emotion, and simply said, "Now I know how Bois (their nickname for Grand-père) felt after we met." I was pleased that he approved. Whatever problems persisted between my father and me, I knew how much of my character and mind he had formed. I carried a great deal of Timothy in me; his spirit revealed itself in everything from my love of literature, to my neurotic need to research every detail of a foreign city I might visit, to the way I pulled my prominent nose when thinking. Since he'd left my mother, I hadn't always been on speaking terms with him, but as his daughter, I would have had great doubts about marrying someone of whom he did not approve.

Aaron phoned me at 4 A.M. on the last Sunday of his visit to say our engagement was official. I leaped out of bed, let out a loud yell, and told my official fiancé to fasten his seat belt and get ready for the most shameless display of pomp and circumstance the Western world had ever witnessed. No little discreet, impromptu ceremony for me. I wanted flowers, champagne, and yards and yards of tulle. I was at the door of the Saks Fifth Avenue bridal salon before they opened. My mother, in an utterly uncharacteristic nod to practicality, considered big weddings a waste of money. But she wanted to help with every detail of this event from the invitation to the cake to the flowers. She designed the flower girls' dresses herself, and even in her frail state scoured discount fabric houses for the perfect material.

Most important, she prepared for her role as mother of the bride. She went from the doctor to the acupuncturist to the acupressurist in an attempt to strengthen her lungs for the long march

down the aisle. "I'm definitely improving!" she'd insist as she strug-
gled to catch her breath after taking the two steps from a taxi to the
curb. With the help of her designer friend Koos Van Den Akker,
she conceived the perfect mother-of-the-bride ensemble. Though
she and my father spoke regularly on the phone, she hadn't seen
him for five years. Josephine didn't admit it overtly, but she wanted
to look her best in front of the man who had left her, not enfeebled
by illness. By mid-May, two weeks before the wedding, it became
clear that for all her efforts and "training," walking down the long
nave of the nineteenth-century church in which Aaron and I were
to be wed, and my father and grandfather had been christened, was
one dance number Josephine could not execute.

"Your lungs are just too weak. I suggest a wheelchair," her
doctor gently informed her as we sat in his office.

Josephine bit her lower lip, and looked off into the middle
distance. She hated to fail or admit defeat.

After a moment, she looked at the doctor and said, "That's
what has to be." In an effort to deflect attention from her condition
and lessen her disappointment, I decreed there would be no
"mothers' march." My future mother-in-law and Josephine would
discreetly take their seats before the guests arrived. That way my
mother would not have to endure the humiliation of an "invalid's
progress" down the center aisle.

At 3:45 on May 31, 1997, having spent the day socializing and
laughing with my closest girlfriends, I emerged from my childhood
bedroom in my white *peau de soie* gown with large ball skirt and
illusion sleeves—a dress very reminiscent of my mother's Jacques
Fath gowns.

Papa stood in his tux waiting for me. "Yes, very pretty," he
offered awkwardly as he pecked me on the check and furtively
looked me over.

"Mommy!" I called from the living room to the bedroom. She had spent the better part of the day in bed, catching her breath, receiving injections from her doctor, and slowly "putting on her face." After a moment or two, she appeared at the doorway of her bedroom.

"Hello, Timothy," she said with her best Blithe Spirit nonchalance.

Papa kissed her, and tried to hide his shock at her emaciated and weakened appearance.

"How do you like it?" I asked, twirling to give her the full effect of my wedding regalia.

"Beautiful," she said, catching her breath, her right hand on her bony chest, then quickly retreated to her room. She later told me her knees had gone weak at the sight of me, and that at that moment she didn't think she'd make it through the day. Papa and I left for the church as my good friend Glenn arrived to escort my mother.

I couldn't fit into the silver-gray vintage Rolls Royce I'd ordered as a bridemobile. The back seat was so narrow and cramped that my full skirt rose about my ears, like a gargantuan meringue. I laughed at my grandiose delusions of arriving in a vintage car, like visiting royalty. Papa and I left the Rolls for my mother—it matched her ensemble perfectly—and jumped in the limo. We rode down West End Avenue, the street I had known all my life, the scene of so many pilgrimages with my mother in her fluffy Mongolian lamb fur.

I thought perhaps Papa would offer some words of wisdom on life or matrimony. But he retreated into his usual shy silence and held my hand, occasionally giving it a tight squeeze. I smiled; this was classic Fales inability to express emotion. It didn't matter—at least he had come. He hadn't faced the full panoply of family and his wife's friends in over a decade. It took courage for him to be

there. Whatever had passed between us, I wanted no one but him to walk me down the aisle on my big day.

Still concerned with my mother's progress, I phoned her house every ten blocks or so. The housekeeper reported she was moving very slowly. I asked Papa the time.

"Four-thirty."

We'd called the wedding for five. My mother was nowhere near ready. I struggled to remain calm.

We arrived at the church early and had to circle the block. Debbie Allen stood on the sidewalk, armed with her digital camera, directing. She had already given the flower girls, including her daughter Vivian, their choreography. "Let's see that string coming out of the top of your head! Come on, girls, wake up and live," she ordered, ever the dance captain. Having watched me kiss an endless parade of swamp-dwelling frogs when we worked together in Los Angeles, she was thrilled that, as she put it, "my black prince had arrived, armed with his love."

Crowds of onlookers had gathered on the sidewalk to watch the proceedings. My mother's friends had come out in full force, out of respect and love for her. They knew what this day meant. Harry Belafonte and his wife, Julie; Bobby Short; John Galliher, who'd introduced my parents; Chita Rivera; Phylicia Rashad; Lynn Whitfield; and all the *semper* fabulous—Gloria Foster; Carmen De Lavallade and her husband, Geoffrey Holder; Aunt Diahann. The bells struck five-thirty. I entered the church—still no sign of my mother. Inside, the guests grew restless and worried. They had been waiting thirty, forty, now fifty minutes.

Our minister accosted me: "Where's your mother?"

"She's not here yet, Reverend," I responded.

"Well, I think we should get started," he barked impatiently.

It took all the reserves of my Christian patience not to smack

him. Had he lost his Episcopal seminary–trained mind? Me get married without my mother?!

My father watched me "pull up" Josephine-style and interjected, "We will not begin without Mrs. Fales." The reverend understood from Papa's tone that the issue was not open to further discussion.

"How close is she?" he asked, frustrated.

"You'll have to ask the limo people outside," my father told him. The minister left my sight and my mind. I wasn't going to let a time-stickler of a minister ruin this day. Five minutes later, word spread from outside: Josephine had arrived. I caught a quick glimpse of my mother in her shades of gray as Glenn wheeled her past me and through the doors of the sanctuary. The doors swung shut behind her. My bridesmaids and I took our places. I cringed. The very thing I had worked to avoid was about to happen. My mother was being wheeled down the center aisle, in plain view of everyone.

Suddenly, I heard applause, subdued at first, then thunderous and accompanied by whoops and cheers of "Brava!" I smiled to myself. My mother's friends and loved ones had greeted her with an ovation. Though she couldn't walk, her progress down the aisle was indeed a triumphal march. In the car heading to the church, she had fretted to Glenn that she had spoiled my wedding day, that she was a failure as a mother. Once she arrived, she realized she wasn't. Her showgirl instincts took over, and she smiled and waved at the guests as Enrico, taking over for Glenn, wheeled her to her seat. Her entry wasn't what my mother had envisioned, but it was more than she could have dreamed. She took her place next to Diahann, her friend of forty-three years, and her husband, now estranged, of thirty-nine.

A gospel singer sang "Amazing Grace" a cappella. As Aaron and I spoke our vows, my mother held her head high and her eyes

shined bright with pride. In that moment she knew that whatever trials and misfortunes lay before me, they would be different from hers. I had done as she'd said, not as she'd done, and therefore would probably never suffer as she had. And to my mother that seemed amazing grace, indeed.

Now Look Here, Jesus . . .

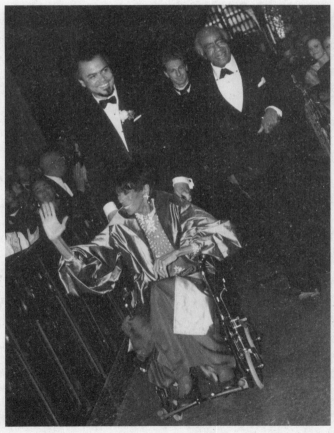

*Portrait of a diva, or my mother, smiling through her
last big public appearance, my wedding.*

"I'm not ready to die yet. When I am, I'll let you all know."

—JOSEPHINE PREMICE

In the first few months of my marriage, I became obsessed with stories of the doomed *Titanic*. I attended lectures about the ship at the Metropolitan Museum and nearly wept when the three-lecture series ended. I devoured every book I could get my hands on—*Maiden Voyage, The Memoirs of Archibald Gracie*. Night after night, I'd sit in bed reliving the icy sinking in lurid detail with *A Night to Remember*, and *The Night Lives On*. My husband had other ideas for creating a night to remember. He found this morbid fascination with a ship that had foundered some eighty years ago most alarming. Was this what they meant when they said you don't know someone till you marry them? One day, I finally drove him to the end of his nearly infinite patience. As I recounted in minute detail yet another tragic anecdote about the doomed voyage, he asked, "What is it with you and that ship?"

I blurted out an explanation that shocked me: "It's a story about people having to say good-bye, watching the clock tick, and knowing that in a few moments, they're not sure how many, they're going to have to let go of the people they love most in the world, and do it with dignity and courage. That's how I feel with my mother." Indeed, there lay the metaphor for our last three years, a slow, agonizing farewell as I watched the disease engulf her, knowing I could do nothing to save her, and not knowing exactly when she would slip away from me forever, but knowing it would be soon.

From that day on, Aaron never questioned my interest in the epic disaster. In fact, he supported it, buying me the reprint of the

New York Times edition that had appeared the day of the sinking and adding to my growing library on the subject. He knew how passionately I adored my mother. And within months of marrying me, he learned the terror of bedside phones ringing in the middle of the night, of harried cab rides to emergency rooms, of nail-biting days spent shuttling to and from the hospital, praying my mother would be able to come home "just one more time." He understood my fear every time we went away for even a few days that we would suddenly be summoned back, only to find my mother already dead. He learned the frenzied rhythm of my existence under the Damoclean sword of emphysema: Work on pilot scripts; dash to my mother's house to make sure she's all right. Write; get my mother to the doctor. Write some more—three jokes per page, please; bring chocolates in a vain attempt to bolster my mother's incredibly shrinking frame. Try to enjoy life, and assume an air of calm and normalcy when every morning I wake up thinking, *This could be the day I get The Call.* Come up with "hard funny" jokes as I watch the woman who used to waltz me around our apartment, the woman who sang and danced her way through eight Broadway shows a week, struggle to catch her breath after simply stepping out of bed. A clear plastic oxygen tank cord stemming from two tubes inserted in her nostrils had, at this point, replaced her *Bubbling Brown Sugar* feather boa. She tossed it about like a glamorous, exotic accessory, but it reminded us that with every passing day her lungs weakened and we moved inexorably toward silence.

Focusing on the *Titanic* centered me, as a mantra might a Buddhist. Others had survived a wrenching farewell; so could I. The elegant Edwardian setting also held the magic and innocence of my childhood. It reminded me of watching *Upstairs, Downstairs*, the PBS series chronicling the rise and fall of an aristocratic English family, with my parents. We hadn't just watched the series—we'd lived it. Papa and I would march around the apartment replaying

entire scenes. And on weekends, as we entered the long gravel driveway at Faleton, affecting English accents, we could really pretend it was 1912 and the world had not yet been convulsed by two world wars. Reading about the *Titanic* not only steeled me for the looming farewell, but also transported me to a world before "the fall."

My mother defied illness with unconquerable optimism. She applied her "no one's going to give me wrinkles" philosophy to her battle with emphysema. Each day, she donned her armor: a silk blouse with the collar turned up, wide-leg palazzo pants, which flapped around her fleshless shins like sails, and, of course, her wig and full makeup. She sent my brother out to buy champagne and strawberries and served them to her steady stream of visitors: her sister, Adèle; a calm, constant presence; her elegant cousins, Françoise and Lolotte; my aunt Kak and uncle Hal, with whom she'd remained close even after she and my father separated; their daughter, Nancy, a playwright and my mother's favorite niece; Aunt Diahann and all the *semper* fabulous; and Lynn Whitfield (then starring in the *Cosby Mysteries* television series), who sat by her bedside holding her hand and asking advice on everything from men to her career. Guests who had come to comfort her left feeling uplifted themselves by her humor, her glamour, and her still present smile.

Each time I crossed the threshold of her bedroom, she beamed as though the sun had just risen after forty days of rain. As I reached her bedside, she'd throw her arms around me and rock me to and fro as though I were a baby. I was a married woman in my thirties, far too old for such mollycoddling, but I loved it. With my cheek against hers, even as I listened to the grating of the oxygen struggling to make its way through layers of nicotine-burnt lung tissue, with each labored breath, I was home.

"Where is Aaron taking you tonight?" she'd ask, eager for the vicarious joys of my young, happy marriage.

"Our favorite restaurant, Circo."

"Lovely!" Then, very seriously, "What are you going to wear?" She wanted details, name of designer, dress or pants, suit or skirt, long or short? What color? What cut? What texture? She wanted to envision it all. Once she could picture the black silk pants with the cashmere halter top, the Miriam Haskel pearl-and-gold necklace and matching earrings, she moved on to gastronomy. "What are you going to eat?" Again, she wanted specifics. If pasta, what sort of sauce; if lamb, what cut? After I'd offered my imagined meal blow-by-blow, she'd sit back on her bank of pillows, sated. Taking a deep breath, she'd sigh, "That's wonderful!"

Though I could no longer create parts for her to perform, I longed to create a character who paid homage to her uniqueness. Whoopi Goldberg offered me the opportunity to do so when, through my agents at the time, she hired me to write a half-hour comedy script about a Broadway diva whose career bulb had dimmed. She had optioned the rights to a little-known television pilot called *The Decorator,* written for Bette Davis in the early sixties by Aaron Spelling, in response to an ad the screen legend had placed in the trades. "Actress, Academy Award winner, seeks work." The character was a martini-swilling grande dame who rearranged people's lives while rearranging their furniture. In our updated version of this concept, she became Gloria Crawford, thirtysomething African-American star of such hits as *Hello, Dalai,* the apocryphal Andrew Lloyd Weber musical tribute to the Dalai Lama. With her humor, her high style, her irreverence, we intended her to be a descendant of the pantheon of great black divas—Eartha Kitt; my mother; Josephine Baker; Diahann Carroll; the great soprano Leontyne Pryce; Florence Mills, the black American performer who'd gone to Paris before Josephine Baker; and Elizabeth Welch, who'd become the toast of London in the thirties.

The battery of white network executives listened to the pitch

with rapt attention, laughing out loud. All except one, who sat looking utterly befuddled and bewildered, as though he'd wandered into a part of the forest he didn't quite know. They "loved, loved, loved" the idea. They nodded eagerly as we cited Jennifer Lewis, a Broadway veteran dubbed by the New York press "queen of camp cabaret" as a potential lead. They relished the originality of depicting a black diva. No one had ever shown a black woman in that light before on television—with the possible exception of *Dynasty*'s Dominique Devereaux.

Their tune changed drastically after we handed in the first draft of the script, which Whoopi, no stranger to comedy or good writing, had loved. I had just returned from delivering my mother's weekly supply of chocolate truffles and sat waiting for the conference call with two midlevel executives on the West Coast. Finally, it came: "Please hold for Bob and Glenda." Whoopi also sat in on the call from her apartment on New York's Upper East Side. We waited in silence to see what our humorless judges would have to say.

Bob, a perfectly pleasant and harmless young man, did most of the talking. "Glenda and I were asking each other, What are the qualities of a diva? She's bawdy, sexy, self-centered, funny . . ." He rattled off a list as though giving a primer to the uninitiated.

Even from eight blocks away, I could feel Whoopi's rage mounting with mine. Two utterly bland middle managers who'd grown up in terminally bourgeois homes in the suburbs were lecturing us on the qualities of a diva. Neither of us interrupted, but we seethed. *This is it, I've reached it after twelve years in the business,* I thought to myself. *The low point in my career. The abyss. You can teach me a lot, about a lot of things—story structure, dialogue, even how to write a better joke, BUT NO ONE HAS ANYTHING TO TEACH ME ABOUT DIVAS! I WAS BREAST-FED, WEANED, DIAPERED, AND RAISED BY THEM! I JUST LEFT THE*

BEDSIDE OF A WOMAN WHO'S IN FULL MAKEUP ON AN OXYGEN TANK! I shifted on my bed, and pursed my lips to keep the tirade building within me from pouring out. *Lose the battle win the war, lose the battle win the war,* I kept repeating in my head.

"So who's a diva? Who are the divas we know? Glenda and I asked ourselves," Bob droned on in nasal tones. "Bette Midler, Mercedes Ruehl, Bikram, our yoga instructor in Santa Monica."

"She's definitely a diva," the heretofore silent Glenda interjected brightly. "We're not seeing their qualities in your character."

There ensued a deafening beat of silence as I squared my shoulders and Whoopi prepared her assault. Then she began with deceptive calm: "None of the women you've mentioned is a woman of color."

"Oh, yes," Glenda piped up eagerly, "Bikram, our yoga instructor in Santa Monica, is Indian."

"I don't know your yoga instructor," Whoopi deadpanned. "And we're not talking about yoga instructors. We're talking about women who broke barriers. These women didn't hit glass ceilings, they hit marble ceilings, women like Josephine Baker, Josephine Premice, Leontyne Price, Lena Horne . . ."

"Eartha Kitt, Diahann Carroll, Carmen De Lavallade," I added.

"These women have a knowledge of style, a sophistication," Whoopi continued.

It was the "opposition's" turn for dead silence. It became clear we might as well have been speaking Mandarin. They didn't get it. Their image of a diva was a spoiled, petulant, white woman with an ample chest and an off-color sense of humor—Mae West, or Sophie Tucker, perhaps. They'd never in their entire lives met anyone like the women we were talking about; they'd never even seen any of them perform, except perhaps Diahann Carroll, on television. We were attempting to explain a dark and alien civilization to

them. We knew in that phone call that though we could rewrite the script from A to Z, the project would never go forward. Even in the Year of Our Lord 1998, as fictional characters, my mother and her gang still proved "too big for the room."

I sat on my mother's bed the next day, angrily recounting the exchange to her. She listened, then said with a smile, "It hasn't changed. But one day . . . " She was past raging at the powers that be in the entertainment world. She was engaged in a far greater battle for her life. She refused to waste energy on the trivial. The most powerful weapons in her arsenal were her will to live and her uncanny ability to ignore the bleakness of her situation and create a counterreality. These two qualities served her well when nine months later the sword of Damocles finally fell.

I was back in New York on hiatus from *Linc's*, the series I'd cocreated with Tim Reid for the Showtime cable network. Aaron, Enrico, and I rushed my mother to the intensive care unit in the middle of an October night. Over the next few days, my mother clung tenuously to life. I would arrive at the ICU every morning and find the nurses pale with terror.

"Your mother almost didn't make it last night," they'd say, a tremor in their throats. I could tell by their faces they didn't believe she would make it out of the ward alive. I prayed that would not be the case. I hated the idea of her dying in the hospital. But they had underestimated her. The fifty-year-old man with a young family to the left of her died, then the elderly gentleman two cubicles on the right passed. Josephine refused to join them.

She was coherent but unable to speak because they'd had to perform a tracheotomy to attach her to a respirator. Nonetheless, with a hole in her throat and a plastic umbilical cord emanating from it, she still behaved like a queen in residence. She would daintily cross her emaciated legs under the hospital bedsheets, and she'd wave her long tapered hands and beam whenever a visitor

appeared—and there were many. Aunt Diahann flew in and breezed into the ICU in a sable-trimmed cashmere coat. Uncle Roscoe arrived to recite naughty poems and tell my mother how splendid she was. Aunt Adèle would sit for several hours a day, reading a book and stroking her baby sister's head. Uncle Bobby dropped by to regale his former party escort with "dispatches from the social world."

After a few weeks, she graduated from the ICU to the regular pulmonary unit, a very drab postwar edifice badly in need of a paint job. Sensitive as she was to the beauty or ugliness of her surroundings, my mother never once uttered a complaint. With no private rooms available, her wardmates, many of whom looked as though they might have been youngsters during the Civil War, were a cheerless lot. I believe my mother took one look around at these walking cadavers and said, "I'm not going out like these stiffs!" And indeed, compared to them, she looked ready to dance a number from *Jamaica*.

During one of our daily visits, as I recounted an outing to the opera, she interrupted to say, ever so nonchalantly, "I saw Jesus the other day."

In my entire life, she had never mentioned Jesus, except to take his name in vain. "Jesus Mary and Joseph, can I have a moment's peace?" she'd cry as she slammed shut her bathroom door. Now she was mentioning him as though he were the hospital orderly.

"Really," I responded.

She nodded emphatically.

"Under what circumstances did he appear to you?"

She indicated a pounding, a pressure on her chest. Clearly this "visitation" had occurred in the ICU on one of the nights she had nearly died. She mimed Jesus enveloping her in his arms as she struggled for life. As promised in the verses of the Twenty-third

Psalm, he had walked her through the valley of the shadow of death.

I sat astonished. "What did he say to you?" I asked.

"No," she rebutted, frowning like an impatient little girl, "I told him!" Even with her vocal chords demolished, my mother had no intention of letting *anyone*, be he the son of God himself, have the last word.

"What did *you* say?" I asked.

"I told him, I'm not ready to do this dance with you. I'm not ready to die yet."

"Did he give you a sign that he had heard you?" I asked, riveted.

Josephine sighed and rolled her eyes in exasperation. Was I following the story at all? "I'm still here, aren't I?" she whispered with what the tracheotomy had left of her voice. Yes, indeed she was, alive if not entirely well, bowed, but certainly not broken. Once again, by sheer force of will, she had put off our final farewell. I hugged her. She rocked me, then looked me in the eye. "I'm not going anywhere," she insisted.

The doctors told me privately, "She has six months, a year at most." But Josephine knew better. She had bent the ear of the son of God. He'd come for her, and she'd declined the dance. She had more living to do. The respirator would follow her home and confine her to her bed and round-the-clock care. But nothing could destroy her enthusiasm. She continued to dress like a fashion plate and apply her dramatic Cleopatra makeup.

At her monthly doctor's visits to change the bandage on her tracheotomy, she would impatiently ask her physician, "When are you getting me off this machine?"

He'd humor her with an encouraging response, withholding the true answer: "Never."

My mother's sense of fantasy, though at times thoroughly

exasperating, enabled her to survive the pain of living with a gaping hole in her throat, as well as to defy all medical odds. She made it well past the doctor's predictions of "six to twelve months."

Two years into her ordeal, we lost the insurance that paid for her night nurses. One evening, a month or so before the policy expired, I stood in my mother's bedroom discussing possible replacements for the nurses with one of her devoted caretakers. It was a tense time, with our out-of-pocket costs skyrocketing. I didn't even know if I could find the staff to care for her, let alone how long I could afford it. I was spending nearly every penny of my earnings as it was, and my Showtime series had just been canceled. Nonetheless, I was determined to keep her out of a nursing home. She could stand anything but that. As the nurse and I struggled to find solutions to our dilemma and come to acceptable terms, my mother sat placidly studying her face in a handheld mirror, ignoring our discussion completely.

Finally, she interrupted our intense exchange with an important announcement: "I'd like a face-lift." The nurse and I both looked at my mother dumbfounded. She stared back expectantly, sitting up imperiously, as if to say, "Well, I don't have all day, ladies. What's it going to be?"

After a few beats of stunned silence I managed an incredulous "You are kidding, aren't you?"

My deluded diva frowned and shook her head emphatically. "No, I'm not!" She then tugged at her face to indicate the areas in "dire" need of a surgeon's improvements.

She's certifiable, I thought to myself, as I surveyed her sixty-five pound frame, literally skin and bones with absolutely not an ounce of flesh in between. *She can barely muster the strength to step out of bed, yet she wants to undergo major surgery. Would any other rational adult in this family please stand up?* I thought with some desperation. Not knowing whether to laugh or sob I said, "Mom,

you know the twenty-five-dollar-a-week petty cash allowance I've given you."

"Yes," she grumbled, still bristling at the fact that I had taken control of her checkbook.

"When you save that up, we'll get you a face-lift."

My mother's face broke into a huge smile, and she laughed in spite of herself. Even she knew she was nuts.

She never lost her sense of humor or her mothering instincts. "Is there anything I can do for you? Can I sew something for you? Help with your research?" she'd offer regularly, and with total seriousness. In sacred moments, I'd sit on her bed while she rocked me and hummed gently in my ear, sometimes even singing, ever so faintly, a Haitian lullaby, "*Ti oiseau.*" She refused to give up trying to set the world right again even though everything had changed. Rather than The Call, I would pick up the ringing phone and hear her defiant whisper as she willed sound out of shattered vocal cords: "Hello, darling, are you having a wonderful day?"

And they tried to tell me about divas.

Don't Like Good-byes

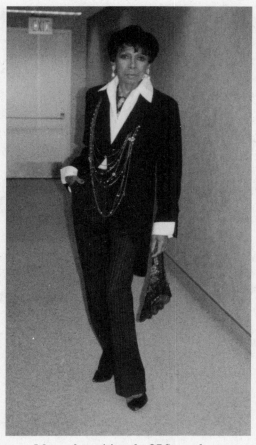

*My mother exiting the CBS soundstage
in Los Angeles.*

"You can wear the same thing twice, but never to the same places, or with the same people."

—Josephine Premice

I had to steady my mind and decide what my mother should wear. Sartorial considerations had always been foremost in our deliberations when we accepted any invitation, whether it was to speak before a gathering of professional peers or to feast on smelts at a fish fry in someone's backyard. We had devoted countless hours of our lives as mother and daughter to pondering the eternal question. For us this was not, What is the meaning of life? but, What are we going to wear?

For my mother, fashion had served as a means of expressing her individuality and her artistic voice when she wasn't performing and, in earlier years, when Jim Crow laws denied her entrée into certain locales. Narrow-minded producers could deny her work because she was too black or not black enough. Racists could abrogate her rights, and men could try to squelch her strength, but no one could prevent her from donning the waist-cinching evening gowns, rhinestones, and stilettos that declared to the world, "Here stands Josephine, magnificent, unique, and undeniable."

Now as her body lay motionless on her bed, slowly stiffening into a waxen corpse, it was more important than ever to find just the right ensemble. A Buddhist might require prayers and incense as homage by his survivors. My mother didn't care for burnt offerings and mumbled psalms. She wanted makeup, wardrobe, and jewelry! She would want us to make sure she made her final journey from her home looking divine. We had to honor her in death as she had accessorized in life.

I stood by her large pewter bed, clutching her lifeless hand and fingering the pearls she had given me so many years before. I stared at her shrunken face, straining to focus. To *think*. Her friend Corice, one of her many "adopted daughters," sat, rhythmically stroking my mother's bony legs through the bedcovers. I began by process of elimination. Clearly, we couldn't send her off in the beige-and-black-striped silk jersey T-shirt and pants she presently wore. They were far too casual. She hadn't changed that morning. Death had claimed her at 7:35 A.M., before she'd had a chance to dress for this particular occasion. Then again, perhaps she'd planned it that way, her casual attire a protest against the Grim Reaper's arrival. Perhaps it was her way of saying, "I don't really want to go to this function, but I suppose *I must*."

I'd been awakened by a call from her nurse Peggy. "I think you better come," she'd hoarsely intoned.

I leaped out of bed and threw on some narrow black pants, a white wool jacket, and my mother's pearls—even though distraught, I felt it incumbent upon me to look as soignée as possible for what I thought would be her last vision of me. I had an uncharacteristically cheery and chatty cab driver. I tried to make pleasant conversation, all the while wishing I were being driven by one of the city's surlier cabbies, ceaselessly chattering into his cell phone thus leaving me to think and pray. When I arrived, twenty minutes after receiving the call, the door of my mother's bedroom stood shut and her two nurses, Peggy and Margaret, sat in the living room. My heart stopped.

"Doctor Marion wants you to call him," Peggy gently commanded.

"Is she gone?" I asked, panicked.

"Call the doctor," Peggy insisted, blocking my way to the bedroom and handing me her cell phone.

In gentle tones, Dr. Marion told me she had passed away

moments after I'd left my house. She had "slipped off the mortal coil" peacefully, quietly, in her sleep. "This was just the way she wanted it," Dr. Marion assured me.

No, it wasn't, my mind rebelled. She didn't want to die. Only three weeks before, she'd struck the bed with her fist in frustration and said, "I'm sick," with tears in her eyes. Two nights before, she'd let the nurse put a straw down her throat and feed her oatmeal in an attempt to gather her strength. She didn't want the fight to end. She'd spent the last few weeks going in and out of hallucinatory states during which she'd cry out, "I'm dancing!" But she couldn't will her body to go on any longer.

I hung up the phone and dashed into her room. There she lay, propped up on a Dover cliff of ruffled white pillows as always, her eyes shut, an expression of deep, abiding peace on her face. How many times had I hugged her twice before leaving, then poked my head round the corner of the room to make sure she was still there, still alive? How many times had I awakened her from a nap and watched her face burst into her trademark thousand-watt smile? There was no waking her now. I threw myself on her stomach and sobbed like a child, "Mommy, Mommy!" I draped her limp arms around me, desperate to re-create the hugs I would never feel again. Never. Never. The word solemnly entered my vocabulary. It coursed over me like water over Helen Keller's hands, concrete, palpable, irrevocable. *Never.* I could finally grasp its full meaning, feel in the pit of my stomach its wrenching finality. I would never hear my mother's voice again. It was no longer just a word, a collection of letters and sounds. It was my reality. My mother had raised me on a diet of somedays. To a child of hope there is no such thing as never.

Several hours passed; my tears evaporated into thin salt streaks on my face. We had to get ready to send my mother off to the Frank Campbell Funeral Home. I could hear her chastising,

horrified voice in my head. "You're sending me out in *that*?!" It was the same panic I felt the first time we rushed her to the emergency room as she slipped into a coma. All during the ambulance ride, I kept thinking, *Will she live? And if she does, won't she kill me for letting her leave the house without her wig and nary a jewel in sight? Not to mention the tacky, non-Hermès scarf tied on her head?* This time, there was no danger of her "coming back" to exact punishment. Her ten-year struggle with emphysema, and six-year dance with death, had ended. But I knew her soul would never rest in peace unless her corpse was properly clad.

She needed not only a traveling ensemble for the journey across town to the funeral home, but also something stately and fitting for the funeral itself and her cremation. As I mentally catalogued the contents of her bulging closets, my mind reeled. For once in my life I could not answer the great question, What should one wear? A white silk blouse with billowing sleeves and black palazzo pants? No, too simple, too "I just threw this old thing on to pick up some ground beef at the supermarket." I heard my mother's voice again. "You don't wear slacks to be consumed by the flames of Eternity, darling!" None of her signature pantsuits would do either. Her redingotes hung on her emaciated, fleshless body like a potato sack on an unstuffed scarecrow. Nothing was right. Even with a closed casket service, she had to be beautiful.

"What about the gray silk brocade Koos designed for her for your wedding!" her friend Corice exclaimed, brightening and wiping an errant tear off her brown cheek. Perfect! It was elegant, exquisite, and had been made just for her, according to her specifications. And when she had worn it, she was happy.

We found the ensemble neatly packed in its original garment bag in her study closet. Layers of gray chiffon in a palette of shades, silver-thread embroidered, the jacket a romantic poet's blouse of whisper-thin pewter taffeta. She had helped to design it. "Shades of

gray," she had pronounced, "I want to be in shades of gray." And she purchased strands of gray-and-white pearls from Kenneth Lane to match.

"You're going to blow Captain Fales away," my friend Adriana had exclaimed upon seeing the finished ensemble.

"That's the idea," my mother purred, winking.

We sent it off with the Campbell Funeral Home undertaker. My mother was wheeled out of the bedroom to which she had been confined for the last two years, through the apartment she had lived in for thirty-six years, and out into the hall.

I had mentally prepared for this day for the last six years, and yet I wasn't ready. Each time I had careened through the streets of New York in a yellow cab on my way to the hospital, I had silentlly rehearsed the steps I should take. Whom did I call? What was the guest list for the memorial party we would throw in her honor? After calling relatives to tell them of her passing, book the Peter Duchin Orchestra to play. My mother had no interest in a lugubrious funeral. She wanted a celebration, with everyone dressed in their finest, "*zouté*" as the Haitians would say. I considered drawing up the list and having it at the ready in my computer for when the day came. It was a calming exercise when really every block, every mile, I prayed with all my heart and soul that this would not be it. That emphysema would grant us just one more stay. In the last year, though, as I watched death steal across my mother's features, and the merciless illness suck every last ounce of flesh from her body, I had sometimes wished for deliverance, for her and for me. And yet I was not ready. It was April 13, Good Friday. Jesus had come to claim his dance partner, and the word *never* branded itself onto my heart.

After the funeral home had wheeled my mother's corpse away, Aunt Adèle and I sat mutely on the living-room couch, trying to

calm our shattered nerves and absorb the events of the last few hours. Suddenly, I heard the doorbell ring, and a commotion in the hallway. A loud female voice screeched, "I am sorry for your loss!" I rose and went to the door to find the nurses and my husband surrounding a five-foot-two black female police officer in full *Ebony Fashion Fair* makeup and her young, white rookie partner. She was a size fourteen squeezed into a size ten uniform, he six-foot-two and lanky, with an air of abject cluelessness. They had driven by the building and, seeing the body being loaded into the funeral-home van, phoned their local precinct for reports of a death. Finding none, they'd decided to investigate.

Before I could say a word, the female officer barreled up to me, grabbed my right hand, and shook it as if to loose my shoulder from its socket as she repeated, "I am sorry for your loss. But no one here has called the po-lice. I must ascertain that there has been no foul play."

"I spoke to my attorney, and she told me calling the police was unnecessary. My mother was terminally ill. Her doctor just saw her this week," I answered.

"Well, you need to call your attorney back 'cause she is *wrong*." Then she continued, imperiously stabbing the air with the air-brushed nail of her index finger, "No one called the police, no one called the medical examiner. There are a lot of laws being violated here!"

My husband looked from New York's finest munchkin, as she sized me up with a disapproving "Mmph," to me as I tugged the bottom of my jacket, girding for battle. He could see that no sistah-to-sistah bonding moment was in the offing. He could also see my temper about to erupt, and that left to my own undiplomatic devices, I would end up spending the night in the confines of a jail cell at the local precinct.

"Officer, let's continue this conversation outside," he gently

suggested as he ushered the policewoman and her partner out into the hall.

For the next hour, we paced the living room like raging bulls as my husband handled the situation. I phoned our physician, who'd pronounced my mother dead, and brought the phone out to the hall so that our inquisitor could speak to him herself. My husband led me back to the apartment and begged me not to interfere any further.

A police detective showed up to photograph the "scene of the crime," that is, my mother's bed with its ruffled pillow shams and the respirator on the nightstand. Finally, after about an hour and a half, my husband returned to announce, "She's gone."

He had managed to win over the ornery policewoman so completely that she agreed not to seal off the apartment and had even wanted to bid me farewell. My husband suggested that in my bereavement, that might not be the best idea. The problem resolved, we all quieted down.

Suddenly, Peggy broke our silence and announced, "Your mother sent that lady. Miss Josephine wasn't leaving here that easily. She wanted an encore."

We all started laughing and agreed with her assessment. Even in death, my mother had managed to return for a second round of bows. She refused to exit the stage quietly without delivering one last punch line.

CHAPTER FIFTEEN

Redemption Songs

My father's photograph of his wife's hand, taken in Guadeloupe, 1967.

"I've never had to tell [my children] to stand in front of
the mirror and tell themselves they are beautiful.
They feel beautiful, which is what we give them."

—JOSEPHINE PREMICE,
in an interview for the *Daily News*, February 11, 1968

"We all like to be accepted for what we are, but first we
must accept ourselves for what we are."

—JOSEPHINE PREMICE

"Those of us in show business, we don't die.
We go on tour."

—GEOFFREY HOLDER
at my mother's memorial

"Your mother is the opposite of death."

—JUDY PRINCE

A week after my mother passed away, I began the excavation of her apartment, a task as monumental and daunting as uncovering an ancient city. Every day brought a new discovery, a long-lost artifact that told the story of our family and of our journey as mother and daughter. In a folder by her bed, I found a letter I had written her during my first semester at Harvard. "I want so much to make you all proud of me, to triumph," it read. "I miss New York, I miss my friends, I miss you and Papa. Most of all, I miss Greg." The last line stunned me, evoking the lost, drowning adolescent I had been all those years ago. Why had my mother kept this forlorn, utterly pathetic letter? Had she intended me to find it, that I might know how far I'd come and how very much I'd improved my taste in men? A drawer in her eighteenth-century Venetian vanity yielded a cleaning bill from 1966, unopened, pristine in its envelope. Had my mother ever paid it? Had she retrieved the clothes? Judging from the seemingly endless content of the walk-in closets, indeed she had, and even if she hadn't, we could afford the loss.

The wardrobe spanned the era from Papa's childhood in the thirties to my mother's early days as a performer in Paris, through New York in the sixties and seventies, to the endless forays to Loehmann's, the discount department store, in the eighties and nineties, to the pants whose waists had to be nipped ever tighter to accommodate her incredibly diminishing girth during her last years. It chronicled the story of a grand, varied, impractical, and

gallant life. I found the Jacques Fath ballgown she had transformed into my theatrical costume. Delighted, I held it up in front of me as I looked in the mirrors of the four double-doors. The fabric was frayed in spots, but the whalebones remained intact. I packed it away to pass on to the next generation of junior-divas-in training. I found the wooden doll carriage handle she had used to curl my hair into corkscrew curls every morning. She had thrown nothing away. She had kept every antique shoe buckle, every rhinestone, fake emerald, and bugle bead in endless Ziploc bags, ready for some future day of "bedazzling." She hoarded fake gems the way Depression-era people stash money. "You never know when you might have to bead something in a hurry and hightail it out of town." The ticket from a pawn shop where she'd consigned a brooch bespoke a time of penury in the early sixties.

She'd always glossed over her financial worries, preferring to ignore them in the hopes they would vanish. Had she kept this ticket with the intention of retrieving the brooch one day or as a warning to me after her death? A cabinet in her study yielded the endless correspondence with her attorney about the never-completed divorce proceedings. Reading the actual summons, I remembered the day in 1985 when she donned a suit and painted her face to go and meet Squire Bozorth. He had pressed her to give more details, a more shocking anatomy of my father's cruelties toward her, and she steadfastly refused. The summons also revealed my father had threatened to leave her for a Brazilian woman two years before he went to Paris. She'd seen the end coming but carried on, hoping for the best, never revealing her fears to me. I folded the papers and put them away in a trunk.

In a folder full of clippings, I discovered reviews and the program for a one-woman show my mother had done in 1966 titled *Here's Josephine*. With songs like "Charge It," "Beat Me," and "The Last Cigarette," she'd made lighthearted allusions to her weaknesses:

shopping, bad boys, and smoking. She sang *"Et Maintenant,"* the cry of a woman abandoned by her great love, and *"La Mamma,"* Charles Aznavour's lament for a dying mother. Thirty-four years before her death, my mother, aged forty, had stood on a stage in a flowing white gown with a jeweled clasp and unwittingly foretold the story of her life.

Each layer of excavation brought me deeper and deeper into complicity and understanding of the glories and miseries of our family. My paternal great-grandfather's racist pamphlet, "Plain Talk on the Negro Problem," which warned of the imminent disappearance of the great Anglo-Saxon race through intermarriage and miscegenation, contrasted with his daughter's—my grandmother's—loving report of her visits to us, her mulatto grandchildren, in her Roman travel diary, which I found in a hatbox full of pictures. I'd always thought my father exaggerated when he described his grandfather's pamphlets. If anything, he hadn't done justice to the vile, ignorant words they contained. I shuddered as I read lines like:

> That Negroes and whites differ fundamentally can hardly be questioned. The average Negro is inclined to be good-natured, lazy and imitative. His gift for vocal music is well known. He is generally kind to children and animals. On the other hand, his deficiencies are equally apparent. He is seldom a skilled mechanic. Like his ancestors, he is superstitious and easily moved by mass hysteria in religion or politics.

Or:

> Rape by Negroes is a common crime. According to our newspapers, during a few months in a recent year five white women were raped by Negroes in the North; and in New York City during one week five white women were attacked by them on the streets or parks; and the notorious case of a colored man who sneaked into the train berth of the young

wife of a white officer, and on her resisting him, cut her throat is well known. . . . The demand for segregation . . . is the only means of protecting our race from deterioration.

But then I laughed and thought, *Be careful what ethnic groups you wish oppression upon—your family may eventually belong to them.*

Buried deep in closets and drawers piled high with papers lurked boxes and boxes of magnificent photographs. My mother performing in the fifties, standing onstage belting out a song, her arms outstretched as if to embrace life and her audience. I unearthed long-lost photographs of the four of us on holiday in Guadeloupe, Papa young, dark-haired, and handsome, my mother looking wistfully into the camera as she sewed. Papa had taken one photograph of my mother's right hand in a pose absolutely emblematic of her femininity, her grace, her pride. It was the work of a man who loved his wife, right down to her finely tapered fingertips. Another black-and-white from the Roman days captured the two of them sitting in Papa's Alfa Romeo convertible on a sunny day, preparing to take off on a marvelous adventure. He smiles with all the joy and boundless hope of beautiful youth. In her polka-dot sundress, Josephine seems prepared to follow him anywhere, and looking at the photograph, I couldn't blame her. It reminded me of the joy my mother and father had once known. In the six years of her acute illness, I had forgotten the good times, the fun we had as a family, and all there was to celebrate in my parents' marriage. Now I wept at having it all brought back to me.

My mother had left a trail that seemed to say, "Build on this. Know our past and improve upon it." Even in death, she held me up to the looking glass to show me that in spite of all its pain and disappointments, life is indeed beautiful.

Her death redeemed our past in my memory, and brought Papa back to Enrico and to me. I had phoned my father, who was

back in Paris, on the morning she passed away. Not finding him at home, I'd left a message on his answering machine: "Papa, it's Susan. Please call. I'm at Mommy's."

The phone had rung two hours later. "Cougie, *c'est Papa.*" We hadn't spoken in seven months, as a result of an argument neither of us cared at that point to rehash or remember.

"I'm calling to tell you . . . " I broke down. "Mommy is dead."

"*Merde*, she's dead," he repeated, as if processing the information. Then, without a moment's hesitation, he said, "What do you want me to do?" For the six years my mother had struggled for her life, I had waited to hear these words from my father and ultimately given up hope that I ever would.

"I want you to come to New York," I said, tears of relief streaming down my face.

"I'll be there tomorrow. I love you." He had not had the courage to face her decline. But now he would honor her in death.

On a perfect, crisp, clear day in April, I walked down Park Avenue, my husband on one side of me, my father on the other. We made our way in the near-blinding sunlight on concrete to the funereal shade of the Frank E. Campbell Funeral Home. While Aaron went off to take care of arrangements, Papa and I rode the tiny elevator to the viewing room to make sure they had clad my mother as I requested.

The coffin stood on a riser in the far left corner of the visitation suite. From the doorway, we could see Josephine's tiny head resting on its cushion of white satin. As Papa and I walked closer and closer, arm-in-arm, my mother's sharp profile came into focus. Finally, we stood right above her, a shrunken little figure, arms folded in the posed attitude of peace and beatitude, eyes closed, hair carefully arranged in a sort of pageboy helmet, stiff on her diminutive head.

Papa's chin quivered at the sight of her. "She resembles Bois," he whispered hoarsely. With the slightly overdone embalmer's makeup and the unnatural, ashen hue of her skin she looked less and less like herself, less so even than the body on the bed the previous morning. I felt no urge to grab her hand, for her spirit had clearly departed and we now stood in the presence of a lifeless form, an effigy of the woman we had loved.

Papa just stared at the corpse of his wife of nearly forty-three years. It was April 14, 2001, the eve of the anniversary of their first date. We knelt before my mother in silence. After a few moments, we rose to exit. When we reached the door, Papa hesitated.

"Would you like some time alone with her?" I asked.

Papa nodded, unable to speak, and turned back into the room. I stood in the antechamber for several minutes, staring at the gaudily bright, brass wall sconces, bad attempts at American Colonial reproduction. I imagined him alone in the floral room with the corpse of the woman he had loved. For so long, I had resented him for not having the courage to come and see what she had become, how time, heartbreak, and illness had ravaged her body, if not her indomitable spirit. Now, however, I felt very sorry for him, for the man who loved deeply but couldn't find the vocabulary to express it. After five minutes or so, Papa emerged, his shoulders stiff and high about his ears. I stepped forward and hugged him. His body did not relax, but remained rigid in my embrace, as if to keep all his emotions from spilling forth.

"Mommy loved you to the very last day of her life, with all her heart," I whispered into his ear.

"I loved her too," he whispered back. "More than I ever loved anyone."

As we walked in the park afterward, I told him she wanted her body cremated.

"I know," he said, "and the ashes scattered on the Bay of

Pigeons in Guadeloupe." I looked at my father stunned. My mother had never mentioned that detail to me. But she had told my father some thirty years before, while they looked out at that bay during a romantic vacation. And Papa had never forgotten.

We kept the funeral short, sweet, and small. I knew if we had done an *Imitation of Life* spectacle in a dreary echo chamber of a gothic revival cathedral, my mother would have come back from the beyond and scolded, "Why are you boring these poor people? You know I hate organ music. What are we doing in this dreadful place? This is not 'Song of Bernadette.' And would a little champagne be too much to ask?" The "main event" would be her memorial celebration, planned for Mother's Day in the ballroom of the St. Regis Hotel, where she'd once done a benefit performance and sung *"Je ne regrette rien"*—"I Regret Nothing."

We called the memorial tribute for six o'clock in the Versailles Room, and the supper dance for seven on the roof—black tie, naturally. Papa, Enrico, and I formed a receiving line at the tall double-doors as some two hundred and fifty guests, friends, family, adopted family, poured in. The range of people reflected my mother's openness and capacity to love. Former Katherine Dunham dancers and jazz musicians mingled with impoverished intellectuals, socialites, celebrities, and just plain regular folk. My mother had created a united nation of people who adored her.

Uncle Roscoe began the proceedings by speaking of my mother's courage and integrity in walking away from *House of Flowers* when Pearl Bailey took her show-stopping number, "Two Ladies in the Shade of a Banana Tree," and reassigned it to three chorus girls. Josephine had always rehearsed perfunctorily, having noticed that any number that garnered a big response in rehearsal Miss Bailey would co-opt, declaring, "I will reprise that number in the second act," if not taking it away from the other performer entirely. Thus, a song that had once belonged to Diahann Carroll, became her solo

with Diahann listening to it with her face turned away from the audience. To everyone's shock, on opening night, Josephine brought the audience to its feet with what everyone had hitherto considered "that boring banana song." Two days later, Diahann called my mother and said she'd better get down to the theater. Josephine walked in to find the three other girls rehearsing her song. She phoned her manager, saying, "Get me out of this show, and book me in a club."

"She was a woman of exquisite integrity," Roscoe declared.

Bobby Short sang an a cappella tribute to his soul mate: "I'm a little black bird, looking for a blue bird." Amy Greene, a former magazine editor who'd known my mother since the fifties, spoke of an era dimming with her passing. Carmen De Lavallade, clad in a gold brocade ballgown, recited a list of the great women in history, from Cleopatra through Helen Keller and ending with "my friend, Josephine Premice." Together, Debbie Allen, Phylicia Rashad, Jasmine Guy, and Lynn Whitfield sang the praises of the diva who had blazed a trail for them with "This Little Light of Mine." Jasmine's one-and-a-half-year-old daughter Imani refused to allow her mother to leave her out of the number and joined in. Aunt Diahann, wielding a multicolored handkerchief my mother had given her, did her best not to break down as she rendered homage to the woman who had taught her the social graces and nurtured her.

Finally, Enrico rose to speak. In the final months of our mother's life, he had found his path, supporting himself as a bicycle messenger by day and writing short stories and essays in the evenings. Clear, eloquent, and dignified as he spoke, he alluded to some of the conflicts in their close but complicated relationship. He then went on to describe a wonderful day he had passed in her company in the mid-eighties. They'd debated an article in the *Village Voice* about the first black Miss America. Enrico had marveled at our mother's razor-sharp analysis and ability to dismiss old

hackneyed ideas. Later they'd dined at a neighborhood restaurant. "I never did tell Mom while she was alive that I considered that day the perfect mother-son time. So I'd like to thank my mother for one perfect day and an extraordinary life." As he walked off the stage to the appreciative applause of the guests, we embraced. We both knew that our mother's passing set him free to live his life.

I took to the podium last, wearing a gunmetal-gray gown from one of my mother's many discount designer clothing sources. The woman who'd sold it to me told me my mother had bargained with her for it on my behalf until about a month before she passed away. With her last breath, she made sure her baby had designer evening gowns, *at cost*. I'd accessorized with a pair of earrings as big as chandeliers, in keeping with my mother's motto that more is more. I thanked her for showing me, through the manner in which she faced death, the way I must live my life—with courage, humor, glamour, and optimism.

Papa did not wish to speak. "If I were to say anything, it would be in Creole," he shyly added, as if to apologize.

We gave Josephine, the performer, the last word, showing a tape of one of her appearances on Merv Griffin's show. She sang *"La Mamma,"* Charles Aznavour's lament for a dying mother, in Italian. The tape dated from 1966, the year she'd done her one-woman show. Even then, at forty, she was too thin, very frail, and short of breath. I saw a tremendous sadness in her eyes I'd never noticed as a small child. Upon finishing the song, she joined Merv for an interview.

Jokingly he said, "I love you Italian singers." No one in his studio audience laughed. As she belted out the tune, she had become an Italian singer. This skinny, brown-skinned woman had managed even back then to transcend stereotypes and make people accept her as she was, a citizen of the world.

We ended the tribute with a song from the *Josephine in Paris*

album my mother had recorded at twenty-six. As her signature anthem, "The Waltz of Lilacs," rang out, everyone sat just a little taller. "One cannot live as you do," her vibrant, gravelly voice admonished. "Off a memory which is now nothing more than a regret, and nothing more than a few tears. Because of these few pages of melancholy, you shut the book of your life and you believed that everything was over." Then she belted out the triumphant refrain, a dare to us all: "But all the lilacs of May will forever bloom, and forever dance for joy in the hearts of those who love and are loved."

At that point, Papa, who'd sat straight and stiff, a soldier of stoicism, convulsed into sobs, his whole body racked with the pain of his loss of the years, of happiness, of the woman of his life, of irretrievable time. I had not noticed, so transfixed was I by my mother's voice, until I turned and saw the tears streaming down his face. Enrico wrapped his right arm tightly around Papa's shoulder. I took my father's right hand in my left. He squeezed with all his might, as though he would never again let go. And so we sat, Papa, Enrico, and I, hand in hand in the bright lights of the mirrored Versailles Room, our eyes lifted toward a distant, as yet invisible horizon, my mother's triumphant voice forever ringing in our ears.

Geoffrey Holder had it right in his eulogy; Josephine is certainly not dead, she's merely on tour. My mother watches over me, still. And so every day since the memorial, I find myself quietly uttering a prayer of thanks for all the joys and all the sorrows, for all the songs she left in me. How can I sing the blues while my mother dances in heaven?

NOTES

18 *Many leftists and bohemians:* John O. Perperner III, *African-Amer-ican Concert Dance* (Urbana and Chicago: University of Illinois Press, 2001), p. 3, 5, 7, 8.

19 *one of a handful of performers:* Richard Long, *The Black Tradition in American Dance* (New York: Rizzoli, 1989), p. 79.

19–20 *Asadata Dafora, the first impresario to present African dance to Amer-ican audiences as an art form rather . . . First Lady Eleanor Roosevelt:* Perpener, p. 103.

20 *Only seventeen years old at the time:* Perpener, p. 125.
 the funky West Village night club where: Max Gordon Live at the Vil-lage Vanguard, pp. 61, 62, 67.

21 *"I gave a party for the Premices . . . in her gestures":* Anaïs Nin, *The Diary of Anaïs Nin, Volume Three 1939-1944* (New York: Harcourt Brace, 1969), p. 272.

34 *While most of the fabled black Broadway musicals:* Allen Woll, *Black Musical Theater* (Baton Rouge: Louisiana State University Press, 1989), p. 215.

34 Jamaica *was the first Broadway musical to:* Steve Suskin, liner notes accompanying CD of RCA. Victor CD of Jamaica, origi-nal cast recording (New York: BMG Classics, BMG Music, 1958), p. 12.

35 *"I'm a bachelor girl":* Whitney Bolton interview, *Morning Telegraph,* 27 January 1957.

39 *The* News *article neglected:* Nat Kanter, "Negro Singer Weds Socialite Ship Exec," *New York Daily News,* 19 November 1958.

40 *With tongue firmly in cheek*: *Chicago Defender*. "US Maps New Plan for Integration," 29 November 1958.

49 *My mother grew up in an America of lynchings—there were thirty-four the year she was born*: David Levering Lewis, *W. E. B. Du Bois: The Fight for Equality and the American Century, 1919-1963* (New York: Henry Holt and Company, 2000), p. 193.

58 *Such experimentation*: Woll, p. 213.
 Now my mother and her friends could : Donald Bogle, *Brown Sugar* (New York: Da Capo Press, 1990), p. 154.

99 *The cast featured veterans like*: Woll, pp. 125, 214, 215.

99 *The* Bubbling *overture*: Woll, pp. 75, 76, 134.

103 *She earned rave reviews*: Noël Coward, *The Noël Coward Diaries*, edited by Graham Payn and Sheridan Morley (New York: Little, Brown & Company, 1982), p. 366.
 "But Miss Premice, beyond her snake wiggles as a dancer . . . " Cyrus Durgin, "Tropical Song and Dance: *Jamaica* at the Schubert'," *Boston Daily Globe*, 9 October 1957.

118 Dreamgirls, *which dealt with the dark side*: Woll, p. 250.

169 *one critic smirkingly*: Jack Kroll, "The Black Cherries," *Newsweek*, 22 January 1973.
 "On the evidence of this deplorable production" : John Simon, *New York Magazine*, 29 January 1973.

261 *"That Negroes and Whites . . . "* : Clarence Blair Mitchell, "Plain Talk on the Negro Problem" (privately printed pamphlet, 1947), p. 3.
 "Rape by Negroes . . . ": Ibid, p. 4.

BIBLIOGRAPHY

Bogle, Donald. *Brown Sugar*. New York: Da Capo Press, 1990.

Bolton, Whitney. "Premice on Men and Actresses." *Morning Telegraph* (January 1958). New York Public Library for the Performing Arts.

Coward, Noël. *The Noël Coward Diaries*. Edited by Graham Payn and Sheridan Morley. New York: Little, Brown & Company, 1982.

Durgin, Cyrus. "Tropical Song and Dance: '*Jamaica* at the Schubert'." *Boston Daily Globe* (9 October 1957). New York Public Library for the Performing Arts.

Gordon, Max. *Live at the Village Vanguard*. New York: St Martin's Press, 1980.

Kanter, Nat. "Negro Singer Married to Socialite Ship Exec." *New York Daily News* (19 November 1958).

Lewis, David Levering. *W. E. B. Du Bois: The Fight for Equality and the American Century, 1919-1963*. New York: Henry Holt and Company, 2000.

Long, Richard. *The Black Tradition in American Dance*. New York: Rizzoli, 1989.

Martin, John. *The Dance*. New York: Tudor Press, 1946.

Mitchell, Clarence Blair. "Plain Talk on the Negro Problem." Privately printed pamphlet, 1947.

Nin, Anaïs. *The Diary of Anaïs Nin, Volume Three 1939-1944*. New York: Harcourt Brace, 1969.

Perpener, John O. *African-American Concert Dance*. Urbana and Chicago: University of Illinois Press, 2001.

Simon, John. "Beware the Greek, Even as a Gift." *New York*, vol. 2 (25 August 1969). New York Public Library for the Performing Arts.

Suskin, Steve. Liner notes accompanying CD of RCA Victor CD of *Jamaica*, original cast recording. New York: BMG Classics, BMG Music, 1958.

Wahls, Robert. "Return of the Native." *New York Daily News* (11 February 1968). New York Public Library for the Performing Arts.

Woll, Allen. *Black Musical Theater*. Baton Rouge: Louisiana State University Press, 1989.

"US Maps New Plan for Integration." *Chicago Defender* (29 November 1958).

1943 Asadata Dafora's First African Dance Festival, at Carnegie Hall. Josephine, soloist. Eleanor Roosevelt, patron.

1945 Asadata Dafora's Second African Dance Festival, at Carnegie Hall. Josephine, soloist. Eleanor Roosevelt, patron.

1945 Tour of the United States with blues singer Josh White.

1945 *Blue Holiday* at the Belasco Theater on Broadway. Musical revue by Al Moritz and Earl Robinson. Starring Ethel Waters and Josh White. Also starring Josephine Premice. Featuring Lavinia Williams, Talley Beatty, and the Katherine Dunham Dancers.

1947 *Caribbean Carnival* at the International Theater on Broadway. Musical by Samuel L. Manning. Starring Pearl Primus, Claude Marchant, and Josephine Premice.

1954 *House of Flowers* at the Erlanger Theater, Philadelphia, and Schubert Theater, Boston. Musical by Truman Capote and Harold Arlen. Directed by Peter Brook. Starring Pearl Bailey. Also starring Diahann Carroll and Josephine Premice.

1956 *Mr. Johnson* at the Martin Beck Theater on Broadway. Play by Norman Rosten, based on the novel by Joyce Carey. Directed by Robert Lewis. Earl Hyman in title role, Josephine as his wife, Bamu.

1957–58 *Jamaica* at the Imperial Theater on Broadway (558 performances). Musical by E. Y. Harburg and Fred Saidy, music by Harold Arlen. Directed by Robert Lewis. Starring Lena Horne and Ricardo Montalban. Josephine as Ginger. Josephine nominated for Tony Award as Best Featured Performer.

1966 *Here's Josephine* at the East 74th Street Theater. One-woman show, staged by Claude Thompson; Sammy Benskin, musical director.

1966 *A Hand Is on the Gate* at the Longacre Theater on Broadway. Evening of black poetry and music, arranged and directed by Roscoe Lee Browne. Starring James Earl Jones, Gloria Foster, Ellen Holly, Godfrey Cambridge, Cicely Tyson, Roscoe Lee Browne, and Josephine Premice. Josephine received Tony nomination.

1968 *House of Flowers* revival at the Theater de Lys, off-Broadway. Directed by Joe Hardy. Choreography by Talley Beatty. Josephine as Madame Fleur. Also starring Novella Nelson, Hope Clarke, and Thelma Oliver.

1969 *Electra,* New York Shakespeare Festival Mobile Theater. Olivia Cole as Electra. Josephine as Clytemnestra.

1969 *The Killing of Sister George* at the Tappan Zee Playhouse. Play by Frank Marcus. Directed by Michael Howard. Starring June Havoc. Featuring Blythe Danner, and Josephine Premice as the fortune-teller.

1970 *Yoohoo Aunt Carrie's Coming* at the Lamb's Club, off-Broadway. Musical by Raymond League.

1973 *The Cherry Orchard* at the Public Theater (Anspacher Theater). Directed by Michael Schultz (originally directed by James Earl Jones). Starring James Earl Jones, Zakes Mokai, Ellen Holly, James Preston, Gloria Foster, and Josephine Premice as Charlotta, the governess.

1974 *This Bird of Dawning Singeth All Night Long* at the Actor's Studio. Play by Philip Hayes Dean. Starring Sylvia Miles and Josephine Premice.

1976–77 *Bubbling Brown Sugar* at the Anta Theater on Broadway (766 performances). Created by Rosetta LeNoire. Book by Loften Mitchell. Starring Avon Long, Vivian Reed, Joseph Attles, and Josephine Premice as Irene Page.

1978 *Pal Joey '78* at the Ahmanson Theatre, Los Angeles Music Center. Musical by Rodgers and Hart, adapted by Jerome Chodorov and Mark Bramble. Directed by Michael Kidd. Co-starring Lena Horne and Clifton Davis. Josephine as Melba.

1982 *The Mind of Danielle Edwards* at the American Place Theater. Josephine in title role.

1989 *The Glass Menagerie* at the Cleveland Playhouse. Play by Tennessee Williams. Directed by Tazewell Thomson. Josephine Premice as Amanda Wingfield.

NIGHTCLUB APPEARANCES

In the 1950s:

New York (Blue Angel, Village Vanguard), Los Angeles (Mocambo, Interlude, Bar of Music), Las Vegas (Frontier), Paris (Chez Florence), Montreal (The Ritz Hotel, and again in 1964), London, Madrid, Rio de Janeiro, and the Scandinavian countries.

TELEVISION

The Merv Griffin Show 1966–1968, semi-regular
The Autobiography of Miss Jane Pittman 1974, starring Cicely Tyson, with Josephine as Madame Gautier
Positively Black 1976
Not for Women Only 1977
The Jeffersons 1979, Josephine as Maxine, Louise's sister
The Robert Guillaume Show 1989, Josephine as the psychiatrist
A Different World 1991, Josephine as Eardine Abernathy, 1992–1993 as Dean Desiree Porter

ALBUMS

Josephine in Paris (Verve)
Calypso (GNP Albums)
Jamaica Cast Album
Bubbling Brown Sugar Cast Album

ACKNOWLEDGMENTS

This book would not have been possible without the unflagging support and extraordinary guidance of the following individuals and organizations:

My agent, Suzanne Gluck; my editor, Dawn Davis; Peter Bacanovic; Richard Storey; Glenn Berenbeim; Nanon De Gaspé Beaubien-Mattrick; Nan-B De Gaspé Beaubien; Jeanne Moutossamy-Ashe; Alison Taylor; Tim Reid; Charles Randolph-Wright; Carol Sidlow; Joyce and George Wein; Bobby Short; John Galliher; Peter Duchin; Gene Hovis; Brooke Hayward; Geoffrey Holder; Carmen De Lavallade; Professor Errol Hill; Grace Hope Hill; Lorie Stoopack; Elizabeth Dawson; Marvin Taylor; Diane La Chatagnère, Antony Toussaint, and Mary Yearwood at the Schomburg Collection; Louise, Jeremy, Jasper Powell III, Clinton, and the rest of the staff at the New York Public Library for the Performing Arts; Reinaldo, Ms. Moseley, and Tom Lisanti at the New York Public Library; Angela Troisi, Lenore Schlossberg, and Ed Fay at the *Daily News*; Zinn Arthur; the *Chicago Defender*, Marsha Hudson; and Herman Leonard.